# TURNER

## THE FIGHTING TEMERAIRE

*In association with Esso UK plc*

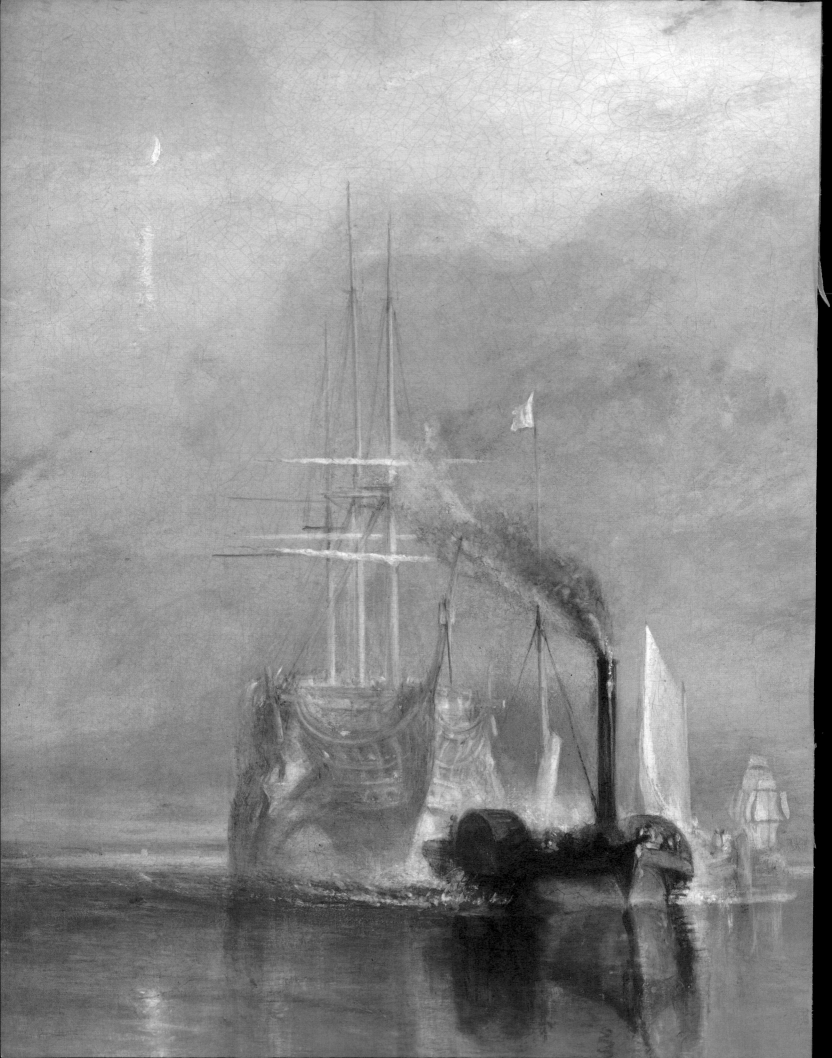

# MAKING & MEANING

# TURNER

## *THE FIGHTING TEMERAIRE*

Judy Egerton

*WITH A TECHNICAL EXAMINATION OF THE PAINTING BY*
*MARTIN WYLD AND ASHOK ROY*

NATIONAL GALLERY PUBLICATIONS, LONDON
DISTRIBUTED BY YALE UNIVERSITY PRESS

*To J. M. W. Turner*
*A 98-gun salute*

*&&&*

This book was published to accompany an exhibition at
The National Gallery, London
8 July–1 October 1995

© National Gallery Publications Limited and Judy Egerton 1995

All rights reserved. No part of this publication may be transmitted in any form or by any means, electronic or mechanical, including photocopy, recording, or any storage and retrieval system, without the prior permission in writing from the publisher.

First published in Great Britain in 1995 by
National Gallery Publications Limited
5/6 Pall Mall East, London SW1Y 5BA

ISBN 1 85709 068 3 (cased)
525197
ISBN 1 85709 067 5 (paperback)
525188

British Library Cataloguing-in-Publication Data
A catalogue record is available from the British Library
Library of Congress Catalog Card Number: 95–68075

Designed by Gillian Greenwood
Edited by Celia Jones
Index by Diana Davies
Printed and bound in Great Britain by
Butler and Tanner, Frome and London

For permission to quote extensively from the log of Captain Sir Eliab Harvey, 1805, PRO, Adm. 51/1530, Crown copyright, we are grateful to the Controller of Her Majesty's Stationery Office.

The quotation from 'Next, Please', by Philip Larkin, is reprinted from *The Less Deceived* by permission of The Marvell Press, England and Australia.

Front and back cover: Details from 'The Fighting Temeraire'
Frontispiece: 'The Fighting Temeraire'

# CONTENTS

# Author's Acknowledgements

I offer my great thanks to Neil MacGregor for inviting me to present one of the National Gallery's British paintings in the *Making and Meaning* series. Choosing 'The Fighting Temeraire' brought widespread responses to requests for help, from Wapping to Whanganui. My colleagues at the National Gallery have been invariably helpful. I am especially grateful to Martin Wyld and Ashok Roy for frequent discussions over the picture, and for contributing an illuminating essay on its 'making' to this book. Christopher Brown, Erika Langmuir and Nicholas Penny made constructive criticisms of each part of the typescript. Diana Davies's editorial wisdom was invariably sustaining, Jacqui McComish helped with research in the Gallery's archives, Neal Soleil of the Finance Department guided me through the ship-breaker John Beatson's system of double-entry book-keeping, and Rachel Billinge, Philip Clarke, Elspeth Hector, Jo Kent, Marcus Latham, Liam Ramsell, Alexander Sturgis, David Thomas and Deborah Trentham each helped to improve the text.

Among my former colleagues at the Tate Gallery, David Blayney Brown and Ian Warrell have been unfailingly helpful; I also want to thank Lindsey Candy, Anne Chumbley, Richard Miller, Peter Moon, Mollie Luther, Kasia Szeleynski, Robert Upstone and Andrew Wilton. At the National Maritime Museum, I am particularly indebted to Brian Lavery and Pieter van der Merwe for reading the typescript of Part I. They helped to save me from foundering in unfamiliar waters, but are not responsible for any vagaries of interpretation. Pieter van der Merwe also offered much knowledgeable advice in the early stages and, with Bill Robson, contributed a valuable note on the probable timing of the *Temeraire*'s last journey (pp. 42–3). Gloria Clifton, Julia Green, Sarah McCormick and Rosalind Whitford helped most kindly over loans from the National Maritime Museum.

Many curators of other collections have gone out of their way to help, including Sir Geoffrey de Bellaigue, Richard Burns, Mungo Campbell, Anne Goodchild, Alex Kidson, Charles Nugent, Caroline Paybody, Hugh Roberts and Luke Syson. Among scholars who generously provided information from their own research, I am deeply grateful to Janet Carolan, John Munday, Jan Piggott, Cecilia Powell, Nick Powell and David Wallace-Hadrill.

More widely, I offer my thanks to R.R.Aspinall, Museum in Docklands Project; Captain Mike Banbury, Alexandra Towing Company Limited; Anne Cowne, Lloyd's Register of Shipping; Harriet Drummond, Christie's; Stephen Humphrey, Southwark Local Studies Library; Rodney Merrington and Andrew Wyld, Agnew's; Kate Pinkham, Whanganui Regional Museum, New Zealand; Nick Savage and Helen Valentine, Royal Academy Library; Victor de Silva, Company of Watermen and Lightermen; Sergeant Christopher Smith, Rotherhithe Police Station; John Southern, of Blackwall Green Ltd, who introduced me to the *Monarch*; Linda Tait, at work on a history of H. Castle & Sons; and Thomas Woodock, Somerset Herald, College of Arms.

Gillian Greenwood, designer of this book, has responded throughout to the material with perception and high skill. Calmly and most capably, Felicity Luard has piloted it through all its stages.

# SPONSOR'S PREFACE

It is a pleasure to be associated once again with the National Gallery in this the third in the 'Making and Meaning' series of exhibitions.

As with the previous exhibitions that we have sponsored with the Gallery, 'The Fighting Temeraire' exemplifies the excellent research and scholarship that are the Gallery's hallmarks. We are delighted to be able to build on the success of the previous 'Making and Meaning' exhibitions by supporting this study, which explains the background to one of the best-loved pictures by a nineteenth-century British artist.

This sponsorship is important for the opportunity it gives the Gallery to make more of its vast array of treasures. We are pleased to be continuing our relationship with the Gallery in supporting its mission to increase public understanding and appreciation of its collection.

*K. H. Taylor*
Chairman and Chief Executive, Esso UK plc

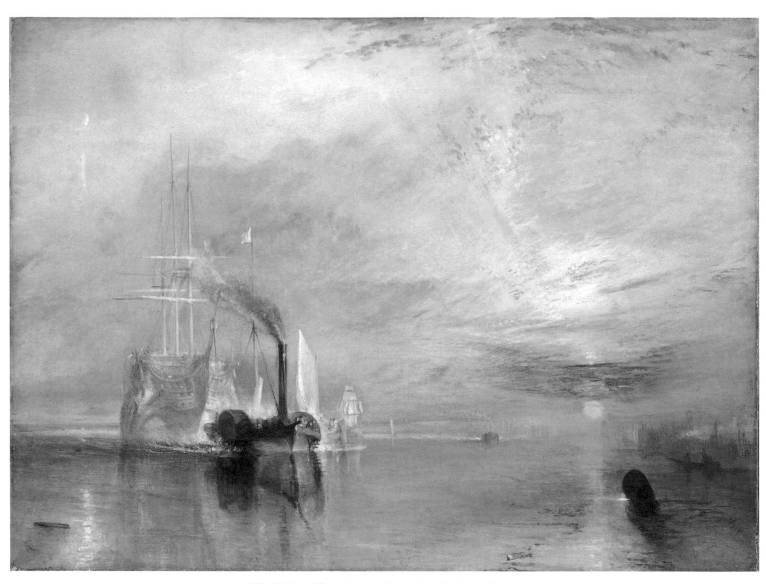

'The Fighting Temeraire, tugged to her last berth to be broken up, 1838'.
Exhibited RA 1839. Oil on canvas, 90.7 x 112.6 cm. Turner Bequest: London, National Gallery.

# FOREWORD

Turner called 'The Fighting Temeraire' his 'darling' and it is a verdict that the British public has, for over a century and a half, resoundingly endorsed. It has effectively always hung in the National Gallery, and there, copied again and again in the nineteenth century and reproduced as poster, postcard and print in the twentieth, it has become, in the widest possible sense, a national picture.

It is one of Turner's best-preserved works. Beyond the removal of some surface dirt, it has never been cleaned. And as it spent the highly polluted Victorian years under glass, it has come down to us pretty much as it left Turner's hand. Some of the pigments have altered – the iodine scarlet, newly discovered by Humphry Davy and enthusiastically taken up by Turner, has lost some of its intensity – but broadly, the picture addresses us now much as it did those who first saw it in 1839.

In this catalogue Judy Egerton traces the life of both Turner and his 'darling'. The making of a ship and its legend runs alongside the forming of an artist through years of obsessional (the word is not too strong) study of ships and seas, until the two careers cross, and the experienced artist transforms the actual event of the ship's breaking into a supreme poetic fiction.

The prime aim of the exhibition is to allow visitors to follow this process. If the chemistry of Turner's pigments can be rapidly grasped, the alchemy of his painting and his steadily expanding skill and vision can be no less clearly apprehended through his treatment of related subjects. In this instance, it might be said that the making of the artist is the making of the painting.

We are extremely grateful to the many owners and particularly the Trustees of the Tate Gallery for so generously supporting the exhibition with their loans. Our greatest debt of thanks is to Esso UK plc, for once again enabling us to explore in depth the treasures of the National Gallery and to give the public the opportunity to know and understand better what it has long loved. Their sponsorship of these ventures over many years has been appreciated and admired both in this country and abroad. And their generosity, which allows free admission to the exhibitions, would have been applauded by that champion of free art, Turner himself.

That is of the utmost importance; for in this instance, Turner is both artist and benefactor. 'The Fighting Temeraire' hangs in the National Gallery because Turner gave it – and much besides – to the nation. The history of that bequest has been troubled. Institutional incompetence (particularly the National Gallery's) and beneficiaries' initial greed combined with muddle, shortage of public funds, and finally a court settlement, to produce an outcome that was certainly not what Turner intended, and which cannot now be unscrambled. Yet I think it can be said that the result is unequivocally happy. The nation has honoured Turner not as he expected, but much more extensively. In the Tate Gallery (which he could not have envisaged) he is shown as the pivot of the British landscape tradition; in the National Gallery he is a giant on a European scale. This is no less than his due. It is the aim of both galleries to do him honour and to pay fitting tribute. And it is certainly the aim of this exhibition.

*Neil MacGregor*, DIRECTOR

# INTRODUCTION

Turner was in his sixty-fourth year when he painted 'The Fighting Temeraire, tugged to her last berth to be broken up, 1838'. His late works were often considered to be bad, mad and incomprehensible; but this picture was widely praised. Turner himself regarded 'The Fighting Temeraire' with particular affection. He once referred to it as 'my Darling'; he refused offers to buy it. The picture entered the National Gallery's collection in 1856 as part of Turner's bequest to the nation. It quickly became one of the best-loved pictures in the National Gallery; and, unlike some once-famous pictures, it has never lost the power to quicken an emotional response in spectators.

The exhibition which prompts this book is the third in a series presented under the general title *Making and Meaning*. In the purely technical sense of 'making', the history of 'The Fighting Temeraire' is unsensational. As Martin Wyld and Ashok Roy show here (pp. 121–3), 'The Fighting Temeraire' was painted in a relatively straightforward technique to which it must owe its largely sound state of preservation. But if Turner's technique in 'The Fighting Temeraire' is basically uncomplicated, the mind that coloured the canvas and charged it with meaning is complex enough for endless exploration.

The picture was inspired by the fate of the *Temeraire*. Doomed and ghostly in Turner's painting, the *Temeraire* in her prime was emphatically a real and very substantial 98-gun fighting ship, launched in 1798, built of over 5,000 oaks and manned by more than 750 men. Part I of this book recounts the history of the *Temeraire* herself. In the Battle of Trafalgar, she fought with conspicuous bravery beside Nelson's flagship the *Victory*. But that was in 1805. Trafalgar was so decisive a victory that the French posed no further threat by sea. Great war-machines like the *Temeraire*, once venerated as 'hearts of oak' and 'bulwarks of the nation', were kept moored in harbour, and relegated to humbler duties. Inevitably, wooden ships decayed. The Admiralty's standard practice was to strip outworn ships of fittings which could be re-used in the Navy, and then to sell them for the value of their timbers. That, quite simply, is what happened to the *Temeraire*. On 16 August 1838 she was sold by auction to a London ship-breaker, who arranged for two steam-tugs to tow her up-river to his wharf at Rotherhithe. Her fate was common to her kind. By 1838 fourteen of the ships under Nelson's command at Trafalgar had been broken up; others were to follow.

Why should the fate of the *Temeraire* have prompted such a powerful response in Turner himself? Like a private death, her passing was unremarked by most of his contemporaries. No other painter saw a subject in it. But out of a 'four foot canvas, representing a ship, a steamer, a river and a sunset', Turner made a thing of such beauty and emotion that Thackeray likened 'The Fighting Temeraire' to 'a magnificent national ode, or piece of music'.

Part II, a sketchy account of Turner himself, his patriotism, his urgent but often incoherent vein of poetry and various contemporary subjects which he painted before 'The Fighting Temeraire', may suggest some answers. War at sea had dominated the years in which Turner made a name for himself as an artist.

Turner was 18 when those wars began. When the *Temeraire* was launched, he was 23; when the Battle of Trafalgar was fought, he was 30. He never forgot those wars, nor his hero Nelson.

Part III chiefly examines contemporary reactions to the picture, both when it was exhibited and after it entered the National Gallery in 1856. Contemporaries assumed that a picture of a recent event must largely represent what actually happened, and that Turner therefore 'must have' witnessed the tow; indeed he was variously reported to have watched it from Greenwich, from the deck of a Margate packet-boat or from the end of a pier at Bermondsey. But the last days of the *Temeraire* are fairly well documented. Turner's image of the doomed ship is not that of an eyewitness. His picture is almost wholly a work of imagination. Newspaper reports were probably enough to inspire him to paint 'The Fighting Temeraire', just as, four years later, reports that the body of Sir David Wilkie had been committed to the deep in Gibraltar Bay were enough to inspire him to paint 'Peace    Burial at Sea'.

Endlessly, the *Temeraire* and her tug re-enact their roles. The tug has had a bad press, since our instinctive sympathy is for the *Temeraire*. Ruskin believed that 'of all pictures not visibly involving human pain, this is the most pathetic that ever was painted': nothing, he thought, could be as affecting as this 'gliding of the vessel to her grave'. Like all of us, the *Temeraire* is going to meet the inevitable; and the tug, as it trumpets noisome smoke through her ghostly masts, appears to be the agent of her doom. The most frequent interpretation of the picture is that the old order is being forced to yield to the new; but that makes little sense historically. The *Temeraire*'s tragedy was that she had become 'old', or obsolete, by 1815, and then not because she and her fellow men-of-war were supplanted by steamboats but because England was at peace.

As for the tug, she is no formidable prototype new-born in 1838, merely a small all-purpose working vessel of the sort which had been familiar on the Tyne, the Seine, the Mississippi and many other commercial rivers for two decades. Emotions run so high over this picture that if you ask anyone about the role of the tug, they will invariably answer (so long is the collective memory of Thackeray's famous outburst, quoted on p. 88) that the tug is dragging the *Temeraire* along in a diabolically eager and spiteful manner. But look at the picture itself, and you will see that apart from the water churned up by the tug's own paddles, there is hardly a ripple on the water as the pilot carefully deploys the power of his small engine to carry the *Temeraire*'s vast inert weight safely up-river. The tug is no executioner; it is merely hired to carry out a job. Turner knew all this: he had drawn steamboats of various kinds since the early 1820s. In 'Staffa', exhibited seven years before 'The Fighting Temeraire', he had cast a very ordinary tourist steamboat in a heroic role in a sublime landscape. He would also have known that the steamboat which made history in 1838 was not the *Temeraire*'s 32-ton tug but Isambard Kingdom Brunel's 1,340-ton *Great Western*, the largest steamer afloat, which that year inaugurated transatlantic passenger crossings. Turner's contrast between the *Temeraire* and her tug is not between the old and the new; it is more like the contrast between the noble bloodhound and the small brisk terrier in 'Dignity and Impudence', which Landseer exhibited at the British Institution in 1839 a few months before Turner showed 'The Fighting Temeraire' at the Royal Academy.

If the tug is not to blame for the fate of the *Temeraire*, who is? With such a spectacle in front of us, we can hardly be blamed for assuming that this is a drama with only two players, the relentless tug and the doomed *Temeraire*. But in fact Turner gives us a coded message. When exhibiting the picture in 1839, he added the following two lines to its title:

*The flag which braved the battle and the breeze,*
*No longer owns her.*

Turner knew that the *Temeraire*'s last berth must inevitably be the breaker's wharf: 'hearts of oak' all must, like 'golden lads, and girls', and chimney-sweepers, 'come to dust'. What he could not forgive was the fact that the *Temeraire* had been sold out of the Royal Navy when she was no longer of use. From the moment that she was knocked down by the auctioneer to the ship-breaker, the ship which had 'braved the battle and the breeze' in her country's defence could not fly a flag of the Royal Navy, even on her last journey. Significant details in the painting, long unnoticed, symbolise this heartless change in the *Temeraire*'s status. The villain of the piece, in Turner's eyes, is not the tug, but the Admiralty Board.

But what else could the Admiralty have done with a rapidly decaying oak ship? By 1838, few ships were broken up in the Royal Navy's own dockyards. Shipbuilders wanted teak and iron, not oak. With Turner's image before his eyes, Thackeray urged rhetorically that England's most famous ships should be preserved as shrines; but most of them were huge, and the practicalities of conservation were – and still are – daunting. The survival of the *Victory*, the Trafalgar flagship of the nation's hero, is exceptional (much restored, the *Victory* rests in dry dock at Portsmouth Dockyard, open to the public but still in commission as a ship of the Royal Navy). At the moment of writing, *The Times* reports the uncertain future of HMS *Caroline*, sole survivor of the 150-strong British fleet in the Battle of Jutland, 1916; will she be rescued by a musuem as a tourist attraction, or will she, in much the same way as the *Temeraire*, have to be sold off for scrap value?

In creating the picture of 'The Fighting Temeraire', Turner also created the posthumous fame of the ship herself. Without Turner, the *Temeraire* would probably now be remembered only by naval historians. Nor did the *Temeraire* become a subject for poetry until after Turner had made it the subject of his painting; then at least five poems were inspired by it, the best-known being by Sir Henry Newbolt. Part of Turner's own response to the fate of the *Temeraire* may have been to the rare beauty of her name. He had not responded when the *Bellerophon* was towed to another Rotherhithe ship-breaker's wharf in 1836, nor when the *Conqueror*, *Colossus* and *Mars* (all Trafalgar ships) had met similar fates. The poetry in the name 'Temeraire', with its three light syllables suggesting now the urgent effect of a drum-beat, now an ethereal fading away, may well have helped to preserve her memory in Turner's thoughts.

By 1839 Turner was the oldest Royal Academician still regularly exhibiting. Ruskin was to suggest that 'The Fighting Temeraire' was the last picture Turner painted 'with his *perfect* power'; but Turner still had such aces up his sleeve as 'Peace – Burial at Sea', 'Snow Storm – Steam-boat off a Harbour's Mouth', 'Rain, Steam, and Speed', all of which are illustrated here. He continued to exhibit until 1850, the year before his death. In buoyant mood in 1807, he had

scribbled verses in his Spithead sketchbook suggesting that when the 'Old Mower of us all' came for him, one simple phrase might be engraved on his tombstone: 'Thank Time for all his Jewels'. 'The Fighting Temeraire' ('my Darling'), which he kept until his death, was one of those jewels.

<center>&&&</center>

## A NOTE ON THE NAME OF THE TEMERAIRE, ACCENTS ETC

The *Temeraire*, launched in 1798 and the subject of Turner's painting, was named after *Le Téméraire*, a French ship captured in 1759 which later served in the Royal Navy. French accents were not used during the British ship's forty years of service in any of her captain's logs nor in any other Admiralty documents or contemporary British references to her; nor is it likely that they would have been used for a British ship of the line which served against the French.

Accents appear to have been introduced after the exhibition of Turner's painting in 1839, when interest in the ship herself led to confusion with the French prize after which she was named. As a result of this confusion, J. T. Willmore's engraving of Turner's painting was published in 1845 with the title 'The Old Téméraire' substituted for Turner's exhibited title. Thereafter, those who took the trouble to investigate the true history of the ship referred to her as the *Temeraire* and those who thought they knew better than Turner referred to her as the *Téméraire*. Accents were used in the National Gallery's previous *General Illustrated Catalogue* (1973, revised 1986, p. 630), but are deleted from the new *Complete Illustrated Catalogue*. To avoid confusion, accents where mistakenly used by other writers have been silently dropped here; but they are retained in the published title of Willmore's engraving.

The now established practice of underlining or italicising ships' names was not current during the period of the *Temeraire*'s service, 1798–1838; nor does Turner follow it in his title. In the discussion that follows, ships' names have been italicised in accordance with later official usage, but in quotations from contemporary sources (such as Admiral Harvey's account of the Battle of Trafalgar) they appear as originally recorded.

The name *Temeraire* was borne by two later serving British warships (see p. 115), and was destined for a fifth whose construction was cancelled in 1939.

*Works illustrated are by J. M. W. Turner unless otherwise stated.*

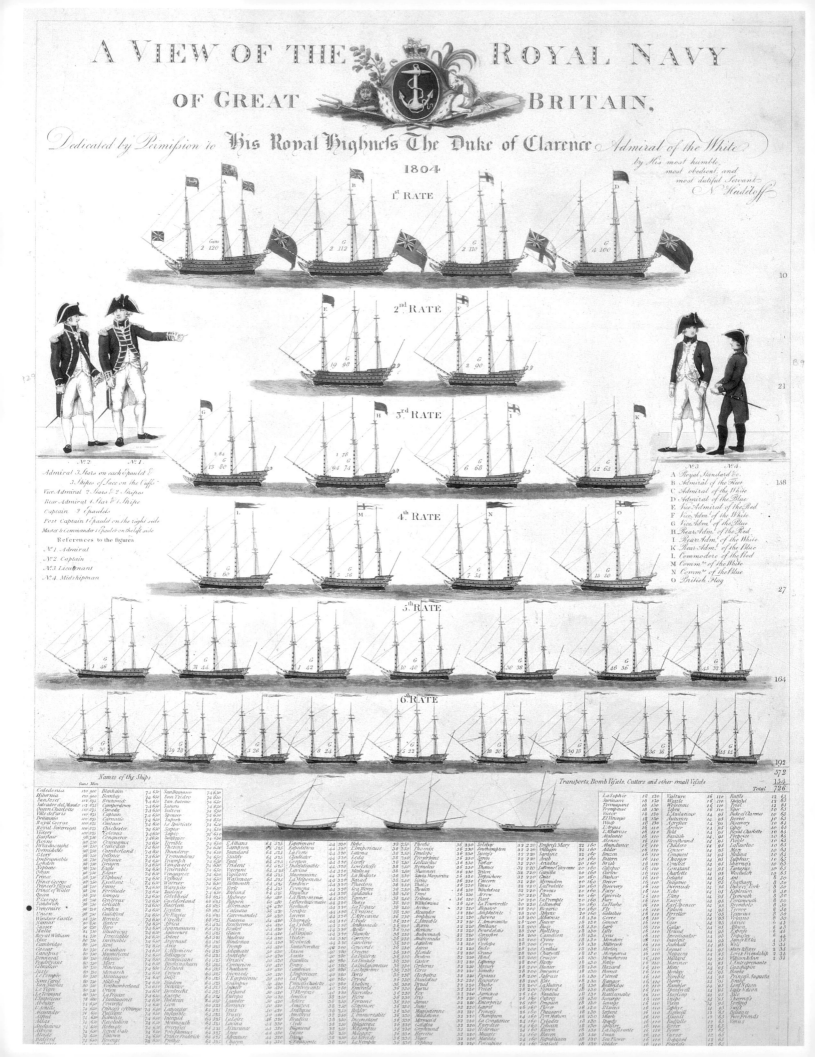

# PART I

---

# HIS MAJESTY'S SHIP
## *TEMERAIRE*

---

*The royal navy of England hath ever been its greatest*
*defence and ornament; it is its ancient and natural strength;*
*the floating bulwark of the island...*

WILLIAM BLACKSTONE, 1765[1]

His Majesty's Ship *Temeraire*, launched in 1798, was not merely a ship of the Royal Navy: she was a ship of the line, which means that she was specifically built and equipped to form part of the line of battle. Battleships were rated according to the number and power of their guns; the *Temeraire*, with 98 guns, was a ship of the Second Rate, second only to the most powerful ships in the fleet, First Rates with 100 guns or more, such as Nelson's flagship *Victory*. An engraving of 1804 entitled 'A View of the Royal Navy of Great Britain' (PLATE I) presents, in useful and elegant pictorial form, a simplified idea of the rating system in the British fleet. Stylised images of ships of each rate from the First down to the Sixth Rate represent the effective fighting force; their names, listed below, number 572. The *Temeraire*, one of 21 ships of the Second Rate, is listed in the first column; since the scale of this reproduction hardly allows her name to be read, a marginal dot has been added to indicate her status: twenty-seventh on the list whose total number (including over 150 vessels too small to be rated, depicted in the bottom row) is 726 ships. The length of the list itself indicates the strength of the Royal Navy in the year before the Battle of Trafalgar.

In setting the words 'Rule, Britannia!' to music in 1740,[2] Thomas Arne had given emphatic voice to a national conviction that was already by then centuries old: Britain must rule the waves, if her own islands were to be safe from invasion and her interests overseas were to be protected. Though parliaments might sometimes quibble over the amounts of money needed to finance the building of 'great ships', it was generally agreed that Britain must maintain a battle-fleet strong enough not only to repel any attempt at invasion, but also to blockade the enemy on his own coast, attack him wherever he might strike, and keep the sea lanes open for British merchantmen as well as for cruising squadrons.

In the half-century leading up to the Battle of Trafalgar, Britain's greatest naval triumph had been in 1759 when, in the course of the Seven Years War, Sir Edward Hawke chased the French fleet into Quiberon Bay and virtually annihilated it. Contemporary paintings of this victory by such artists as Richard Paton, Dominic Serres, Francis Swaine and Richard Wright helped to elevate marine painting to the status of history painting.[3] But the oceans were vast, and enemy fleets could be rebuilt; particular victories at sea, however resounding, could never guarantee absolute control of the seas in every quarter of the globe. Enemy squadrons might attack unexpectedly in India or the West Indies. While the British were preoccupied in a vain attempt to subdue their rebellious American colonies (in the War of Independence, 1775–83), the Spaniards besieged Gibraltar and attempted (unsuccessfully) to recapture it.[4] Sir Joshua Reynolds's portrait of Gibraltar's indomitable defender, General Lord Heathfield,[5] painted in 1787 and hanging since 1824 in the National Gallery, is a powerful reminder that although this account concentrates on the Navy, the role of the army (in Heathfield's victory, the gun batteries) was just as important. Waterloo, which moved Turner to paint one of his most sombre paintings

1 *(page 14) Nicolaus Heideloff (1761-1837): 'A View of the Royal Navy of Great Britain, 1804'. Engraving, coloured by hand, published 15 March 1804, 61.5 x 45 cm. London, National Maritime Museum. In this representation of the strength of the British fleet in the year before Trafalgar, a marginal dot indicates the name of the Temeraire, a ship of the Second Rate. The uniformed figures represent a captain and admiral (left) and a lieutenant and midshipman (right).*

2 *Sir John Henslow's lines plan for a new class of Second Rate 98-gun three-deckers, c.1788. Pen and black, green and red ink on paper, 184 x 66.8 cm. London, National Maritime Museum. Henslow's design, approved by the Admiralty Board in 1788, was used for building the Temeraire and her sister-ships Neptune, Ocean and Dreadnought.*

and an equally powerful watercolour (PLATE 68), was as decisive as Trafalgar.

In the 1790s 'the enemy' meant chiefly the French and, to a lesser extent, their Spanish allies. Turner was eighteen years old when the French Revolutionary War began in 1793; Napoleon's imperial ambitions intensified the combat, and the Napoleonic Wars lasted until 1815. War dominated the years in which the *Temeraire* was built, and in which Turner made his name as an artist. In 1798, the year in which the *Temeraire* was launched, Nelson trounced the French in the Battle of the Nile. Turner depicted that battle in a picture (long lost) exhibited at the Royal Academy in 1799.[6] In that year Turner was elected an Associate of the Royal Academy; in 1802, at the startlingly early age of 26, he was elected a Royal Academician.

<p align="center">&&&</p>

## THE TEMERAIRE IS LAUNCHED AT CHATHAM

<p align="center"><em>ENGLAND hails thee with emotion,<br/>
Mightiest child of naval art!<br/>
Heaven resounds thy welcome; Ocean<br/>
Takes thee smiling to his heart.</em></p>

<p align="center">THOMAS CAMPBELL<br/>
'The Launch of a First-Rate', 1840[7]</p>

His Majesty's Ship *Temeraire* (the abbreviated prefix 'HMS' was not yet current) was launched at Chatham on 11 September 1798. From the laying of her keel in July 1793, she had taken just over five years to build. She had been built to a design perfected in 1788 by Sir John Henslow, Surveyor of the Navy: his 'Draught propos'd for building a Ship of 98 Guns' (PLATE 2) would have been

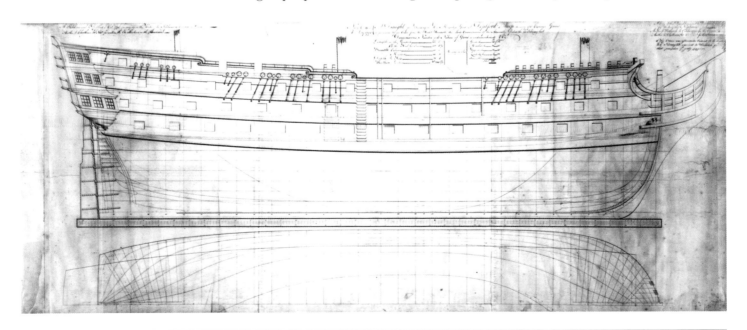

copied and constantly consulted for building the *Temeraire* and her sister-ships.[8] This draught of the ship's 'lines' or profile is termed a 'sheer plan'; other drawings were made of the bow and sections of the body. Four ships, ordered at different dates and built in different dockyards, were built to this design, each taking several years to build. The first to be launched was *Neptune*, at Deptford in 1797. Three sister-ships followed: *Temeraire*, launched at Chatham in 1798, *Dreadnought*, launched at Portsmouth in 1801, and *Ocean*, launched at Woolwich in 1805.[9] *Dreadnought* and *Neptune* were both to fight in the Battle of Trafalgar with the *Temeraire*; the *Ocean* was to oversee her final days.

Above his design, Henslow gave the exact dimensions of the ships to be built to it; these were strictly followed by the Chatham shipbuilders in constructing the *Temeraire*:

| | |
|---|---|
| Length of gundeck | 185 ft |
| Of the Keel for Tonnage | 152 ft 6⅝ in |
| Breadth Extreme | 51 ft |
| Depth in Hold | 21 ft 6 in |
| Burthen in Tons | 2110 |

Each ship of this class was built for a crew of up to 750 men: this seems a huge number but, as Lavery points out, 'the main reason why a warship demanded such a large crew (about ten times that of a cargo ship of similar size) was the need to man the guns in action'.[10] The *Temeraire*'s 98 guns were distributed in Henslow's design as follows: 'Gundeck 28; Middledeck 30; Upper deck 30; Quarterdeck 8; Forecastle 2.' Because the great mass of gun power was mounted on ships' broad sides, naval battles were traditionally fought by ships in sidelong opposition; 'a broadside' meant a massive discharge of guns from one or other side of a battleship.

Henslow's design merely indicates the places where three masts would be installed when the ship was in the water: the mainmast; the slightly smaller foremast, carried well forward, its sails providing most of the ship's power; and the mizzen-mast, placed aft.[11] As Turner was to depict the *Temeraire* going to her doom with her masts still standing, the process of masting (and dismasting) a ship should be briefly noted here. Masting – effectively converting 'mastless ships in a muddy river',[12] such as David Copperfield observed at Chatham, into ships which could be rigged, sailed and sent to sea – was carried out by a sheer-hulk, an outworn warship converted into a floating crane. Moored alongside a ship, it hoisted the lower masts above their allotted position, then dropped them into place (an operation demanding precise judgement) so that they passed through all the ship's decks to the mast step in the upper keel. Then the upper sections were added. Turner had evidently observed the operation of masting close-to and probably more than once; in 'The Confluence of the Thames and the Medway', exhibited in 1805,[13] he gives prominence on the left to a detail (PLATE 3) of the sheer-hulk from Sheerness Dockyard at work alongside a man-of-war, about to hoist a topmast into position; he shows another sheer-hulk at work in 'Dockyard, Devonport, Ships being Paid Off', a watercolour of about 1828 (PLATE 4). To dismast an old ship, a sheer-hulk would draw out the masts like teeth: this was to happen to the *Temeraire* in the summer of 1838.

The Admiralty, which habitually re-used good names from old ships, named the *Temeraire* after *Le Téméraire*, a 74-gun French ship taken as a prize in 1759 by

3 *A sheer-hulk working alongside a man-of-war. Detail from 'The Confluence of the Thames and the Medway'. Exhibited 1808. Oil on canvas, 89 x 119.4 cm. Petworth House, Tate Gallery and the National Trust (Lord Egremont Collection). A sheer-hulk, an old man-of-war cut down and equipped as a floating crane, could be moored alongside a ship to heave masts in or out as required. This presumably shows the sheer-hulk from Sheerness Dockyard; dismasting the Temeraire in 1838 would have been done much like this.*

the British in the battle of Lagos Bay, a victory won three months before Hawke finished off the French fleet at Quiberon Bay. Under the British flag, and with a British crew, *Le Téméraire* then served in the British Navy until she was sold off in 1784. In France her name had recalled the legendary boldness of Charles le Téméraire, Duke of Burgundy (1433–77); but his name meant nothing to English seamen. The accents were silently dropped from the name of the French prize, and were never used by contemporaries for her namesake, the British ship launched in 1798.[14] As the *Temeraire*, her name rolled easily off English tongues, and was accepted as having a meaning every bit as appropriate to a British man-of-war as 'Fearless' or 'Dreadnought'.

4 *'Dockyard, Devonport, Ships being Paid Off', c.1828. Watercolour on paper, 27.1 x 42.9 cm. Cambridge, MA, The Fogg Art Museum. Seamen's wages were paid irregularly, sometimes only after a ship's return from years of service abroad. The regulation straw hats worn by sailors for disembarking were part of the paying-off procedure: each man in turn was asked for his hat, which was returned to him 'with his wages in it and the amount chalked on the rim'. Boats carrying women and pedlars hasten to tempt sailors to spend their money. Devonport, on the stretch of the Tamar estuary called the Hamoaze, was known until 1824 as Plymouth Dock (Turner's title is up to date), and is now part of Plymouth. In the background centre are the long covered 'slip-shops' for building and launching ships (one survives); in front of them rises the crane apparatus of a sheer-hulk, and on the right is the New Dockyard Chapel, built in 1816.*

# HEARTS OF OAK, OR THE WOODEN WALLS OF ENGLAND

*Heart of oak are our ships,*
*Heart of oak are our men:*
*We always are ready;*
*Steady, boys, steady;*
*We'll fight and we'll conquer again and again.*
DAVID GARRICK, 1759[15]

The *Temeraire*, like most English ships of her day, was built of oak. Turner's vignette 'Shipbuilding (An Old Oak Dead)' (PLATE 5), is one of two small water-colour illustrations to Samuel Rogers's poem 'To an Old Oak', engraved by Edward Goodall for the 1834 edition of Rogers's *Poems*.[16] Working on a small scale did not inhibit Turner from producing a remarkably detailed image out of several different strands of the poem, nor from adding a few embellishments of his own. A great oak tree, once the proud centre of the village green, has been felled and wheeled off to a naval dockyard (Turner's background suggests Chatham), where a marine stands sentry and troops from a nearby garrison exercise. Oaks, in Rogers's characteristic hyperbole, are destined to furnish 'many a navy thunder-fraught' (i.e. equipped with guns); as this old oak waits its turn to be sawn into ship's timbers, Turner depicts a new ship under construction, 'destin'd o'er the world to sweep', and prophetically crowns its frame with battle-flags.

Over 5,000 large oaks would in fact have been needed to provide timber for a ship the size of the *Temeraire*.[17] By the end of the eighteenth century, not surprisingly, oak was in short supply. The Industrial Revolution, which made iron relatively cheap and plentiful, enabled shipbuilders, with the Admiralty's approval, gradually to supplant wooden parts with iron; and after 1800, many ships were built in India, of teak. But the popular belief that English ships were and should be made of English oak died hard.

The oak was a symbol of enduring strength. 'Heart of Oak', David Garrick's hugely popular song (its chorus is quoted above) was originally written for his patriotic pantomime *Harlequin's Invasion*, first performed on 31 December 1759, a month after Hawke's victory in Quiberon Bay. Garrick himself referred to it as 'my hurly burly Song';[18] but William Boyce's setting conferred dignity and long

5 *'Shipbuilding (An Old Oak Dead)', c.1832. Pencil and watercolour vignette, approx. 10 x 14 cm on paper 19.1 x 24.8 cm. Turner Bequest: London, Tate Gallery. One of two illustrations to Samuel Rogers's poem 'To an Old Oak'. As an old oak is trundled off to the dockyard sawyers, the framework of a new 'heart of oak' arises.*

life upon it. 'Heart of Oak' was soon (and almost invariably) popularly rendered as 'Hearts of Oak'. Garrick's song recurs as 'Hearts of Oak' in verse anthologies such as Dibdin's *Sea Songs and Ballads* and in song albums such as *Musical Bouquets* of the mid-nineteenth century. As 'Hearts of Oak', it has come to be regarded as the anthem of the Navy.

'Hearts of oak' quickly became a term of pride and affection for the nation's men-of-war. Tennyson, whose ardently patriotic early poems are far less well known than 'The Lady of Shalott' (1832), extended the phrase from England's ships to her people: the third and fourth lines of his 'National Song' (1830) are 'There are no hearts like English hearts/Such hearts of oak as they be'.[19]

Even more popular, since it suggested impregnable defence for the island race, was the metaphor 'wooden walls' for the kingdom's Navy. That phrase had been coined in 1635 by Thomas Coventry, Lord Keeper of the Great Seal under Charles I; defending the unpopular ship-money tax, he declared that 'The wooden walls are the best walls of this kingdom'.[20] The Navy inspired more popular affection than the army; as Blackstone perceived with his usual clarity, 'no danger can ever be apprehended to liberty' from an outward-facing force, 'however strong and powerful'.[21] National sentiment soon extended 'wooden walls' to 'the wooden walls of old England'. This became a patriotic watchword, even a cliché, especially in times of war; used in many a poem and ballad of the Napoleonic era, it was to be revived when the *Temeraire* met her end in 1838.

*&&&*

# THE SEAMAN'S LOT

*No man will be a sailor, who has contrivance enough to get himself into a jail;*
*for being in a ship is being in a jail, with the chance of being drowned.*
DR JOHNSON, 1759[22]

For the sailors who manned the 'hearts of oak', life was far from exalted. Grog, their daily allowance of rum (or brandy) mixed with water, and the fact that women were allowed aboard while a ship was in port were among the few compensations for a life of extremely hard work for low pay. There was the chance of winning prize-money from a ship taken in battle; though the ordinary seaman's share in the precisely regulated distribution of prize-money was small compared with that of officers, the thought of prize-money, as Lavery observes, 'probably gave the seaman some residual hope, like winning a lottery'.[23] One of the hardest conditions of service was that seamen had no right to shore leave; some spent years without leaving their ship. Their lives were endured in unhealthy and overcrowded conditions. Between watches, sleep (on hammocks of fourteen inches regulation width) can only have been fitful; food was very rarely fresh. Discipline was rigorous; flogging (for 'mutinous expressions', for 'skulking', but most commonly for drunkenness) was frequent and severe. But, as Garrick's 'hurly burly' song urged:

*Come, cheer up, my lads! 'tis to glory we steer,*
*To honour we call you, not press you like slaves,*
*For who are so free as the sons of the waves?*

# THE TEMERAIRE PUTS TO SEA

*The fighting Temeraire*
*Built of a thousand trees,*
*Lunging out of her lightnings,*
*And beetling o'er the seas...*
HERMAN MELVILLE
'The Temeraire', 1866[24]

The *Temeraire* had been launched in September 1798. In Melville's lines quoted above, his characteristically vigorous phrase 'lunging out of her lightnings' eludes interpretation through naval or other dictionaries,[25] but it is so expressive that we can forgive its obscurity. When newly launched, a ship was an empty shell, 'unpainted, unsheathed, unrigged, lacking masts, guns and most of the necessities for survival at sea'.[26] Her masts would then have been put in by a sheer-hulk moored alongside (see p. 18). The *Temeraire* was painted in black and yellow, the divisions of colour following the lines of the decks; this is most clearly shown in a later engraving of her (PLATE 25). Before she could begin 'beetling o'er the seas' (another idiosyncratic Melville phrase), the *Temeraire* had to be fully fitted out, supplied with guns and ammunition and laden with provisions and stores. Turner's watercolour 'A First Rate Taking in Stores' (PLATE 6; detail, PLATE 7) gives some idea of how the *Temeraire* (a ship of the Second Rate) might have appeared as she too 'took on stores'. The total cost of building, copper-bottoming, masting and equipping her was probably well over £60,000.[27] Preparing the *Temeraire* for active service was undertaken at Chatham by Captain Peter Puget, first of her several captains; he was then superseded by a younger man, Captain Thomas Eyles. Eyles came on board at St Helens on 26 July 1799;[28] under his command, the *Temeraire*'s period of active service as a ship of the line began.

7 (right) *Detail from 'A First Rate taking in Stores' (Plate 6). A First Rate such as the Victory had a crew of 875 men; the Temeraire had a crew of 750. Such ships needed huge stores of provisions (as well as ammunition). Regulations allowed each man a pound of ship's biscuit daily and a weekly ration of four pounds of beef, two pounds of pork, two of peas, one and a half of oatmeal, six ounces of sugar, six of butter and twelve ounces of cheese; each was issued daily with a gallon of beer if available, or a pint of wine, or half a pint of rum or brandy mixed with water.*

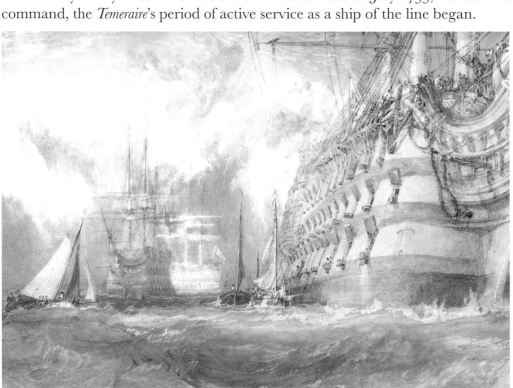

6 *'A First Rate taking in Stores'. Pencil and watercolour on paper, 28.6 x 39.7 cm. Inscribed 'J M W Turner 1818' lower right. Bedford, Cecil Higgins Art Gallery. Painted while Turner was staying with Walter Fawkes at Farnley Hall in Yorkshire, in response to Fawkes's request for 'a drawing of the ordinary dimensions that will give some idea of the size of a man of war'. Completed between breakfast and luncheon (see p. 70), this displays Turner's virtuoso technique, and also his ability to conjure up a subject from memory.*

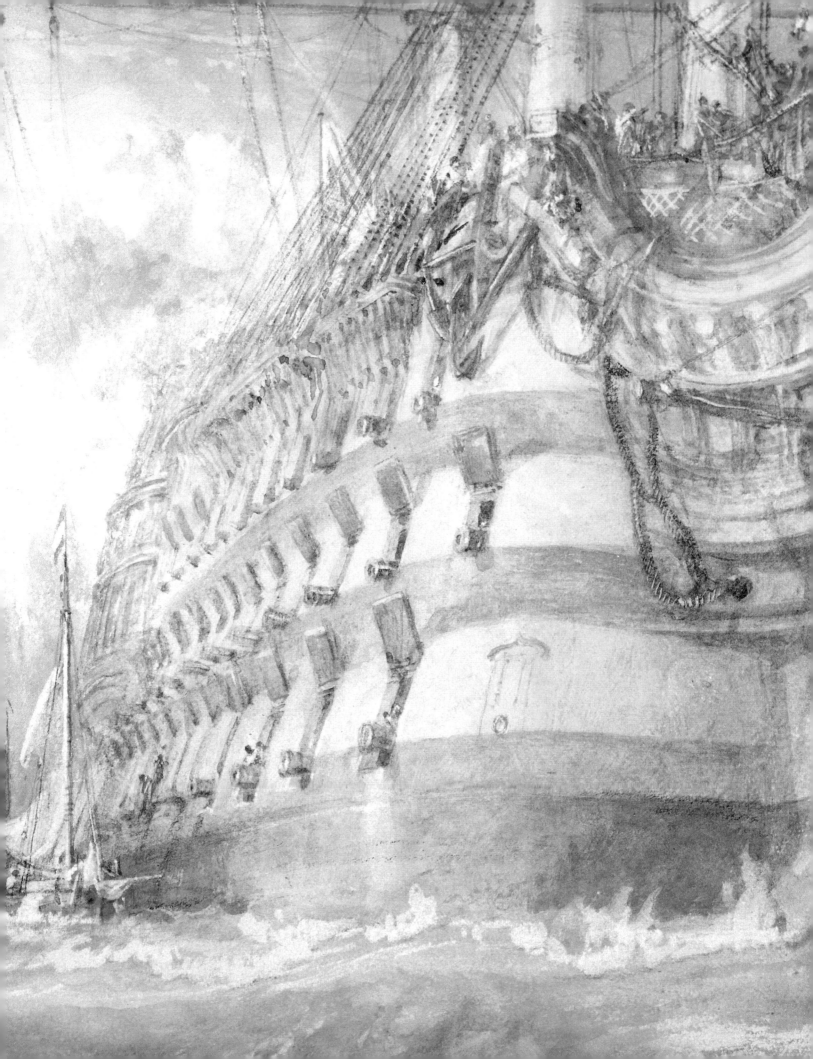

The *Temeraire* put to sea in July 1799, her first assignment being to join the Channel Fleet off Brest; and in that fleet she had the honour (for a year, and probably because she was the newest ship) of being the flagship of Admiral Sir John Borlase Warren. The Channel Fleet (sometimes called the Western Squadron) was generally thought of as Britain's strongest bulwark: as Admiral Lord Anson had stated in 1755, 'the best defence... is to have a squadron always to the westward as may in all probability either keep the French in port, or give them battle with advantage if they come out'.[29] In 1800 it consisted of 47 ships of the line: three First Rates, eleven Second Rates (including the *Temeraire*) and 33 others. As a debut for the *Temeraire*, to be the flagship in such a fleet could hardly have been bettered.

Turner's painting was to confer such nobility on the ship that it comes as a shock to learn that in December 1801 there was a mutiny on the *Temeraire*. She was then in Bantry Bay, off the coast of Ireland, awaiting sailing orders. When they came, those orders were that the *Temeraire* was to sail with a division of the fleet to the West Indies, where a French attack was rumoured. But word had spread through the ship's company that a peace treaty between England and France had been concluded (the brief Peace of Amiens, agreed on 1 October 1801, ratified on 27 March 1802). Some of the *Temeraire*'s crew had been at sea continuously for between seven and nine years;[30] now, convinced that the war was virtually over, they refused orders to weigh anchor and make sail unless for England. Captain Eyles's log records that on 7 December 1801 the men 'came aft', that is, on to the quarter-deck, 'crying out "No, No, No" in response to orders, & "England, England" was several times repeated'.[31] This was mutiny: by no means unique in the Navy at that period, though this one was non-violent, and on a far smaller scale than the mutinies at Spithead and the Nore in 1797.

The mutiny on the *Temeraire* was quickly quelled. Put in irons, the ringleaders somehow smuggled a letter to the Admiral of their squadron, protesting that they intended no violence, that they had served their 'King and Country' long and loyally but that as 'free-born Britons' they now expected to enjoy the blessings of peace. The letter, with its vaguely defiant echoes of Thomas Paine's *The Rights of Man* (1791–2) was signed 'His Majesty's/Faithful and Loyal Subjects/ THE TEMERAIRES'. Discipline in the Navy was rigorous; there could be no appeal against punishment for a refusal to obey orders. A court-martial convened aboard the *Gladiator* in Portsmouth Harbour tried the ringleaders of the mutiny; fourteen of them were sentenced to death.[32] The dreadful yellow flag signalling execution was twice run up on the *Temeraire*. At 9.30 a.m. on 15 January 1802, four 'Temeraires' – John Fitzgerald, captain of the foretop, William Hillyard and James Chesterman, both belonging to the foretop, and James Collins, the ship's butcher – were hanged from the yard-arm of their own ship. Four days later, four others – John Allen, George Dixon, Edward Taylor and Thomas Simmonds, duties not stated – were similarly 'launched into eternity'. Six of the other mutineers were hanged on different ships, according to Admiralty custom, so that crews through-out the fleet should witness the final penalty of disobedience.

The *Temeraire* then carried out her orders to sail for the West Indies. By 24 February 1802 she was off Barbados. There the crew at least had the benefit of fresh lime juice. To prevent scurvy, the Admiralty had ruled in 1795 that seamen

8 'Portraits of the Mutineers, late of His Majesty's Ship Temeraire, sketched at their Trial on Board the Gladiator, in Portsmouth Harbour, January 1802'. Anon. etching, 16.7 x 9.5 cm, published in The Trial of the Mutineers..., 1802. A mutiny on the Temeraire in December 1801 was short-lived. Expecting that a rumoured peace treaty would entitle them to home leave, some of the crew refused to obey orders to weigh anchor and set sail, except for England. This was mutiny. The ringleaders were court-martialled. Fourteen men were sentenced to execution. On 15 January 1802, four of those depicted here – Fitzgerald, Hillyard (or Hillier), Chesterman and Collins – were hanged from the Temeraire's yard-arm.

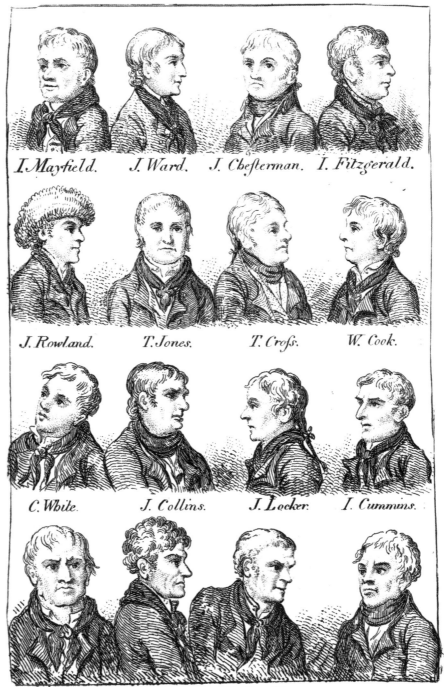

I. Mayfield.  J. Ward.  J. Chesterman.  I. Fitzgerald.

J. Rowland.  T. Jones.  T. Cross.  W. Cook.

C. White.  J. Collins.  J. Locker.  I. Cummins.

W. Hillier.  I. Dayley.

PORTRAITS of the MUTINEERS

should be regularly dosed with lemon or lime juice, however much they preferred grog. A typical entry in Captain Eyles's log, 5 August 1802, reads 'Mixed Lime Juice & Sugar for 679 men'; this incidentally gives the number of the *Temeraire*'s crew at that date. On the *Temeraire*'s return to England, now officially but very uneasily at peace with France, her crew were paid off; they are said to have left the ship wearing black bands round their regulation straw hats in memory of comrades hanged for mutiny.

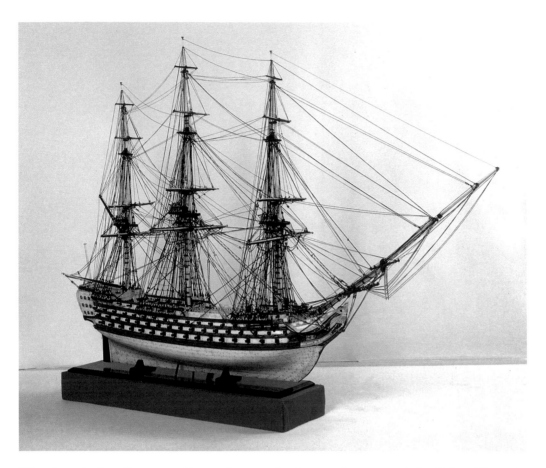

9 *Prisoner-of-war bone model of the Temeraire, c.1805. Length from figurehead to taffrail 85 cm. Southampton, City Heritage. Made by French prisoners-of-war, probably sailors, largely out of bones salvaged from the kitchen, boiled, sawn and shaped, with some wood in the ship's core and lower mastheads. Since they could not be made from first-hand observation, such models were rarely accurate. Here the midship section is too narrow, the bowsprit and jib-boom too long and the figurehead largely imaginary; but the rigging is detailed and accurate, and the model gives some idea of the overall appearance of the Temeraire in her prime.*

The interlude of peace allows time to look at a bone model of the *Temeraire* (PLATE 9), an extremely fine example of the ship models made by French prisoners-of-war in the Napoleonic era. Mostly seamen captured in naval battles and then offloaded in English ports, they were usually consigned to whatever strongholds could take them (prison-hulks, borough gaols or improvised lock-ups). In overcrowded conditions and foul air, with little light to work by, many prisoners kept *ennui* and despair at bay by using their skills to make models of ships they may once have known, or glimpsed. This model was probably made around 1805, when the *Temeraire*'s fame was at its height, by prisoners in Southampton's Wool House, a medieval warehouse where the model may have remained, and is nowadays usually displayed.

The *Temeraire* model, 84 cm long, to some extent helps the design for the ship (PLATE 2) to swell in the imagination into the contours of the *Temeraire* herself. It is chiefly constructed from slivers of bone: beef or mutton bones salvaged from the prison kitchens, then sawn, shaped, boiled and bleached. A little wood is used for the ship's core and in the lower mastheads, where the heavy shrouds supporting the masts are spread, but the masts themselves are of bone. The model was restored in 1950; some comments from its restorer and other experts are noted here.[33] The rigging is accurate and carried out in great detail; but the bowsprit, with its excessively long flying jib-boom (or extension), is out of proportion. The lines of the model are not the same as those of Henslow's draught. The narrowness of the midship section is thought to be more like that of a 74-gun Third Rate ship than that of the 98-gun *Temeraire*; and the stern is said to be 'typically French'. But with no access to ships' plans and little chance of first-hand observation, such models

could not be wholly accurate or made to scale; and the ships' names they bear are no proof that each model was exactly like the real ship. The very large figurehead, perhaps the work of a prisoner who specialised in finishing touches, represents a Greek or Roman warrior, helmeted and armed. This may be an exaggerated version of the truth. The *Temeraire* was launched not long after the Admiralty had given (in 1796) austere orders that decoration should be kept to a minimum. No figurehead is discernible in Turner's picture; but from oblique glimpses offered in E. W. Cooke's watercolour (PLATE 18) and J. J. Williams's engraving (PLATE 25), the *Temeraire* seems to have borne rather a small martial bust at her head.[34] All in all, the model should be considered as a beautiful approximation to reality, made in circumstances in which exact knowledge was impossible.

&&&

# THE TEMERAIRE AT TRAFALGAR

*Ah, je le connais bien, ce Téméraire-là.*

ADMIRAL FEDERIGO GRAVINA
in command of the Spanish fleet in the Battle of Trafalgar[35]

The Peace of Amiens lasted only a year. Hostilities having resumed in May 1803, Captain Sir Eliab Harvey was given command of the *Temeraire*, and came aboard that November.[36] It was under Harvey that, two years later, the *Temeraire* was to have her finest hour.

There have been innumerable accounts of the 'ever-memorable' Battle of Trafalgar, and particularly of Admiral Lord Nelson's part in it, from the despatches penned the following day by Admiral Collingwood to the Admiralty to the present day. The brief and simplified account given here concentrates almost entirely on the part played by the *Temeraire* in that action, drawing on Captain Eliab Harvey's log, his letters written to his wife a few days after the battle and Collingwood's despatches.

In early October 1805, the *Temeraire* formed part of the fleet under Nelson off Cadiz, in a state of readiness for battle, waiting for any movement from the enemy which might be reported by off-shore frigates watching the port. On 19 October, the combined French and Spanish fleet of 33 ships of the line put to sea, heading south towards Gibraltar. Nelson, with 27 ships of the line, immediately made all sail in pursuit. By daybreak on 20 October they were 'off Cape Trafalgar': that name, which was to carry long-lasting significance in British history, then signified only a point on an Admiralty chart. Rockets and flares that night informed them that the enemy's fleet was not far off. By daylight on 21 October they could see the French and Spanish ships for themselves.

Nelson ordered his fleet to bear up in their sailing order, in two columns, anticipating (correctly) that the enemy fleets would form a single crescent-shaped line. Nelson had previously outlined his strategy to his captains (his 'band of brothers'); Harvey, who had dined with Nelson on board the *Victory* on 3 October, may have learnt of it then. Nelson in the *Victory* (Captain Thomas Masterman Hardy) led the weather column, on the windward side; Vice-Admiral Collingwood in the

*Royal Sovereign* led the leeward column. Nelson allotted the *Temeraire* the position immediately astern of the *Victory* in the weather column. As they bore down towards the enemy, Harvey in his eagerness for action almost overtook the *Victory*, reputedly causing Nelson to shout through his speaking-trumpet: 'I'll thank you, Captain Harvey, to keep in your proper station.'[37] Harvey recorded in his log that the *Temeraire* then dropped back to 'within a Ship's length of the Victory'.

The action began at noon. Nelson's supreme success at Trafalgar was in 'breaking the line' of enemy ships swiftly and at strategic points. The *Victory* engaged the tenth ship from the van, the *Royal Sovereign* made for the twelfth from the rear: the *Temeraire* went for 'the 14th Ship of the Enemies line from the van', and the other ships broke through 'in all parts...engaging the enemy at the muzzles of their guns: the conflict was severe...'[38]

Baldly, when battle opened the *Temeraire* at once engaged the *Santissima Trinidada*. The *Victory* became interlocked in battle with the *Redoutable*, and in danger of being boarded by her. So close were the two opposing ships during this episode that when a marksman fired at Nelson from the mizzen-top of the *Redoutable*, it was at a range of only fifteen yards. Harvey, then imperfectly aware of Nelson's injury, saved the *Victory* by firing the *Temeraire*'s larboard broadside

10 *'The Battle of Trafalgar, as seen from the Mizen Starboard Shrouds of the Victory'. Exhibited in Turner's Gallery, 1806 (reworked 1808). Oil on canvas, 171 x 239 cm. Turner Bequest: London, Tate Gallery. In a key to the picture made for visitors to his gallery, Turner noted that 'in the centre is Lord Nelson with the Officers and Seamen that attended to him after he was wounded... the Redouttable [is] entangled with the Victorys foreshrouds... over her shattered stern is The Temeraire 98 guns Ad<sup>l</sup> Harvey. ingaged with the Fogieux and part of the French line...'*

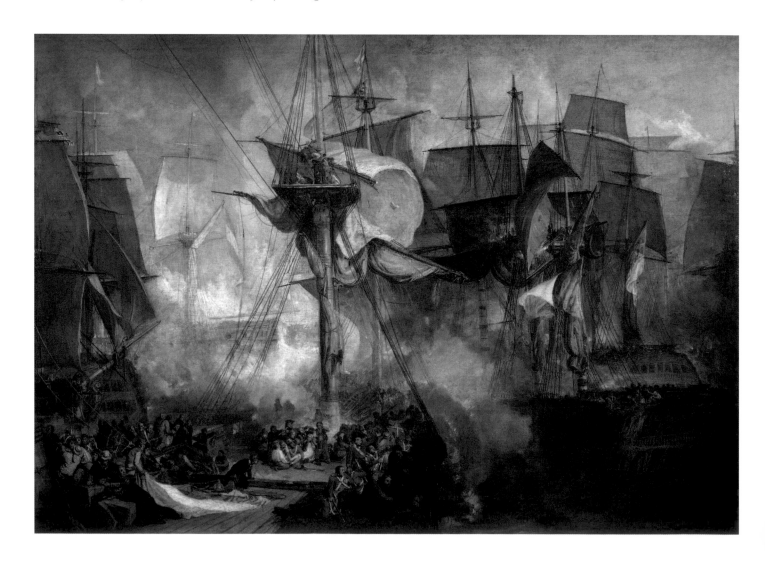

11 *Sketch for the large 'Battle of Trafalgar' c.1822-3. Oil on canvas, 90 x 121 cm. Turner Bequest: London, Tate Gallery. One of two oil sketches (both in the Tate) for the very large (259 x 365.8 cm) painting now in the National Maritime Museum. Characteristically, Turner concentrates on the courage of ordinary British seamen. With the battered Victory behind them, some have launched a longboat, others try to scramble aboard it; one sailor's shirt is lettered VICTORY. Drowning figures on the right are probably French. The castle depicted on a capsized flag symbolises the equal humbling of the Spanish fleet.*

into the *Redoutable*. The mainmast of the *Redoutable* fell right across the *Temeraire*, whose crew lashed the French ship to their larboard side; a party from the *Temeraire* then boarded her and took her as the first of their two prizes. Then the *Fougueux* bore down on the *Temeraire*; when she was within a yard-arm's distance the *Temeraire* fired its starboard broadside into her, boarded her and lashed her to its starboard side as its second prize. Throughout, the *Temeraire* was under close fire from other enemy ships.

Far more vividly, the *Temeraire*'s part in the action is recounted in Captain Harvey's log,[39] its urgent entries (written up within hours of cessation of firing) conveying the heat of the battle, the gun-smoke and the inevitable confusion which made it impossible for any one ship to have an overall view of the battle as a whole. Extracts (with some punctuation added) are quoted here:

*At 18 minutes p$^t$ [past] Noon the Enemy began to fire. At 25 minutes p$^t$ Noon the Victory opened her fire: immediately put our Helm a Port to steer clear of the Victory & opened our Fire against the Santissima Trinidada & two Ships ahead of Her. When the Action became General, some time after the Victory falling on board her Opponent, the Temeraire being closely engaged on both Sides, the Ship on the Larb$^d$ Side [the Redoutable] engaging the Victory fell*

*along side of us & the Victory on her Larb*[d] *side. The Yard Arms locked & immediately after [the Redoutable] Struck [i.e. struck her colours, signalling surrender] & was boarded by some of the Officers & part of the Temeraire.*

*At the same time, [the Temeraire] engaged with one of the Enemy [the Fougueux] on the starb*[d] *side, with a Spanish three Decked Ship being on the Larboard Bow, or nearly ahead who had raked us during great part of the action. About 10 or 15 minutes past 2 the Enemies ship fell alongside of us on which we immediately Boarded her, and [she] Struck her Colours. Lashed both Ships to the Temeraire being totally a Wreck. Fell off and had an opportunity of raking the Enemies first rate for half an hour with some of the Foremost guns, the Ship lashed on the Larb*[d] *side, her Main Mast Y*[d] *and all the Wreck fell on the Temeraire's poop which entirely encumbered the after part of the Ship.*

With 'every sail and yard destroyed, nothing but the lower masts left standing, the rudder head quite gone, and lower masts shot through in several places', the *Temeraire* had become 'totally unmanageable'.[40] Harvey recorded that at '½ past 2 the Temeraire ceased firing'. As he wrote two days later to his wife: 'At that point I thought the battle, with us, was at an end.'[41] He had no alternative but to send a signal for a frigate to take the *Temeraire* in tow. But a moment later four escaping French ships, seeing the *Temeraire* evidently helpless, turned round and opened fire on her. Somehow, with the few shots remaining to her, she saw them off. Then the frigate *Sirius* took the *Temeraire* in tow.

In a famous passage in his despatches to the Admiralty, Admiral Collingwood singled out the *Temeraire*'s part for praise:

*12 and 13 Clarkson Stanfield RA (1793-1867): 'The Battle of Trafalgar', and detail. Exhibited RA 1836. Oil on canvas, approx. 254 x 457 cm. Commissioned by the United Service Club in 1833. London, Institute of Directors. An oil sketch of the subject is in the Tate Gallery; Stanfield also made a small watercolour version, engraved by W. Miller and published in November 1839, the year in which Turner exhibited 'The Fighting Temeraire'. The complete picture represents the centre of the action shortly before 2.30 p.m., about an hour and a half after Nelson was shot. The Victory, in the centre, is trying to disengage herself from the Redoutable, a French 74.*

*The detail (right) depicts the Temeraire simultaneously boarding the Redoutable by her mainmast and firing her final broadside into the Fougueux. She then took both the French ships as her prizes, lashing them to her sides; but by then she was so battered that she had to cease firing, and had to be towed away. Admiral Collingwood wrote of the Temeraire's conduct in the battle: 'Nothing could be finer.'*

*A circumstance occurred during the action, which so strongly marks the invincible spirit of British seamen in the action, when engaging the enemies of their country, that I cannot resist the pleasure I have in making it known to their lordships. The Temeraire was boarded, by accident or design, by a French ship on one side, and a Spaniard on the other; the contest was vigorous, but in the end, the combined ensigns were torn from the poop, and the British hoisted in their places.*[42]

After Trafalgar, Collingwood wrote to congratulate Harvey on the *Temeraire*'s 'most noble and distinguished' part in the action: 'Nothing could be finer. I have not words in which I can sufficiently express my admiration of it.'[43] Collingwood's despatches to the Admiralty, widely published in newspapers and read by countless British patriots – of whom Turner was surely one – secured the fame of the *Temeraire*. The Battle of Trafalgar was the only action in which she took part; but her heroic role on that one day, 21 October 1805, was enough to ensure that when Turner dubbed her 'The Fighting Temeraire' over thirty years later, her exploits would be remembered.

Harvey was much honoured. On his return from Trafalgar, he was promoted Rear-Admiral. The House of Commons, in which he 'sat' (largely from his quarter-deck) for some thirty years, added Harvey's name to those of Nelson and Collingwood in its vote of thanks to the heroes of Trafalgar in January 1806: this followed a speech by General Grosvenor MP, whom Hansard reports as concluding, 'in the words of the song – /"How 'twould cheer/ Our hearts to hear/ That our old Companion he was one"'.[44]

Twenty years after Trafalgar, both that battle and Harvey's command of the *Temeraire* were commemorated in the supporters which he was granted on being appointed a Knight Grand Cross of the Order of the Bath.[45] The supporters are dexter (the viewer's left) a triton holding a trident entwined with a branch of laurel and sinister a horse argent whose neck is encircled with a gold naval crown. The rim of the crown is lettered TRAFALGAR; suspended from the crown is a gold Trafalgar medal. The motto below the arms is REDOUTABLE ET FOUGUEUX, while above the crest, in the position associated with battle-cries in Scottish arms, is the single motto TEMERAIRE.

14 *Arms and supporters of Sir Eliab Harvey, Admiral of the Blue,* KGCB, *c.1825. Gouache and gold leaf on vellum, 16 x 17 cm. London, College of Arms. Above the crest is the motto* TEMERAIRE; *below the arms, the names of the Temeraire's two Trafalgar prizes,* REDOUTABLE ET FOUGUEUX. *The supporters also commemorate the Trafalgar victory.*

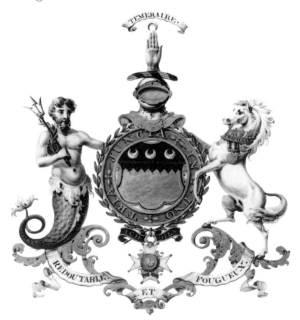

# AFTER THE BATTLE

*War's a brain-spattering, windpipe-slitting act*
*Unless her cause by right be justified.*
LORD BYRON
'Don Juan', canto IX[46]

The battle whose echoes have resounded for nearly two hundred years was over in four and a half hours. Four hundred and fifty British sailors died at Trafalgar; on the *Temeraire*, 47 were killed and 76 wounded.[47] Nelson, the greatest of them all, fatally injured at about 1.15 p.m., died in the cockpit of the *Victory* at about 4.30 p.m., in the knowledge that the day had been won.

Under tow (for the first but not the last time in her life), the battered *Temeraire* moved slowly towards Gibraltar. Her crew did what they could in the way of clearing the wreckage of their ship. The allocation of 75 French and Spanish prisoners-of-war – most of them fished out of the sea while the battle raged, as suggested by Turner in the foreground of his 'Second Sketch for "The Battle of Trafalgar"' (PLATE 11) – did not help. Severe gales which raged for four days after the battle ('shocking weather for our poor wounded', Harvey noted[48]) hindered all operations. The *Temeraire*'s two prizes, the *Redoubtable* and the *Fougueux*, were both wrecked in the storm; her ship's company saw their expectations of prize-money vanish below the waves.

Incomparably sadder was the news, slow to reach the *Temeraire*, of Nelson's death. In the thick of battle, the *Temeraire* had been closer to the *Victory* than any other British ship; but the scene was immensely confused, and the *Temeraire* had had to be taken off in tow well before the hour of victory. Later, with the fleet dispersed and further scattered by the storm, it was several days before Captain Harvey received Collingwood's signals. Then he had to tell his men that Nelson, the idol of all British sailors, was dead.

The *Temeraire*, temporarily repaired at Gibraltar, limped home to anchor off Spithead on 1 December 1805. At last, nearly seven weeks after the battle, the sick and wounded could be sent to hospital, and the prisoners-of-war offloaded. On 4 December ('Fresh Breezes and Squally Weather with rain'), Harvey's log records that the *Victory*, on her own return voyage from Trafalgar, passed by, 'her colours half mast she having the Body of our late Admiral L^d Nelson on Board'.

Turner, aged thirty when the Battle of Trafalgar was fought, must fairly soon after it have begun work on his large painting, 'The Battle of Trafalgar, as seen from the Mizen Starboard Shrouds of the Victory' (PLATE 10). He depicts the moment at which Nelson was mortally wounded, showing the French marksman in the act of firing from the mizzen-top of the *Redoutable* (on the right: REDO..., the start of her name lettered on her stern, identifies her). Behind the *Redoutable* looms the stern of the *Temeraire*. Turner first exhibited the picture in his own gallery in 1806,[49] when Joseph Farington RA pronounced it 'a very crude, unfinished performance, the figures miserably bad';[50] but John Landseer, seeing it in the British Institution exhibition of 1808 after Turner had partly re-worked it, more perceptively called it 'a British epic picture'. He added: 'Mr Turner has detailed the death of his hero, while he has suggested the whole of a great naval victory.'[51]

'Portrait of the Victory, in three positions, passing the Needles, Isle of Wight' (PLATE 15), about 1806, was purchased by Turner's friend and patron Walter Fawkes, who used that title when lending it in 1823.[52] Turner follows a contemporary convention in ship portraiture in presenting three views of a ship on one canvas; but this is primarily an idealised, jubilant image of a First Rate in full sail, and in home waters, rather than an accurate portrait of the *Victory* on any specific occasion. It has been called 'The *Victory* returning from Trafalgar';[53] but that occasion, as Turner knew, was anything but jubilant. When the *Victory* returned from Trafalgar, she bore the body of Nelson; her colours and those of every ship she passed on her cortège-like journey from Spithead to Sheerness flew at half-mast. In Turner's picture, by contrast, exultant patriotism, not death, is in the air; no flags fly at half-mast. Small fishing boats scudding about off the southern coast of the Isle of Wight contribute to a grateful sense of the protection offered by 'the wooden walls of England'. If this picture does indeed depict the *Victory*, it must depict her before the one episode in which she served as Nelson's flagship – and as his bier.[54] Turner was well aware of what the much-damaged *Victory* looked like on her return from Trafalgar, for when the ship reached Sheerness on 23 December 1805 he was allowed on board to make drawings . The largest of these, inscribed 'Quarter Deck of the Victory', with notes of the most visible damage, conveys through its very emptiness a desolate sense of Nelson's absence, and of the unreal suspension of the ship's usual activities.

15 *'Portrait of the Victory, in three positions, passing the Needles, Isle of Wight'. Probably exhibited in 1806. Oil on canvas, 67 x 100.3 cm. New Haven, Yale Center for British Art (Paul Mellon Collection). Turner follows contemporary convention in portraying a ship from three angles; but this is an idealised image of a ship of the line (or 'Heart of Oak') in full sail rather than a specific portrait of the Victory. The painting was purchased by Turner's friend and patron Walter Fawkes, like himself a true patriot.*

16 *Edward William Cooke* RA *(1811-80): 'Dreadnought serving as the Seamen's Hospital Ship off Greenwich'. Etching, published 1829; image size 11.2 x 29.7 cm. London, National Maritime Museum. Dreadnought, a sister-ship of the Temeraire, had like her served at Trafalgar. Hulked in 1825, she was moored for over 25 years off Greenwich, serving as a hospital ship for seamen (250 beds, and room for 150 convalescents) until 1857, when she was broken up. The design of Dreadnought's heads (either side of the figurehead) shown by Cooke is later shown in Turner's picture of her sister-ship the Temeraire. Dreadnought's decks have been cut down and her masts removed; she flies a pennant from a pole. Greenwich Hospital is in the background.*

The *Temeraire*, badly damaged at Trafalgar (though less gravely than some other British ships), spent over a year in Portsmouth Dockyard, undergoing repairs and then refitting. By April 1807 she was pronounced fit for service, and was directed to join the fleet stationed off Toulon, where Napoleon was rebuilding his navy. The British fleet was there to prevent it leaving harbour; in this it was successful.

After Trafalgar, the French offered no further serious challenge to British supremacy at sea. Gradually, many ships of the Royal Navy were laid up 'in ordinary', instead of being re-commissioned for active service. A detailed Admiralty questionnaire concerning the 'Sailing Qualities' of all its ships was sent out between February 1809 and March 1812; answering for the *Temeraire*, her Captain, Master, Boatswain and Carpenter jointly reported that she was 'A well built and strong Ship but apparently much decay'd',[55] though a previous report had stated that she showed 'no particular signs of weakness'.

On 19 March 1812, in accordance with the times, the *Temeraire* was put out of commission. Her career as a ship of the line was over. Like many another once-renowned ship now moored bow and stern to buoys in harbours near naval dockyards, she was allotted humbler duties. The sentimentality with which the great British public regarded 'hearts of oak' was not shared by the Admiralty. From 1813 to 1820 the *Temeraire* served as a prison ship in Plymouth Harbour. From 1820 to 1838 she was moored off Sheerness. There her chief duties were to act as a victualling ship and as a receiving ship, or point of collection for seamen before they were sent on active service. The fates of her sister-ships *Dreadnought*, *Neptune* (both also at Trafalgar) and *Ocean* were no more glorious. *Dreadnought* served as a lazaretto (quarantine ship), then as the seamen's hospital off Greenwich, before being broken up in 1857; *Neptune* as a prison ship (broken up in 1818), and *Ocean* successively as a receiving ship at Sheerness, as a lazaretto and finally as a coal depot before being broken up in 1875.[56] An etching by E.W. Cooke of the *Dreadnought*, hulked and serving as the Greenwich seamen's hospital (PLATE 16), shows how quickly the dignity of once-famous ships of the line could fade. Turner's own observation of such decline is shown in his painting 'Hulks on

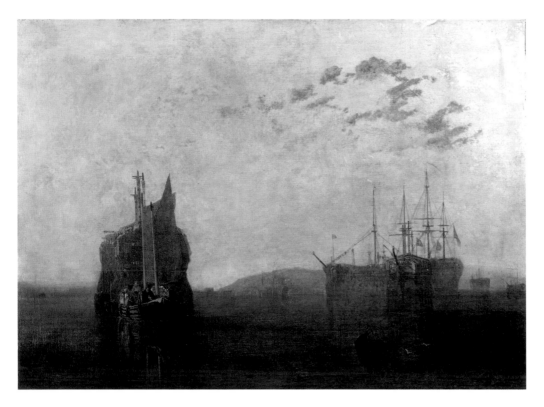

17 'Hulks on the Tamar', c.1810-15. Oil on canvas, 90 x 120.5 cm. Petworth House, Tate Gallery and the National Trust (Lord Egremont Collection). Permanently moored off Naval dockyards, ships of no further active use were used as prisons, hospitals, victualling ships or receiving depots for recruits or the crews of ships in dry dock. Usually they were hulked: i.e. their masts were lowered, or sometimes taken out; often their decks were cut down and roofed. Hulks saved building costs and were difficult to escape or desert from. The Temeraire was not cut down, though her masts were lowered and removed altogether before she was sold; otherwise, as she was towed away to be broken up, she probably looked rather like the ship on the left.

The picture has previously been identified as 'On the Plym', a work Turner is known to have exhibited in his gallery in 1812; but the Plym is too small a river to have accommodated the old battleships seen here (with others in the background). This is more likely to be the Hamoaze, a stretch of the Tamar estuary off Plymouth Dock (near the setting of 'Devonport', Plate 4).

the Tamar' (PLATE 17) of about 1812;[57] the mild sunset glow in which the hulks are seen does not disguise their departed glory. The *Temeraire* escaped reduction to a hulk, keeping the beauty of her lines to the end; and for at least part of her service at Sheerness, she served additionally as guardship, charged with the defence of the harbour – so she retained her 'Great Guns'.

It was while the *Temeraire* was serving as guardship off Sheerness that E.W. Cooke observed her, on a sketching tour in June 1833.[58] In the watercolour he made on his return home and dated 'July 1/1833' (PLATE 18), the *Temeraire* is the ship at anchor on the right. Her topmasts have been 'sent down' (i.e. considerably lowered) and she is in minimal rig, but flying the union flag (correctly, for a ship in harbour) and a hoist of signals. More distant on the left is her sister-ship, the *Ocean*, then serving rather more prestigiously as the flagship of the Admiral of the Nore Command (Cooke shows him, in his cocked hat, having left his flagship, being rowed past in his 'gig' in the foreground); but since the *Ocean* had been cut down to a two-decker in 1821, by 1833 she looked considerably less impressive than the *Temeraire*. Cooke's watercolour reflects the outward appearance rather than the actual status of the two ships; the *Temeraire* appears to be a more appropriate flagship than the cut-down *Ocean*.

While moored off Sheerness, the *Temeraire*'s principal duty was to act as a victualling point, taking in vast quantities of provisions and sending out boats to distribute them to other ships in the harbour. Various orders came from the Superintendent of Sheerness Dockyard: an 'officer and party' would go out from the *Temeraire* to assist in dismasting a ship, or helping ships to their moorings; and working parties were regularly sent to the dockyard to 'paint and gild' other ships. Compared with the rigours of active service, life for her much reduced crew in the *Temeraire*'s last years was comparatively easy. Relays of 'boys' (poor or

18 *Edward William Cooke RA (1811-80): 'The Temeraire stationed off Sheerness'. Inscribed 'E W Cooke July 1 1833' lower right. Watercolour on paper, 23 x 32.4 cm. London, Victoria and Albert Museum. The Temeraire would have appeared much like this throughout the period from 1820 to early September 1838, while permanently moored on harbour duties off Sheerness. Her masts have been lowered and her rigging is minimal. She flies the union flag, correctly for a ship in harbour. In the foreground the Admiral of the Nore Command is rowed ashore from the Temeraire's sister-ship the Ocean, seen on the left, cut down (unlike the Temeraire) but temporarily enjoying the role of his flagship.*

destitute boys rescued by the Marine Society to form a 'nursery of seamen for the public service'[59]) came aboard to be trained in 'reefing and furling, knotting and splicing', and in handling broadswords. Twice a week, the *Temeraire*'s 'Great Guns', kept in working order throughout, were exercised.[60]

In 1834, Captain Thomas Fortescue Kennedy was appointed Acting Superintendent of Sheerness Dockyard. Thirty years earlier, as First Lieutenant on the *Temeraire*, he had led the boarding party which took the *Fougueux*, one of the *Temeraire*'s two prizes at Trafalgar; now he carried out his Dockyard command from his old ship, to that extent giving the *Temeraire* some final distinction.

The last log for the *Temeraire* (begun by Captain Kennedy, continued by Captain Sir John Hill) runs from 1 January to 30 June 1838.[61] Its entries are customarily brief, yet it nevertheless reflects something of the changing scene in the last months of the *Temeraire*'s life. Numerous ships passed by her. Convict ships still transported prisoners from the hulks to Van Diemen's Land, among them ('sailed the 25 June 1838') the *Coromandel*, newly painted by working parties from the *Temeraire*. Steamships now arrived and departed with increasing frequency; those noted in April and May included two steam-vessels of the Royal Navy, *Pluto* and *Lightning*,[62] their very names suggesting unnatural energy. On 4 April 'The *Hastings* was towed out of harbour by the *Messenger* steam ship' (though not in this case to be broken up). The *Temeraire*'s guns were fired for the last time on

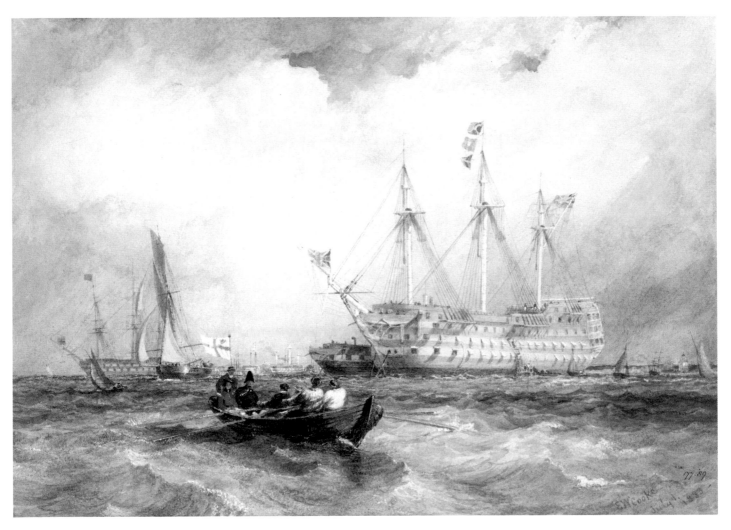

28 June 1838, though not in anger. The third last entry in her log records that day: 'in honour of Queen Victoria's coronation fired Royal Salute. Issued double allowance of Grog to the Ship's Company and allowed Liberty'. A new reign had begun, at virtually the *Temeraire*'s last hour.

19 *'A Dinner given to 14,000 Persons on Parker's Piece, Cambridge, June 28, 1838'. Engraving by R.H. Roe, c.1838. 12.7 x 15.5 cm. Cambridge Central Library. Queen Victoria's coronation on 28 June 1838 inspired various celebrations, including an open-air dinner for 14,000 people organised by the Mayor of Cambridge in the centre of Parker's Piece (an open field); an orchestra of 100 played from a central bandstand, and 60 tables each 125 ft long radiated from it. The presiding image of the new Queen is taken from William Wyon's first coin portrait of her.*

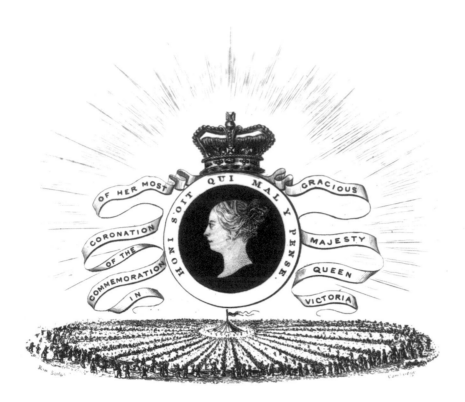

## THE TEMERAIRE IS SOLD OUT OF THE NAVY

In the summer of 1838 the *Temeraire*, by then forty years old, was deemed to be of no further use. The Admiralty therefore decided that she should be sold out of the service. Her fate was by no means unique; by 1838, fourteen of the twenty-seven ships in Nelson's fleet at Trafalgar had been sold to be broken up, and others (always excepting the *Victory*) later met the same fate.[63] In June 1838 orders were sent to the Superintendent of Sheerness Dockyard that the *Temeraire* should be 'prepared for Sale'.[64] According to standard Admiralty practice, preparing a ship for sale meant stripping her of anything which the Navy itself could re-use – her masts, yards and stays, her guns, her anchors, her ammunition and her stores.

The complex task of preparing the *Temeraire* for sale was allotted, by a quirk of fate, to her sister-ship, *Ocean*. The log of the *Ocean*'s captain Sir John Hill notes in detail the progressive reduction of the *Temeraire* to an empty hull;[65] his brief, completely factual log entries are hard evidence as to what she must have looked like when successive working parties from the *Ocean* had completed their work. On 4 July 1838 ('Light airs and fine weather'), Hill recorded: 'commenced dismantling the Temeraire – sent Top Masts & Yards on deck & unrigged the Fore and Mizen

Masts.' Drawing out the lower masts would have had to be done later by the Sheerness Dockyard sheer-hulk. Further entries (all brief) record progress in dismantling the *Temeraire*, as Hill sent working parties over to 'return Stores from the Temeraire & prepare her for Sale' (5 July), 'clear the Temeraire and return Stores to the Dock Yard' (6 July), 'remove the Bower Anchor [the main working anchor, carried at the bow] from the Temeraire' (10 July), 'get the Guns & Ordnance stores out' (13 July), etc. The *Temeraire*'s small remaining crew were then taken aboard the *Ocean* before being paid off by clerks from the Navy Board. By the end of July the *Temeraire* was an empty shell: no masts, no rigging, no guns, no men.[66]

The tradition that the *Temeraire* was sold 'with her masts and yards still in her, just as … Turner saw her and has faithfully painted her' was given popular currency by Edward Fraser in *Famous Fighters of the Fleet* (1904).[67] Such is the power of Turner's image of the *Temeraire*, moving tall-masted towards her doom, that few have questioned Turner's fidelity to the truth. In his catalogue of British paintings in the National Gallery (1946, 1959), Martin Davies stated that after the *Temeraire*'s masts were removed at Sheerness, 'temporary masts were put on her for the journey to Rotherhithe'.[68] This explanation, contracted by Butlin and Joll (1977, 1984) into the statement that the *Temeraire* was 'remasted',[69] was echoed by other art historians, including Postle in 1988,[70] but derided by Eric Shanes in 1988: 'The notion that the *Temeraire* was remasted before being towed to the breaker's yard is risible, equivalent to having a car resprayed before destroying it'.[71] But the idea of 'temporary masts' was in fact very nearly put into practice. After the *Temeraire* had been fully prepared for sale at Sheerness, the Admiralty toyed with the alternative idea of breaking her up in the Naval Dockyard at Plymouth; they therefore directed 'that the *Temeraire* should be fitted with Jury Masts before she is removed to Plymouth to be taken to Pieces'.[72] Jury-masts are temporary short masts which could carry light sailing rig; had she been fitted with them, the *Temeraire* would certainly not have looked like Turner's image of her: but his masts would then have been large artistic licence rather than pure invention. But in the end the Admiralty reverted to their original plan; the *Temeraire* was sold from Sheerness as an empty hull. The very fact that jury-masts were even considered is additional proof that by then there were no masts of her own left in the *Temeraire*.[73]

The *Temeraire* was one of thirteen ships sold by the Admiralty at this date. She was by far the largest ship on the list, which included the *Venerable* and the *Aboukir* (both 74 guns), the *Imperieuse* (38 guns), various brigs, a schooner and a victualling hoy. They were sold from their various dockyard stations. Anyone interested in buying the *Temeraire* would have had to view her at Sheerness, but her market value by now could interest only ship-breakers who knew how to make money out of her timbers.

The sale itself was conducted on 16 August 1838, by Dutch auction, at the offices of the Navy Board in Somerset House. The *Temeraire* was knocked down to John Beatson, a Rotherhithe ship-breaker and timber merchant, for £5,530. From the moment the auctioneer's gavel fell, the *Temeraire* ceased to be a ship of the Royal Navy. It was that summary change in her status which moved Turner, when he exhibited his painting at the Royal Academy, to add to its title his own adaptation of lines from Thomas Campbell's poem 'Ye Mariners of England': 'The flag which braved the battle and the breeze/No longer owns her.'

# THE TEMERAIRE TOWED
# TO BE BROKEN UP, SEPTEMBER 1838

*O Titan Temeraire,*
*Your stern-lights fade away;*
*Your bulwarks to the years must yield,*
*And heart-of-oak decay.*
*A pigmy steam-tug tows you,*
*Gigantic, to the shore –*
*Dismantled of your guns and spars,*
*And sweeping wings of war…*

HERMAN MELVILLE
'The Temeraire', 1866

John Beatson[74] ran a flourishing family ship-breaking business from a wharf at Rotherhithe, on the south bank of the Thames; his premises, marked in a survey of 1857 as 'SHIP BREAKER'S YARD AND OPEN WAREHOUSE … MR BEATSON' – (now built over), were next to the wharves at the head of the Grand Surrey Canal.[75] Beatson was used to breaking up East Indiamen, and had broken up some Fourth Rate naval ships (including the *Grampus* in 1832 and the *Salisbury*, which had had to be towed from Portsmouth, in 1837). The *Temeraire* was a far bigger undertaking.

Beatson, a methodical man of business, kept journals in which he entered day-by-day transactions, also entering debtor-creditor accounts in a ledger. Four of his journals and his ledger are preserved in Southwark Local Studies Library.[76] From entries made in his journal in autumn 1838 and summarised in his ledger, Beatson's organisation of 'Operation *Temeraire*' can be reconstructed.

*20  Extract from John Beatson's Journal, June 1835-December 1839. MS volume, page size 41 x 27 cm. Southwark Local Studies Library. Beatson, the Rotherhithe ship-breaker who purchased the Temeraire while she was lying at Sheerness, records under the date 5 September 1838 a debt of £32 to the Thames Steam Towing Company for 'Towage of Ship Temeraire from Sheerness to Wharf'. An entry on the next page details other costs incurred in getting the Temeraire to his Rotherhithe wharf, including the pilot's fee, the men's wages and an allowance for beer.*

For his purchase of 'Ship Temeraire 104 guns 2121 Tons lying Sheerness', Beatson had to pay £5,530 to the Lords Commissioners of the Admiralty. He seems to have had no difficulty in raising the cash: he paid a deposit of £1,500 on the day of the sale and the balance eleven days later.[77] His biggest problem was how to get the *Temeraire* – 2,110 tons when built, now an inert weight without any motive power of her own – from Sheerness to his wharf at Rotherhithe, a distance of some 50 to 55 miles. Newspaper reports were to state that the *Temeraire* was 'the largest vessel that has ever been brought so high up the Thames'.[78] Her size required two tugboats and an experienced pilot who knew every shoal in the Medway and the Thames.

Beatson hired tugs from the Thames Steam Towing Company, as shown in an entry in his journal for 5 September 1838: 'The Thames Steam Towing Co./By Towage of Ship Temeraire/from Sheerness to Wharf/£32. 0. 0 (PLATE 20).'[79] Beatson did not record the names of the tugs hired to tow the *Temeraire*, perhaps because tugs were just a commonplace of his working life. The tugs are however named in the *Shipping and Mercantile Gazette*, 15 September 1838.[80] A news story that day, headed 'The Temeraire' and chiefly devoted to the ship's past glories, gives only a few lines to the tow, but records that 'The Sampson and the London steam tugs were engaged two days in towing her up from Sheerness'.

Both the *Samson* (her official spelling) and the *London* steam-tugs were owned in 1838 by the Thames Steam Towing Company of London, which insured them both with Lloyd's. A concise entry for each in *Lloyd's Register of Shipping* (1838) packs in, in one line, almost all we need to know about them except their engine power. The *Samson*, 32 tons, and the *London*, 37 tons, were both built in Newcastle upon Tyne; the *Samson* was completed in February 1837, and the *London* in May 1836. Both were classed A1 at Lloyd's.[81] Both were thus fairly new and strongly built in early September 1838, when they towed the *Temeraire* 'from Sheerness to wharf', in Beatson's phrase. One of the tugs probably worked from behind, at least during part of the tow, ready to act as a brake on the *Temeraire*, to help steer her round the river bends and to avoid other shipping. Beatson's accounts with the Admiralty include a hefty deposit of £983. 8s. 9d. paid over to the Superintendent of Sheerness Dockyard for 'Stores had to navigate the Ship Temeraire to London': these may have been the very heavy cables (nearly two feet in circumference) and anchors needed for such a large ship.[82]

Purpose-built steam-tugs had begun to work on the Thames from 1832 (later than on the Clyde or the Tyne).[83] The Thames Steam Towing Company, established in 1833, quickly grew into one of the largest of several London towing firms, operating in an increasingly competitive market as the volume of commercial traffic on the Thames swelled. Beatson had had dealings with them before, and owned shares in the company.[84] Plate 21 reproduces one of the company's share certificates issued in 1836; its pictorial heading depicts a steam-tug with 'TSTC' lettered on its flag and more conspicuously on its paddle-wheel casing, smoke belching from its funnel (all tug engines of its day were coal-fired) as it tows a comparatively small merchant vessel past Greenwich Hospital.

Having hired two A1 tugs, Beatson was able to call on his own regular employees for the pilot and the crew. The pilot was William Scott, a Rotherhithe man and a skilled navigator who frequently worked for him;[85] Beatson could rely on Scott's judgement to avoid such accidents as grounding and collision. Scott's fee and the wages of his crew of 25 men, paid five days after the end of the tow, are itemised in Beatson's journal, 10 September 1838:[86]

21 *Thames Steam Towing Company Share Certificate issued in 1836, detail. Engraving, 34 × 25 cm. London, Richard F. Moy. A pictorial vignette engraved by J. S. Hobbs shows one of the company's tugs towing a merchant vessel up the Thames, just passing Greenwich Hospital. The tug's flag and paddle-boxes bear the towing company's initials TSTC; her funnel is in the orthodox position amidships and two towing cables are visible. The two tugs which towed the very much larger Temeraire would have been of similar design.*

| William Scott By Piloting Ship Temeraire to Wharf from Sheerness | £25. 0. 0. |
|---|---|
| 10 Men at 25/– | 12. 10. 0. |
| 15 Men at 21/– | 15. 15. 0. |
| Extra to Sheerness 1 man | 10. 0. |
| Allowed for Beer | 5. 0. |
| William Burleigh [unidentified] | 4. 0. 0. |
| | 58. 0. 0. |

22 *Two tugs towed the Temeraire some 50-55 miles westwards from Sheerness, at the confluence of the Medway and the Thames, to Rotherhithe, a mile from London Bridge. Other points marked here are Chatham, where the Temeraire was launched; Upnor Castle, the principal ordnance store on the Medway (see Plate 32); the Nore, outside Sheerness harbour, one of the six principal home anchorages for the fleet (and the setting for mutiny in 1797); Gravesend and Greenhithe, near which the towing party probably broke their journey overnight, and Greenwich, site of the Royal Naval Hospital. Between Blackwall and Rotherhithe, the rapid expansion of dock construction since 1800 increased the volume of traffic on the Thames.*

In the timing of the tow, an important element was the movement of the tides. Tugs of this date had small engines (20–40 hp); while it was possible to tow against the tide, it was far easier and more economical to work with it, especially if there was no question of urgency. Beatson did not have to wait long after purchasing the *Temeraire* on 16 August for a good opportunity to move her. A full moon on 4 September was followed by spring tides the next two days.[87] Beatson and Scott seized the moment, and the tow took place on 5 and 6 September 1838.[88]

While much has been written about the sunset which plays such a dramatic part in Turner's picture (see pp. 92–3), the most likely actual timing of the tow, as determined by the factor of the tides, has so far been overlooked. The author is indebted to Pieter van der Merwe and Bill Robson for permitting their calculations of the likely progress of the two-day tow, based on the tide-tables for 1838, to be published here[89] As they point out, the average towing speed over the whole journey is unlikely to have been more than three knots, probably less. Pieter van der Merwe's summary of their conclusions follows:

'On 5 September, the *Temeraire* and her tugs would have left the Medway between 7 and 7.30 a.m., at or just before low water slack, to take the last of the ebb tide and head east and north, to round the sands tailing out from the Isle of Grain. At about 8.30 a.m. they would have turned north-west and headed into the Thames itself, with the tide now flooding and the Great Nore to port. By 11.30 a.m. they would be turning south into the Lower Hope Reach, then west past Gravesend, arriving off Greenhithe about 1.30 p.m. Here, or possibly further up the Long Reach towards Purfleet, they would have anchored out of the busy main channel as the ebb turned against them. By the time the evening flood started to run at around 8.30 p.m. it would have been getting dark and the pilot would have decided to sit out the night, perhaps sending the crew ashore.

'On the 6 September the tow would have got under weigh at low water slack, about 8.45 a.m. at the earliest, though it could have been later. Scott the pilot would have ensured that their up-river progress was slow enough to be able to use the rising tide to lift the *Temeraire* off, in case she touched ground in the steadily narrowing river, or in any difficulty in getting her on to her berth at Rotherhithe. His convoy would have moved slowly past Woolwich Dockyard, arriving off Blackwall point around noon. Scott would have known that with only four miles to go and high tide at the London Docks not until 3.24 p.m., he

had both time and rising water in hand. [Forty years later a spectator wrote that the *Temeraire* was proceeding 'lazily' at that stage.[90]] Passing Greenwich Hospital, they turned on the last leg of the journey into Limehouse Reach. At about 1 pm the convoy would have rounded Cuckold's Point and arrived in the Lower Pool off Beatson's yard. The tugs would have carefully let the rising tide swing the ship round in the river so that her bow breasted the current; then they would have waited, making final preparations to lay her alongside Beatson's wharf, as high up on the mud as possible, just before the top of the tide.'

The second day's progress was more liable to accident than the first. The steadily narrowing Thames was crowded with commercial shipping and all kinds of small craft. The weather in London on 5 September had been 'fair, cloudy', according to the 'Meteorological Diary' published in the *Gentleman's Magazine*. For the *Temeraire*'s last day, 6 September, it was 'fair, rain': typical English weather.[91] It should be noted that in the reckoning of the timing quoted above, on both days the tow was conducted well within the hours of daylight.

Very few people along the route seem to have recorded seeing the *Temeraire* pass. No mention of her departure from Sheerness has been traced in the logs of ships stationed there. A few newspaper reporters at the London end, though probably not on the spot, did their best to make a good story of the *Temeraire*'s last journey. *The Times* reported on 13 September that 'The majestic appearance of this fine ship excited much interest and curiosity; every vessel she passed appeared like a pigmy';[92] very similar reports appeared in the *Morning Post* the same day and in the *Morning Advertiser* the next day. The weekly *Shipping and Mercantile Gazette* on 15 September (quoted earlier as the source for the names of the *Temeraire*'s tugs) declared of the *Temeraire* as she passed up the river that 'Though deprived of her war-like appointments, she had still a formidable appearance as she swept along the waters'. *Bell's Life in London*, a Sunday paper, cobbled together a sentence or two from *The Times* and a few fine phrases about Trafalgar ('the action which cost the nation a Nelson') for its issue of 16 September; the *Gentleman's Magazine* carried a similarly syndicated paragraph in October. That seems to have been about the extent of press coverage.

Watermen, lightermen, stevedores, dockers and steamboat passengers must all have glimpsed the *Temeraire* as she was towed up-river; none of them seems to have related what they saw. But it was, after all, no advertised event, no lap of honour; to most onlookers, the great bulk under tow was probably anonymous, just another old though unusually large ship off to the breaker's yard. 'Ships must die as well as men', declared the *Shipping and Mercantile Gazette*; and besides, there is always something going on elsewhere to distract the casual observer's attention from death. While the *Temeraire* was being edged into 'her last berth' at Rotherhithe, there was a regatta in full swing at Wapping, on the opposite side of the river, with races, side-shows and an atmosphere of carnival.[93]

Other tugs may have helped with the final berthing. A long but undocumented tradition links the *Monarch*, a smaller, 26-ton tug owned by Watkins, with the tow.[94] A model of the *Monarch* (PLATE 23) shows the typically slender build of steam-powered paddle-tugs in the 1830s, to which the rather larger *Samson* and *London* presumably conformed. Turner's tug appears bulbous in comparison. The position of the *Monarch*'s mast foremost and its funnel amidships was standard

23 *Model of the tug Monarch, c.1870. Wood and metal, 16 x 30 x 10 cm. Gravesend, The Alexandra Towing Company Limited. Built on the Tyne in 1833 for the London firm of Watkins, the Monarch was a 26-ton wooden paddle-tug, nearly 65 ft long and 14 ft in the beam, with a 20 hp engine. Her design is typical of that of steam-tugs of the 1830s. Another model of her is in the Discovery Museum, Newcastle upon Tyne.*

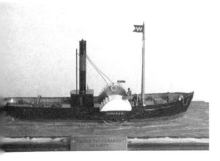

design.[95] Built in 1833, the *Monarch* remained in service until 1876; possibly the tradition that she towed the *Temeraire* grew out of her longevity.

Once the *Temeraire* was safely alongside Beatson's wharf, Scott and his men would have secured her to the wharf with cables, to prevent any possibility of the hull tipping outwards on the slope of the bank as the ebbing tide let it settle on the riverside mud. Things could and did go seriously wrong with getting a huge ship safely to a Thames-side wharf. The 74-gun *Imperieuse*, sold on the same day as the *Temeraire* and towed to another Rotherhithe ship-breaker's wharf shortly before the *Temeraire* arrived at Beatson's, had 'fallen over' and filled with mud, greatly adding to the costs of breaking her up;[96] more famously, *The Queen* heeled over on to the Rotherhithe shore, as depicted in the *Illustrated London News*, 9 September 1871.[97] But Scott and his men had done their work well. They had brought the great ship in without accident and with no damage to her timbers. At this point, perhaps, the last of the 'beer' which figures in Beatson's accounts was drunk by the tugs' crew. As for the *Temeraire*, she was by now in her last berth, as Plates 24 and 25 show her, with her bow facing away from the heart of London, pointing back towards Sheerness and the sea.

<p style="text-align:center">&&&</p>

<p style="text-align:center"><em>The first dark day of nothingness<br>
The last of danger and distress<br>
Before Decay's effacing fingers<br>
Have swept the lines where Beauty lingers.</em><br>
LORD BYRON<br>
'The Giaour', 1813[98]</p>

24 (left) William Beatson (1806-died c.1870): 'The Temeraire at John Beatson's wharf at Rotherhithe, September 1838'. Lithograph, image 13.8 x 22.3 cm. London, National Maritime Museum. A warehouse sign on the right reads 'John Beatson, Ship Breaker'. The artist, an architect or builder, was the ship-breaker's younger brother. Made within weeks of the Temeraire's arrival, this shows her as an empty hull. Note the absence of masts, removed at Sheerness before the tow. Demolition is just beginning on the upper deck. The Atlas-like carved figures (see Plate 80) are still in place on the stern galleries.

25 J.J. Williams Esq., engraved by R.G. & A.W. Reeve: 'The Temeraire at Rotherhithe', c.1838-9. Aquatint, image 22.3 x 32.3 cm, detail. London, National Maritime Museum. Demolition is progressing. This is a more professional piece of print-making than William Beatson's etching, but there is little reality either in the Temeraire's pristine appearance or in her position, seemingly afloat in the river instead of being cabled to the wharf. The Rotherhithe background, in reality a jumble of warehouses, wharves and docks, has also been prettified.

'The first dark day of nothingness' (in Byron's sombre phrase) for the *Temeraire* was 7 September 1838. A lithograph (PLATE 24) by William Beatson, the ship-breaker's brother, dated September 1838, shows the *Temeraire* soon after her arrival at Beatson's wharf, when demolition had just started. The masts which Turner was to depict in her are not shown by Beatson: correctly, since they had been removed at Sheerness. Since the *Temeraire* suffered no damage during the tow, this etching must accurately (allowing for some naivety in drawing) reflect her appearance throughout the tow. A passing dinghy gives a sense of the ship's huge size; one of its occupants points her out with the 'Look at that!' gesture used in more conventional picturesque views. Beatson's etching is a more reliable

document than the rather genteel view of the *Temeraire* at Rotherhithe by J.J. Williams Esq. (PLATE 25): demolition has advanced, yet the ship is oddly pristine, and afloat in mid-river instead of being secured to the wharf.

Breaking up the *Temeraire* was no work for sledge-hammers. The work had to proceed slowly, if maximum profit was to be made. By arrangement with the Admiralty, Beatson sold all copper items back to them, for an agreed price per cwt; for two loads of copper sheathings, pintles, braces, nails etc. returned during 1839, he recouped nearly £3,000, with more to follow (the number of copper nails in the *Temeraire* must be incalculable). Timbers had to be taken apart, treated and sorted into categories for sale. Some authentic objects made from the *Temeraire*'s timbers are described on pp. 116–19. It probably took most of a decade finally to reduce the *Temeraire* to 'nothingness'.

Newspapers reported that going to see the *Temeraire* at Beatson's wharf quickly became a popular pastime. A week after she was berthed there, the *Shipping and Mercantile Gazette* reported that 'Much interest has been attached to the arrival of this old ship in Rotherhithe, for three extraordinary reasons – namely, she is the largest ship that has ever been sold by the Admiralty for breaking up, and also the largest ship that has ever been brought so high up the Thames, and next after the Victory she was the most conspicuous and the most destructive opponent that attacked the French fleet in the ever-memorable battle of Trafalgar.'[99]

*The Times* of 12 October reported that 'an immense number of persons' had been to see her: 'the wharf, and the pier-head of the Surrey Canal dock, have been often crowded with people, more particularly on the Sunday afternoons, to see the remains of the noble vessel which acted so distinguished a part at the memorable battle of Trafalgar.'[100] It added that there was a brisk demand for relics of her. Final rites over the *Temeraire* were delivered, according to *The Times*, by 'Boatswain Smith, the itinerant preacher', who 'has frequently preached to numerous hearers on the pier-head, and mixes up with his discourse entertaining anecdotes of the ship and her exploits'.

# PART II

## J.M.W. TURNER RA

Drawn by C. Foley in Prof. Brophius Tabernacle

When he painted 'The Fighting Temeraire', Turner was in his sixty-fourth year. The son of a London barber, he received little education; but he had an innate ability to draw. He began his career as a water-colourist, painting topographical views within an accepted tradition. In 1789, after some training with architectural draughtsmen, Turner enrolled as a student in the Royal Academy Schools. He, who was to exhibit 259 works at the Royal Academy over the next sixty years, first exhibited there in 1790, with a water-colour of 'The Archbishop's Palace, Lambeth'.[1] He was then aged fifteen.

Turner's originality of mind, his powers of observation and his strong personal response to the individual character of each of his subjects were clearly evident by the time he came of age in 1796. His watercolour of 'St Erasmus in Bishop Islip's Chapel (Westminster Abbey)',[2] for instance, exhibited that year at the Royal Academy (PLATE 27, detail), might at first glance seem to be a conventional if very well-handled cathedral interior, with its soaring fan-vaulting and crumbling carving; but already Turner is pouring into the subject everything he has learned and everything he feels, exaggerating the scale for dramatic effect, introducing shafts of filtered sunlight to warm the stonework and inscribing a quasi-memorial slab in the foreground with a record of his own prodigious genius: WILLIAM TURNER NATUS 1775. He was still only 21. In the same year, he exhibited his first oil painting, a night scene entitled 'Fishermen at Sea'.[3] He was elected an Associate of the Royal Academy in 1799; on 12 February 1802, at the astonishingly early age of 26, he was elected a full Royal Academician. Turner was to give life-long loyalty and service to the Royal Academy; it became the sheet-anchor in an otherwise largely solitary life spent absorbed in his work.

The range of Turner's subject matter throughout his life was vast. He found subjects in classical literature, history, modern poetry and contemporary land-scape; as Constable observed, Turner had 'a wonderful range of mind'.[4] The brief account offered here does not presume to 'survey' Turner's work, but only to focus on some aspects of it before 1838 which help to explain the various emotions and experiences which lay behind his decision that year to paint 'The Fighting Temeraire, tugged to her last berth, 1838'.

The sea provided Turner with continual inspiration. In a purely imaginative passage, Ruskin suggests that Turner's love of the sea and ships began during his London childhood, when 'he must have tormented the watermen' to let him hide in their boats and 'get floated down there among the ships, and round and round the ships... staring and clambering'.[5] More reliably, Turner is known to have spent some time at Margate in or about 1786, at the age of about eleven, making some drawings there while staying with a relative of his mother's.[6] Margate, which later he frequently revisited, may first have excited his interest in the sea. Study of engravings of sea paintings by seventeenth-century Dutch masters, particularly the two van de Veldes and Jacob van Ruisdael, helped to develop it.[7] Towards the end of his life, his paintings of the sea became brooding abstractions on the nature of the sea itself; but in the decades preceding 'The Fighting Temeraire' Turner's oils and watercolours of the sea – and its coasts, harbours and ports – chiefly reflect the activities of human beings who engage with the sea, as fishermen, seamen, boat-builders or mere passengers. Inseparable from his work as a whole, his sea pictures reflect his interest in all aspects of human existence in the natural world; they also reflect – sometimes

26 (page 47) Cornelius Varley (1781-1873): 'J.M.W. Turner at the age of about fifty', c.1825. Pencil on paper, 50.3 x 37.4 cm. Sheffield City Art Galleries. This is perhaps the most sensitive portrait of Turner known. Along the left edge of the sitter's coat is inscribed 'Drawn by C. Varley in Pat$^t$ Graphic Telescope', an instrument which Cornelius Varley invented and patented in 1811; it projected an image onto paper, on which it could then be outlined.

27 Detail from 'St Erasmus in Bishop Islip's Chapel', 1796. Watercolour on paper, 54.6 x 39.8 cm. London, British Museum. The complete work depicts part of the ambulatory of Westminster Abbey, with the chapels of St Erasmus and Abbot Islip on the right. Exhibited at the Royal Academy in 1796, when Turner was 21. On a monumental slab in the foreground, Turner has inscribed his own name and birth-date: WILLIAM TURNER NATUS 1775.

terrifyingly – his knowledge that nature could menace and destroy men.

'Fishermen at Sea', exhibited in 1796, was followed over the next decade by a series of dramatic oil paintings of sea subjects which helped to place Turner in the forefront of modern painters. Their titles indicate their diversity. 'Dutch Boats in a Gale; Fishermen endeavouring to put their Fish on Board', painted in emulation of the younger van de Velde and exhibited in 1801,[8] won high praise from other artists; Joseph Farington noted that Constable 'thinks highly' of it, and that Fuseli 'spoke in the highest manner of Turner's picture of "Dutch boats in a Gale" in the Exhibition as being the best picture there, quite Rembrantish...'[9] In 'Ships bearing up for Anchorage', exhibited in 1802,[10] Turner translates a commonplace scene of sailing-ships off the English coast – coming up into the wind, shortening sail and dropping anchor – into a design of the greatest beauty, carefully worked out in preliminary studies, and given heightened drama by the fall of light under a threatening sky. 'Calais Pier, with French Poissards preparing for Sea: an English packet arriving' reflects Turner's own experience of arriving on the Continent for the first time, during the brief Peace of Amiens; exhibited in 1803,[11] it hangs as NG 472 in the National Gallery.

White spume on storm waves in 'Boats carrying out Anchors and Cables to Dutch Men of War, in 1665' of 1804 provoked a reviewer in *The Sun* to remark that 'the Sea seems to have been painted with *birch-broom* and *whitening*': by no means the last facetious comment on Turner's work.[12] 'The Shipwreck', exhibited in 1805,[13] and the first of his oil paintings to be engraved, is the most heart-rending of all Turner's early sea pictures; here, hope has gone and men are at the mercy of the raging sea. The fate of a fishing-boat prompts him to consider the immense issue of man against nature. This is a supreme essay in the Sublime, with nature's power to arouse awe and terror let loose on canvas. In this period, only 'The Fall of an Avalanche in the Grisons'[14] equals it. Turner exhibited the 'Avalanche' in his own gallery in 1810, with lines of his own which end:

> *The vast weight bursts through the rocky barrier;*
> *Down at once, its pine clad forests*
> *And towering glaciers fall, the work of ages*
> *Crashing through all! extinction follows,*
> *And the toil, the hope of man – o'erwhelms.*

Turner yearned to express himself in poetry as well as paint, but had small talent for metre or scansion. Compared with his compulsion to paint, the flow of his verse was obscurely dammed. He scribbled verses in various sketchbooks, from about 1809 onwards working intermittently but obsessively at a long, rambling, unfinished poem to which he gave the title 'The Fallacies of Hope'; from this he sometimes took quotations to append to exhibited pictures, usually to critical derision.[15] Sometimes trenchant, occasionally lyrical but generally pessimistic, Turner's poetry reflects themes which are omnipresent in his work, though hardly touched on in this section. The decline of empires, the destruction of armies, the deluge, shipwreck, even the specific event of the *Temeraire* going to her doom – these, for Turner, were not just magnificent subjects for the painter; in all of them he saw evidence of 'the fallacies of hope', and knew that 'extinction follows'.

By 1810 Turner was one of the principal exhibitors at the Royal Academy. He also exhibited work in his own gallery where, in June 1806 (eight months after the Battle of Trafalgar), he showed 'The Battle of Trafalgar as seen from the Mizen Starboard Shrouds of the Victory' (PLATE 10) and 'Portrait of the Victory in three positions, passing the Needles' (PLATE 15), two paintings discussed in Part I. The very large (366 cm wide) 'Battle of Trafalgar' which George IV commissioned from Turner in 1822 (now in the National Maritime Museum, Greenwich)[16] was so unorthodox as to provoke heated criticism. Turner had consulted J. C. Schetky, Marine Painter in Ordinary to the King, over particulars of the battle;[17] but the *Literary Gazette* detected 'glaring falsehoods and palpable inconsistencies' in every detail of his picture, and naval men from the Duke of Clarence (later William IV) onwards have not ceased to find fault with it. George IV's decision in 1829 to give the picture to Greenwich meant that England's greatest painter remained unrepresented in the Royal Collection until 1987, when Turner's 'View of Windsor Castle from the Great Park', a watercolour of 1795,[18] was purchased.

In a delectably fresh seascape entitled 'Van Goyen, looking out for a subject' exhibited in 1833,[19] Turner depicts the seventeenth-century Dutch painter Jan van Goyen sailing in a *smalschip* about the Scheldt in search of promising subjects. This was reputedly van Goyen's custom; but we need know nothing about van Goyen to identify him in the picture, since Turner 'crowns' the artist with a Rembrandtesque turban. One of the airiest and least momentous of all Turner's sea paintings, 'Van Goyen' probably reflects Turner's own joy in being *en plein air* and on the water, free to 'look out for subjects' for himself.[20] But Turner never presumed to adopt a Rembrandtesque stance; he was always a 'low profile' artist when working on the spot.

A first-hand impression of Turner himself 'looking out for a subject' is given by Cyrus Redding, Turner's occasional companion, in an account of a day's excursion probably made in 1813, when Turner was aged 33 and Redding 28.[21] In steadily worsening weather, they sailed from Plymouth eastwards along the coast to Bur Island in Bigbury Bay: 'our excuse was to eat hot lobsters, fresh from the water to the kettle.'

*The sea had that dirty puddled appearance which often precedes a hard gale ... When running out from the land the sea rose higher, until off Stokes Point, it became stormy ... The sea, in that part of the Channel, rolls in grand furrows from the Atlantic, and we had run about a dozen miles. The artist enjoyed the scene. He sat in the stern sheets intently watching the sea, and not at all affected by the motion ...*

Landing on Bur Island in seemingly unbroken surf looked impossible, but at last they got round its lee shore.

*All this time, Turner was silent, watching the tumultuous scene. The little island, and the solitary hut it held, the bay in the bight of which it lay, and the dark long Bolthead to seaward, against the rocky shore of which the waves broke with fury, made the artist become absorbed in contemplation, not uttering a syllable. While the shell-fish were preparing, Turner, with a pencil, clambered nearly to the summit of the island, and seemed writing rather than drawing. How he succeeded, owing to the violence of the wind, I do not know. He, probably, observed something in the sea aspect which he had not before noted.*

This low-key description rings absolutely true: 'the self-contained indifference to discomfort, the rapt attention to natural effects, the concentration; and the act of drawing as if writing... all this is Turner to the life', in Andrew Wilton's words.[22] Redding's description is echoed in C. R. Leslie's recollection of Turner: 'He might be taken for the captain of a river steam-boat at a first glance; but a second would find far more in his face than belongs to any ordinary mind. There was that peculiar keenness of expression in his eye that is only seen in men of constant habits of observation.'[23]

Cornelius Varley's portrait study (PLATE 26) seems to reflect Turner's brooding powers of thought ('more in his face than belongs to any ordinary mind', in Leslie's words) and the pessimism expressed in 'The Fallacies of Hope'. Like many of Cornelius Varley's portraits, this one (as its inscription records) was drawn with the aid of his Graphic Telescope, probably while his subject was unaware of 'sitting'. It is not dated, but since Turner appears here to be about fifty years old, a date of around 1825 is suggested.[24]

Most of the works illustrated here are watercolours. Turner never lost his love of the watercolour medium, exploiting its expressive power as no artist had done before. Throughout his life he used pencil, chalk, watercolour, bodycolour (gouache) or oils as and when it suited him, according to whether he was noting swift impressions in his sketchbooks, working up a commissioned drawing for a patron or engraver, or painting a finished picture. Turner's patrons, and contemporaries who visited public exhibitions, could have seen his finished oils and watercolours; but very few people in Turner's lifetime would have seen studies such as those illustrated here in Plates 31, or 46–7. Most of his contemporaries would have known Turner's work chiefly through uncoloured engravings. Turner collaborated in numerous engraving projects, producing finished watercolours for publishers of picturesque views and for illustrated editions of celebrated poets.[25] The subtleties of light and shade, colour and tone in his work were not easily translated into line, and Turner kept a vigilant eye on the progress of various engravers' work. Over 800 engravings of Turner's work were made in his lifetime, including those made after his oil paintings and the *Liber Studiorum* mezzotints from his own chosen themes.

Turner was by temperament a traveller, continually journeying within Britain and 'on the Wing' almost every summer to Europe in search of fresh material.[26] Commissions from print-publishers enabled him to profit financially as well as creatively from his tours. Some of the 250 or so watercolours which he made to be engraved in such publications as *The Rivers of England* (1823–7), *The Ports of England* (1826–8) and *Picturesque Views in England and Wales* (1827–38), are singled out here for illustration.

The amount of work Turner achieved was prodigious. While still working on the *England and Wales* series, Turner produced a miraculous series of small watercolours for the 'Rivers of France' project, published 1833–5 (PLATES 38–42; see pp. 60–5; he also designed vignette illustrations for editions of poems by Samuel Rogers, Thomas Campbell, Sir Walter Scott and others. All this time he was, of course, engaged on oil paintings of great complexity: 'Ulysses deriding Polyphemus',[27] exhibited in 1828 (NG 508), for instance, was painted at much the same time as 'Dockyard, Devonport' (PLATE 4), and 'Caligula's Palace',[28] exhibited in 1831, at about the same time as 'Castle Upnor, Kent'(PLATE 32).

28 'Chatham, Kent', c.1830–1.
Watercolour on paper, 28.2 x 45.7 cm.
England, Private Collection. Engraved
in 1832 for Picturesque Views in
England and Wales. The view looks
along the Medway, past the the dock-
yard from which the Temeraire was
launched in 1798, towards Rochester
Castle and Cathedral in the distance.
Marines and soldiers are on (and off)
duty in the foreground.

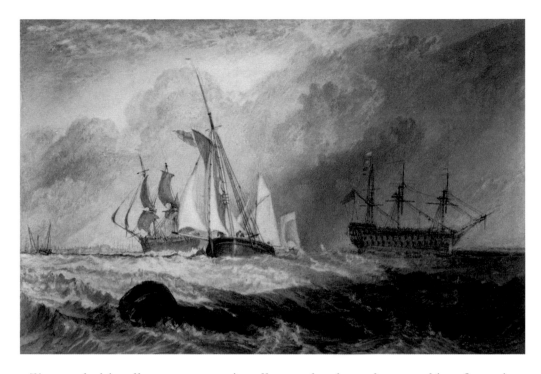

30 'Sheerness', 1824. Watercolour on paper, 16 x 23.8 cm. Turner Bequest: London, Tate Gallery. Engraved for The Ports of England, 1828. Sheerness harbour is at the north-west tip of the Isle of Sheppey, where the Medway flows into the Thames estuary. Here the Temeraire was moored on harbour duties for eighteen years, probably looking much like the two-decker on the right, her masts lowered, and other vessels passing her by.

29 (left) 'Portsmouth', c.1824-5. Watercolour on paper, 16 x 24 cm. Turner Bequest: London, Tate Gallery. Engraved for The Ports of England, 1828. Like most of the finished watercolours Turner made for engraving, this was based on pencil sketches made on the spot. A man-of-war sets sail in a strong breeze, cheered by a sailor in a dinghy. Buildings on shore include the Admiralty Telegraph Tower on the right, part of a network of stations which from 1796 could relay shutter-operated signals within minutes to the Admiralty Office in Whitehall.

Turner habitually gave exceptionally good value when working for print-publishers, filling his scenes with local details and heightening them with whatever effects of fine weather, cloud, storm, rainbow or moonlight he considered appropriate or symbolic. Within his commissions for 'picturesque views', Turner was free to choose and interpret his own subjects. Since his interest in every aspect of human life (apart from *le beau monde*) was unbounded, his 'views' provide an unparalleled picture of contemporary Britain. Turner's work on the great series of 96 watercolours for *Picturesque Views in England and Wales*, begun towards the end of George IV's reign, continued throughout William IV's and was completed after the accession of Queen Victoria.[29] The publication was a commercial failure; but Wilton calls Turner's watercolours for it 'the central document in Turner's art', revealing Turner's humanity 'at its broadest and subtlest'.[30]

Many of them reveal the knowledge of a vast variety of shipping which Turner had accumulated by the time he came to paint 'The Fighting Temeraire'. 'Portsmouth', about 1825 (PLATE 29),[31] is dominated by a two-decker (perhaps a Third Rate) ship of the line preparing to make sail, leaving a harbour lined with maritime buildings, including the Telegraph Tower, from which signals could be relayed to the Admiralty in London; a sailor in a dinghy waves his straw hat in salute as she goes. 'Chatham, Kent', about 1830 (PLATE 28),[32] shows the River Medway (on which the *Temeraire* had been launched forty years earlier) crowded, as always, with shipping. England was now at peace; but marines were still stationed at Chatham, and Martello towers in several Sussex views recall the threat of invasion thirty years earlier.[33] 'Sheerness', of 1824 (PLATE 30),[34] shows a now ageing man-of-war with lowered masts and minimal rig, relegated to harbour duties while other vessels (a collier brig, a Navy longboat, a lugger) sail past. The ship is not large enough to be the *Temeraire* (compare Cooke's drawing of her, PLATE 18); nevertheless, Turner's scene offers some idea of how she too must have appeared during the eighteen years when she was moored off Sheerness, other shipping passing her by.

31 'Castle Upnor, Kent; Preparatory Study', c.1829-30. Watercolour on paper, 33 x 55.1 cm. Inscribed 'H Water' top right. Turner Bequest: London, Tate Gallery. A preliminary study for the finished watercolour (Plate 32). Both were preceded by detailed sketchbook notes on the spot. While some shapes (e.g. of the ships, and of the castle itself) are merely suggested, the study anticipates the finished composition and its pervading golden light.

In 'Castle Upnor, Kent' (PLATE 32),[35] on the Medway near Chatham, old ships are seen across still water in the fading glow of sunset; a sheer-hulk is dismasting the three-decker on the left. The long rays of the setting sun anticipate those in 'The Fighting Temeraire'; but here the mood is milder, and Upnor Castle itself plays a historic role in the scene. A colour study for this (PLATE 31) shows how sure Turner's first thoughts often were:[36] as Ian Warrell recognised, the study is an almost exact preparation for the finished watercolour.

Several scenes illustrate shipbuilding. The most detailed is 'Dockyard, Devonport, Ships being Paid Off', about 1828 (PLATE 4);[37] its background includes four of the long covered sheds in which ships were built (in the centre), a sheer-hulk used for masting ships (right of centre), a man-of-war reduced to a hulk (right) and a still intact two- or three-decker (left). 'Thunder passing away in the west', noted Ruskin, who owned this drawing. Sailors, paid off at the end of a voyage (often after lengthy service), enjoy the sweets of liberty in the foreground, their hardships temporarily forgotten. In 'Plymouth Cove'[38] they dance and drink, celebrating still more more exuberantly in 'Dartmouth Cove, with Sailor's Wedding'.[39] More sombrely, lighthouses from Land's End to Lowestoft warn of perils at sea, but do not always avert disaster.[40] Shipwrights are at work in 'Dartmouth, on the River Dart',[41] and ship-breakers in 'Teignmouth, Devon'.[42] In 'Whitstable, Kent',[43] the locals dredge for oysters; in 'Scarborough'[44] they net shrimps. In 'Fish-Market, Hastings',[45] the catch (skate, sole, whiting, lobster) is spread out on the sand; life has gone on much like this for centuries.

By contrast, some of Turner's scenes reflect industrial development. In 'Newcastle-upon-Tyne', on the river where the tugs *Samson* and *London* were soon to be built, the Gateshead bank is lined with collier brigs and small craft. Coalfields above Newcastle accounted for much of the traffic on the Tyne; in an oil painting of 1835, Turner was to make a strangely beautiful scene out of 'Keelmen heaving in Coals by Night'.[46] On the Newcastle bank, timber is unloaded and winched up. Smoke from factories rises on the horizon. 'Dudley, Worcestershire' (PLATE 33),[47] is a view of a Black Country town which Turner had

32 'Castle Upnor, Kent', c.1831. Watercolour on paper, 29 x 43.7 cm. Manchester, Whitworth Art Gallery. Engraved for Picturesque Views in England and Wales,1833. In a tranquil sunset, old ships lie off Chatham (in the distance left) on the river Medway. Upnor Castle, on the right bank, famous for its successful defence of Chatham against the Dutch fleet in 1667, was thereafter used by the Board of Ordnance as its chief gunpowder store on the Medway.

33 'Dudley, Worcestershire', c.1832. Watercolour and bodycolour on paper, 28.8 x 43 cm. Port Sunlight, Lady Lever Art Gallery. Engraved for Picturesque Views in England and Wales, 1835. For at least half a century before 1835, Dudley (in the Black Country) had expanded as a centre for the production of coal, iron and lime-stone, and for associated industries. Taking Dudley Port as his viewpoint, Turner offers a contrast between the ancient castle and church on the horizon and the smoking chimneys below. A barge in the foreground laden with hoops of sheet iron is lettered DUDLE −.

visited in 1830; by then it had been a centre for industrial manufacture for at least half a century. Churches and factories are alike obscured by industrial smoke; the scene echoes Turner's lines on London in his Greenwich sketchbook of 1808–9:[48]

*The extended town far stretching East & West*
*Thy high raised smoke no prototype of Rest*
*Thy dim seen spires rais'd to Religion fair*
*Seen but at moments th[r]o that world of care...*

Ruskin, who owned this watercolour, assumed that it showed that Turner shared his own hatred of industrialisation. William S. Rodner offers more perceptive comments.[49] He detects in Turner's view of 'Dudley' some positive response to the power and vitality of technological development; and he suggests that in juxtaposing furnaces, factory chimneys, boilers and canal boats against a backdrop of ancient battlements and steeples, Turner was alert to evidence of 'change, continuity and adaptability' in early nineteenth-century England. Turner's portrayal of the energetic steam-tug which was to tow the *Temeraire* to her end in 1838 perhaps similarly recognises 'change, continuity and adaptability'.

Steamboats increasingly appear in Turner's views, both in England and abroad. A paddle-steamer cutting through the wind to harbour in 'Dover Castle', dated 1822,[50] may be the first which he depicts, though not the first to be seen there. In

34 *'Dover', c.1825. Watercolour on paper, 16.1 x 24.5 cm. Turner Bequest: London, Tate Gallery. Engraved for The Ports of England, 1827. Dover Castle dominates the skyline. Almost directly below it is a paddle-steamer; having left the pier, it sends back a zig-zag of smoke. Dover-Calais passenger services were offered by steamboat companies from 1821; steamboats were already operating between British ports by then. Small boats in the foreground include one in which a fisherman waits among his lobster-pots; as often in Turner's scenes, old activities co-exist with new.*

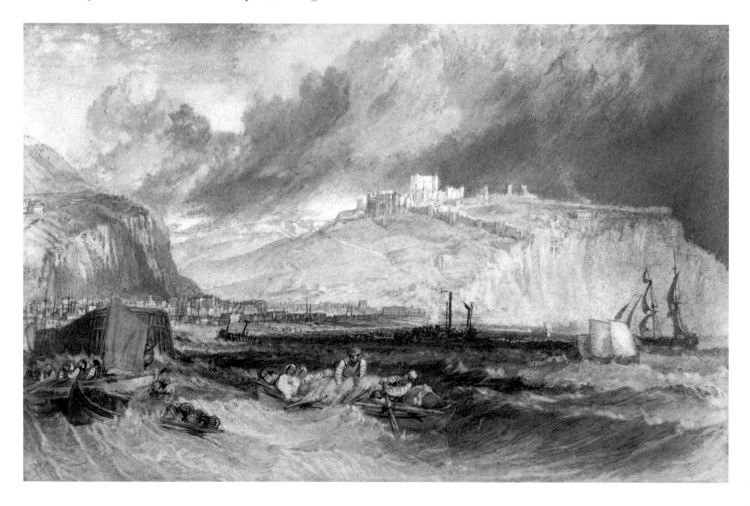

35 *'The Tower of London', c.1825.*
*Watercolour on paper, 30.5 x 43.2 cm.*
*New York, Private Collection.*
*Engraved 1831. Based on pencil draw-*
*ings in Turner's 'River' and 'Old*
*London Bridge' sketchbooks. The cross-*
*Channel steamboats Talbot and Lord*
*Melville wait for passengers' impedi-*
*menta to be ferried from Custom House*
*Quay (off to the left). Note that two*
*carriages have already been been loaded*
*onto the Talbot, while another is being*
*manoeuvred aboard the Lord Melville*
*(compare with the funeral coach in*
*Plate 66). On the right is the Perseus*
*frigate, now a stationary hulk serving*
*as a receiving ship, or depot for seamen,*

'Dover', of about 1825 (PLATE 34),[51] a dark steam-packet is more forcefully silhouetted against the white cliffs. Regular cross-Channel steamer services from Dover to Calais had begun in 1821; by then steamers carrying both cargoes and passengers between English ports had been operating for several years.[52]

In 'The Tower of London' of 1824 or 1825 (PLATE 35),[53] two steamers with boldly striped funnels are depicted still more assertively against the ancient fabric of the Tower itself. Lettering identifies them as the *Lord Melville* and the *Talbot*, both of which advertised their services in newspapers of the day. 'The Superb new and commodious, STEAM PACKET the LORD MELVILLE', now in the third year of its regular service from the Tower to Calais (Wednesdays and Saturdays) and back (Mondays and Thursdays), dominates Turner's scene, as it waits with the *Talbot* for passengers' impedimenta (including a travelling-coach) to be loaded aboard; other vessels including an Admiralty barge are relegated to minor roles.[54] In 'View of London from Greenwich', 1825,[55] three steamboats move downstream, leaving a 'forest of mast and yard'[56] behind them in the Pool of London; as dark smoke from the leading steamer ascends between the stately domes of Greenwich Hospital, Turner leaves us in small doubt that the future is with the steamboats.

Turner himself must have travelled regularly by steamboat from the early 1820s, around Britain, to the Continent and along its great rivers. His most frequent port of call in England was Margate, which he had visited since childhood

36 'Margate Pier with Steam Packets', c.1825. Engraving by E. Wallis, coloured by hand, 25 x 35 cm. Kent, Margate Library. The steamer at the pier is SS Victory, 16 tons, built at Rotherhithe in 1818 for the London-Margate-Dover run; the other is SS Favorite, operated by a rival company. Turner must often have travelled on such steamers on his visits to Margate to stay with Mrs Booth, whose house in Cold Harbour, concealed in this view by other buildings, was situated roughly in line with the top of SS Victory's funnel. In 1830, the number of passengers arriving at Margate by steam packets was 98,000.

*Margate Pier with Steam Packets.*

*London. Published by E. Wallis, 42, Skinner Street*

and where he had (possibly from the early 1830s) an attachment to Mrs Sophia Booth;[57] a woman of about his own age, she is presumed first to have been his landlady in Margate and later his bedfellow, eventually moving to London to keep house for him there. Mrs Booth owned a modest three-storey house on the Cold Harbour foreshore, near the Custom House;[58] its upper bay windows overlooked the harbour, the pier and its continual *va-et-vient*. Mrs Booth's bay windows may not have been the least of her charms for Turner. 'Margate Pier with Steam Packets' (PLATE 36), engraved after an anonymous artist about 1825, indicates the general location of the house (a short walk to the right after landing at the pier). Either *Victory* or *Favorite*, the two steamers in the foreground, might have transported Turner to Margate, though by 1825 many others were operating. The 16-ton *Victory* was built at Rotherhithe for the Margate service in 1818, three years after Marc Isambard Brunel's steamer *The Thames* had inaugurated the run.[59]

In 1820 it was confidently predicted that 'in a few years, vessels of every size, and for every extent of voyage, will be provided with their steam engines, which will be more used, and more depended upon, than winds or tides'.[60] The ninety-mile trip from London then averaged eight hours by steamer, about a quarter of the time taken by the old passenger hoys. Competition produced faster and cheaper services; fares of 'fifteen shillings for the best cabins' in 1820 fell to eleven shillings by 1830. Margate steamers which Turner could have used around 1830 included the *Magnet, Dart, Harlequin, Royal Sovereign, Hero* and *Albion*; but the chief operator was the Margate & London Steam Packet Company, whose four regally named steamers – *William IV, Royal George, Royal Adelaide* and *Royal William* – helped to promote Margate as a pleasure-ground for the people. *Kidd's Pictorial Guide to Margate* of 1831 stated that in the previous year 'no less than 98,000 passengers landed at Margate from steam packets'. Rival attractions

37 *'Margate, Kent', c.1822.*
*Watercolour on paper, 15.6 x 23.6 cm.*
*New Haven, Yale Center for British*
*Art (Paul Mellon Collection).*
*Engraved 1824 for Picturesque Views*
*of the Southern Coast of England.*
*Turner had visited Margate as a boy,*
*and later often returned there. This view*
*looks across the bay towards the pier*
*and Mrs Booth's house (see Plate 36);*
*the view of the town includes Hooper's*
*Mill on the far hillside. In the fore-*
*ground, men salvage wreckage.*

offered by steamboat proprietors included refreshments, 'libraries', backgammon boards and bands: the latter, 'constantly played during passage', helped to drown the noise of incessant vibration and the not infrequent sound of a boiler bursting.[61]

Margate provided Turner with ideas for oils and watercolours throughout his life, from his earliest known drawings to the meditative, almost abstracted seascape, 'Margate(?) from the Sea' of about 1835–40 (in the National Gallery, NG 1984),[62] whose only landmark is a distant white headland. Turner's offshore watercolours of the 1820s show the sea as bright blue and the sky as serene, suggesting his contentment with the place, whatever its occasional disasters. The foreshore in 'Margate, Kent', about 1822 (PLATE 37),[63] is dominated by a fishing-boat's wreckage, with numerous figures salvaging what they can; but across the bay the wide front of the town is bathed in the serene light of early evening. The harbour, more distantly seen than in the anonymous engraving (PLATE 36), is towards the left. A second 'Margate' watercolour[64] from a similar viewpoint, painted a few years later, depicts a brig aground, with blues of varying depths demonstrating shallows; but here too the sky is fair. A steamer keeps company with other shipping in the harbour, its smoke drifting high above the houses on the foreshore.

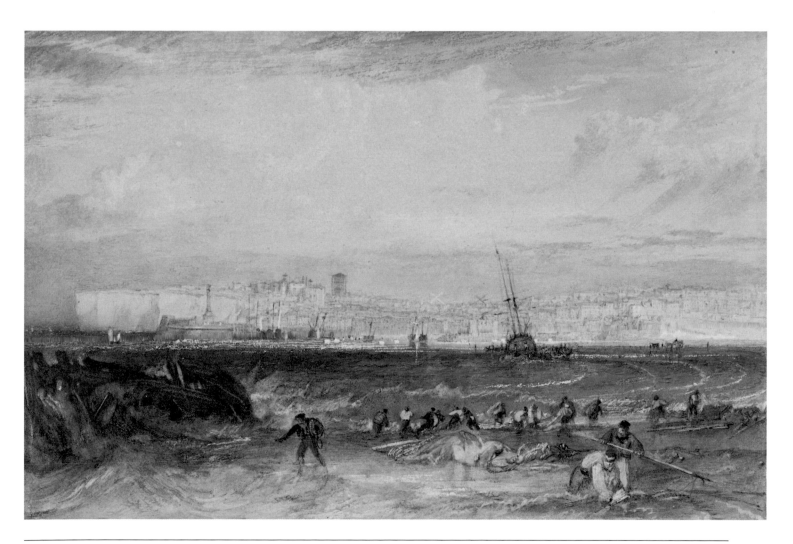

38 'Light Towers of the Hève',
c.1830-2. Watercolour and gouache,
with some pen and brown ink, on blue
paper, faded to grey, 18.9 x 13.4 cm.
Turner Bequest: London, Tate Gallery.
The lighthouses surmount a cliff (its
height greatly exaggerated here) at La
Hève, on the north bank of the Seine
estuary, above Le Havre. This vignette
was used as the frontispiece for Turner's
Annual Tour – The Seine, 1834, and
announces the interest in steamboats
which runs through the Tour.

A commission to draw picturesque river scenery in France gave Turner the chance to focus his attention on steamboats on the Seine. The commission came from Charles Heath, publisher of *Picturesque Views in England and Wales*, who projected an ambitious series in which Turner's engraved views of 'The Rivers of France' would extend to 'The River Scenery of Europe'; but in the end only his views of the Seine and the Loire were published.[65] Turner gathered material for the French rivers project on visits to France in 1829 and 1832, also using details recorded in sketchbooks on earlier tours. He produced an exquisite series of 61 finished drawings in bodycolour on blue paper, small in size but rich in colour and elaborate in content. Engravings of them were first published in book form, in three volumes entitled *Turner's Annual Tour* 1833, 1834 and 1835, with almost entirely unrelated anecdotal letterpress by the journalist Leith Ritchie. The 1833 volume (published in large format) illustrated the scenery of the Loire, the 1834 and 1835 volumes (dwindled in size to what the *Gentleman's Magazine* called 'the humble demy'[66]) that of the Seine.

For *Turner's Annual Tour – The Seine, 1834*, Turner concentrated his attention on steamboats. The subtitle, *Wanderings by the Seine* (from Le Havre to Rouen), might for the armchair traveller evoke images of a tranquil progress from one picturesque old town to another. But the Seine was one of France's busiest commercial waterways.[67] Le Havre was France's principal commercial port (termed by a near-contemporary 'the Liverpool of France'), and Rouen a manufacturing centre; traffic between them (and then to Paris, and beyond) was heavy. But the Seine, with its frequent meanders and sandbanks – both tellingly illustrated

39 'Light Towers of the Hève',
c.1830-2. Watercolour over traces of
pencil on paper, 19.7 x 15.9 cm. Port
Sunlight, Lady Lever Art Gallery. On
white paper, this may be Turner's first
idea for the vignette frontispiece of
Turner's Annual Tour – The Seine,
1834. The vignette preferred (Plate 38)
is on blue paper, like the rest of his
illustrations of the Seine, and moves the
steamboat to a central, more significant
position.

in the play of light over the beautiful but hazardous river in 'Chateau de Tancarville, with a view of Quilleboeuf'[68] – presented considerable navigation problems for sailing-boats. The introduction (from England) of steamboats to the Seine in 1814 was particularly welcome. Many of them were passenger steamers, catering for the tourist; a pocket-guide for the steamboat traveller entitled *Voyage Historique et Pittoresque du Havre à Rouen, en Bateau à Vapeur* had gone into a second edition by 1827.[69] But it was primarily the presence of steam technology on the Seine that fascinated Turner.

In 'Light Towers of the Hève' (PLATE 38),[70] the moonlit vignette designed for the frontispiece, Turner sends the reader a signal: watch these pages for steamboats. The title is taken from the two majestic lighthouses surmounting a cliff (its height greatly exaggerated by Turner) at La Hève, on the northern coastal entrance to the Seine estuary. As a full moon emerges between clouds, fishermen draw in their nets and a silvered sailing-ship shelters under the cliff; but a single intrepid steamboat, its funnel smoking, prepares to sally forth. In an alternative design on white paper (PLATE 39),[71] the steamboat is no longer centrally placed; its juxtaposition to a sailing-ship begins to suggest the eventual relationship of the tug to the *Temeraire*.

Two drawings depict the port of Le Havre. In 'Havre: Sunset in the Port',[72] densely crowded shipping at the quay includes a steamer, conspicuous by its striped funnel and smoke. In 'Havre: Tower of François 1er; Twilight in the Port',[73] a steamboat has quietly followed a sailing-barge through the deep-water channel under the tower built in 1517 by François 1er, founder of the port; its smoke drifts without menace away from the venerable tower, into a tender sky in

40 'Caudebec', c.1830-2. Bodycolour on blue paper, 13.9 x 19 cm. Turner Bequest: London, Tate Gallery. Engraved for Turner's Annual Tour – The Seine, 1834. Caudebec, roughly halfway between Le Havre and Rouen, was then a small town. A distant steamer, either carrying passengers on a picturesque tour or transporting goods, approaches round one of the Seine's broad meanders. In the foreground, a small procession enters a walled grave-yard. Undemonstratively, Turner records the co-existence of death and everyday life.

which sunset is just yielding to twilight. The proximity of a tower and ships at the entrance of a port is an echo of Claude's seaports.[74]

In 'Caudebec' (PLATE 40),[75] a distant steamer approaches the town round a leisurely meander of the river; here Turner's own delight in the Seine landscape of blue water flowing between green banks is evident. To emphasise the idea of power generated within the diminutive vessel, Turner greatly exaggerates the height of the river-bank under which it passes. Leith Ritchie, who contributed the bland letterpress for *Turner's Annual Tours*, expressed astonishment at Turner's ability to convey 'a forcible idea...without a single correct detail' (adding 'When I returned to London, I never failed to roast him on the subject').[76] 'La Chaire de Gargantua, near Duclair' (PLATE 41), whose title is taken from a hillside outcrop locally believed to be the throne of Rabelais's hero (Turner sketches it rapidly in white bodycolour), is altogether more theatrical. Lightning zigzags down one side of the picture: as if in rivalry, steamboat smoke rises up the other side, while small boats in the foreground prepare for yet another storm on the river.

Like their counterparts in England, steamboats on the Seine could operate as tugs. 'Between Quilleboeuf and Villequier' (PLATE 42),[77] probably the best-known of this series, shows steamboats working as tugs (*remorqueurs*) to assist sailing-ships.[78] The hazards of this stretch of the river were notorious, including not only shoals, quicksands and dangerous bends but also a tidal wave known locally as the *barre* (depicted in another of the Seine *Tour* drawings, and in an oil exhibited in 1833 as 'Mouth of the Seine, Quilleboeuf'[79]). On this stretch of the river the services of the *remorqueurs* were invaluable. In 'Between Quilleboeuf and Villequier', Turner depicts five vessels which have navigated a difficult reach of the river in convoy. The leading steamboat tows a sailing-barge (we see hardly more than its masts), with a rosy-sailed boat alongside; a second, smaller tug, having manoeuvred a larger sailing-boat around the bend in the river, is allowing

42 (right) 'Between Quilleboeuf and Villequier', c.1830-2. Bodycolour on blue paper, 13.7 x 19.1 cm. Turner Bequest: London, Tate Gallery. Engraved for Turner's Annual Tour – The Seine, 1834. The hazards of this stretch of the river, near the mouth of the Seine estuary, included tidal waves, shoals and quicksands. Here Turner observes steamboats working as tugs to assist sailing-ships round dangerous bends. The active role played by the steam-tugs and the passive role of the sailing-ships anticipate both the drama and the design of 'The Fighting Temeraire'.

41 *'La Chaire de Gargantua, near Duclair', c.1830-2. Bodycolour on blue paper, 13.7 x 18.8 cm. Turner Bequest: London, Tate Gallery. Engraved for Turner's Annual Tour – The Seine, 1834. Duclair is to the north-west of Rouen. The outline of a gigantic throne on the hillside salutes the local hero, Rabelais's character Gargantua. A sudden storm breaks over the Seine. Lightning strikes left; as if in rivalry, steamboat smoke ascends on the right.*

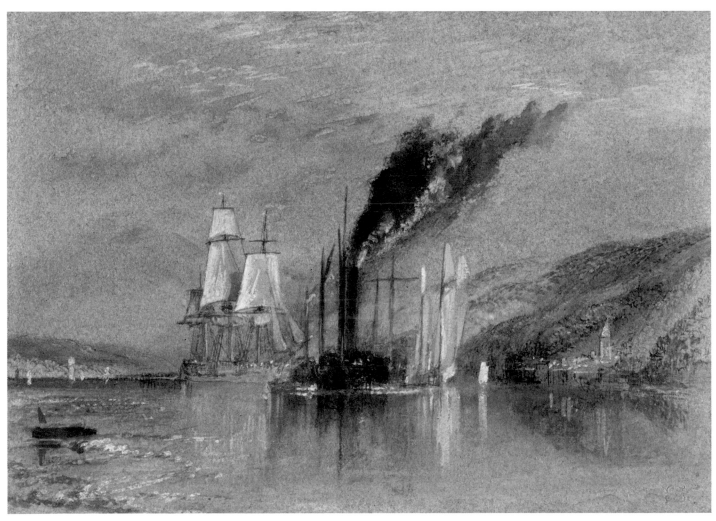

43 'Dawn after the Wreck', c.1841. Pencil, watercolour, bodycolour and touches of red chalk on paper, 25.2 x 36.8 cm. London, Courtauld Institute Galleries (Stephen Courtauld Collection). Ruskin wrote of this work: 'Some little vessel – a collier, probably – has gone down in the night, all hands lost; a single dog has come ashore. Utterly exhausted, its limbs failing under it, it stands howling and shivering. The dawn clouds have the first scarlet upon them, a feeble tinge only, reflected with the same feeble bloodstain on the sand.' Ruskin believed that Turner used scarlet in certain sunsets to associate them with death and destruction: 'In his mind it was the colour of blood.' Ruskin saw the same 'colour of blood . . . subdued by softer hues', in the sunset in 'The Fighting Temeraire'.

it to swing gently round into the straighter course ahead. An additional hazard can be seen on the left, where a red flag warns of quicksands. In the colour study 'Shoal, on the Seine',[80] a steamboat approaches head on, the spokes of its paddle-wheels deftly penned in in ink; here too a red flag signals a sandbank in the middle of the river.

Turner's observation of working steamers on the Seine no doubt influenced his decision, some years later, to paint the *Temeraire* under tow. It has long been recognised that 'Between Quilleboeuf and Villequier' in particular anticipates, to some extent, the composition of 'The Fighting Temeraire'.[81] It would not have been difficult for Turner, in 1838, to refer back to 'Between Quilleboeuf and Villequier', as this drawing remained, with most of his Seine drawings, in his own collection.

In 1836 the *Quarterly Review* discussed a new edition of Thomas Campbell's *Poetical Works*.[82] Its reviewer linked Campbell and Turner as pioneers in creating 'a new object of admiration, – a new instance of the beautiful, – the upright and indomitable march of the self-impelling steam-boat'.[83] The steam-vessel, he continued, must by now be considered as 'naturalized upon the ocean'; but he believed Campbell was 'the first poet' to throw over it 'the protection of his polished verse', in the lines 'Men's *volant homes* that measure liquid space/On *wheel* or *wing*' (the italics are the reviewer's).[84] The reviewer went on (in a footnote) to praise 'the admirable manner in which Turner, the most ideal of our landscape painters, has introduced the steam-boat in some views taken from the Seine'. He may have been recalling 'Between Quilleboeuf and Villequier', in particular, when writing: 'The tall black chimney, the black hull, and the long wreath of smoke left lying on the air, present, on *his* river, an image of life, and of majestic life, which appears only to have assumed its rightful position when seen amongst the simple and grand productions of nature.'

Other reviewers of the *Tour* of 1834 liked Turner's steamboats – somewhat to their own surprise, as the reviewer for *Arnold's Magazine of the Arts* admitted: 'We

44 *'A Paddle-Steamer in a Storm',*
*c.1830. Watercolour over traces of*
*pencil on paper, 23.2 x 28.5 cm. New*
*Haven, Yale Center for British Art*
*(Paul Mellon Collection). Possibly*
*based on Turner's travels by steamer*
*around the Western Isles of Scotland*
*which inspired 'Staffa' (Plate 48); but*
*the low line of hills on the coastline is*
*unidentifiable. The sun is about to*
*break through dark clouds; meanwhile,*
*as in 'Duclair' (Plate 41), lightning*
*flashes in one direction, while steam-*
*boat smoke is blown high on the wind.*
*The ability of steamer smoke to mani-*
*fest itself as 'wavy air' was one of its*
*chief appeals to Turner.*

do not generally admire masses of smoke, or consider steam-boats as delicate instances of the picturesque, but every subject here is so highly managed that we must be cautious lest we incur the charge of being fastidious.' Fastidiousness was left to the *Gentleman's Magazine*, which desired only 'antiquarian' views, ignored Turner's steamboats, and found no good reason why any tourist should waste time on 'so unprofitable an object as a tour from the dirty town of Havre...to the populous city of Rouen'.[85]

Familiarity with steamboats on the Seine probably contributed to the vigour and spontaneity with which Turner recorded recurring glimpses of passing steamers near Margate, in a sketchbook used for studies of seas, shores and skies about 1835–40 (see PLATES 45–7). Looking out to sea, he set down what he saw, swiftly: thunder-clouds over the sea, storm, sunset and moonrise, waves breaking, figures on wet sands. These studies, made purely for his own reference, are charged with a sense of immediacy; some were probably largely completed on the spot. The paper of this sketchbook is grey or buff; the drawings are made in

45 'Sunset off Margate with mackerel shoals', c.1835-40. Pencil, watercolour and bodycolour on buff paper, 19.1 x 27.9 cm. England, Private Collection. From the 'Margate' sketchbook (see Plates 46-7). The subject, common enough in nature, is perhaps unprecedented in art. Shoals of mackerel have been driven by predators perilously close to the shore. Turner, sensing the drama of their situation, enhances it by the addition of a blood-red sunset.

varying combinations of white and coloured chalks, pencil, bodycolour and watercolour. Ruskin, who managed to buy the sketchbook after Turner's death from his 'good Margate housekeeper', later broke it up, selling some of its leaves at Christie's in 1869.[86] They are now widely dispersed; but largely thanks to Edward Yardley[87] we have a good idea of the sketchbook's original contents. The titles for Plates 45-7 are Ruskin's. Justifiably, he described 'Heaped thundercloud over sea and land',[88] as a 'Mighty work', 'Steamers off Margate' (PLATE 47)[89] as 'Superb' and 'Margate Pier' (PLATE 46)[90] as 'Entirely magnificent'.

The steamers in these studies need no explanation; they pass, are glimpsed and recorded. 'Sunset off Margate with mackerel shoals' (PLATE 45)[91] is different, more finished and peculiarly thrilling, though Ruskin pronounced it to be 'careless and bad'. A blood-red sunset is the only witness (apart from Turner himself) of an intensely observed specific natural event. Andrew Wyld notes that 'The mackerel are shoaling close in shore, probably driven in to the shallows by predators':[92] their huge numbers cause the water to 'boil' in the middle distance, while in the foreground some leap clear of the water in an attempt to reach pools of safety. Mackerel are not commonly constituents of the Sublime; the grandeur of this scene is Turner's tribute to the laws of nature. Turner did not merely contemplate nature: he observed it closely. The sunset in 'The Fighting Temeraire' is no extempore special effect. Studies of sunsets recur in his sketchbooks, some no doubt drawn from recollection, but most from momentary impressions. Wilton suggests that the uninterrupted sequence of thirteen annotated drawings in Turner's 'Channel' sketchbook of about 1845 may record 'a single sunset, noting the progressive changes of colour as the sun descends below the horizon'.[93] Ruskin noted that the study which he called 'Running wave in a cross tide' was made for the sake of catching 'the appearance, in clear green waves, of darkness at the thin edge, when they crest without foaming, or before foaming'.[94] 'Rain clouds' and 'Storm clouds, looking out to sea' similarly catch transient effects.

46 'Boats off Margate Pier', c.1835-40. Watercolour and bodycolour heightened with white on buff paper, 21 x 27.7 cm. England, Private Collection. From the 'Margate' sketchbook purchased by Ruskin from Mrs Booth after Turner's death, and broken up by him. Ruskin described this leaf as 'Study of storm and sunshine . . . Entirely magnificent'.

47 'Steamers off Margate', c.1835-40. Watercolour and bodycolour heightened with white on buff paper, 22.5 x 29.5 cm. England, Private Collection. From the 'Margate' sketchbook (see Plate 46). Its leaves include numerous swift, impressionistic studies of seas, shores and skies observed in or near Margate. Here two steamers pass, their scale suggested by two white sails on the horizon, and by the figures on the shore.

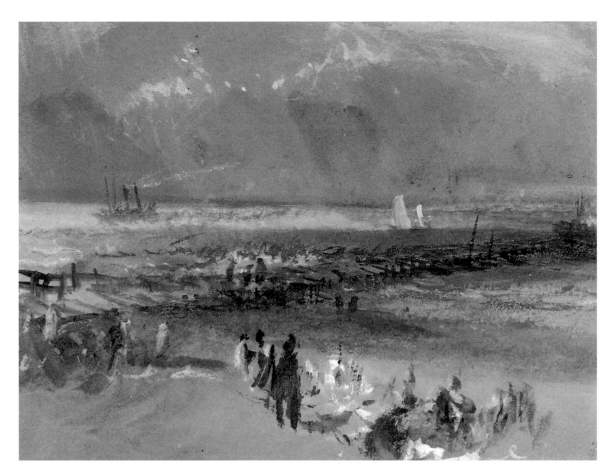

'Staffa' (PLATE 48),[95] exhibited in 1832, elevates a steamer to the principal role in a fully accredited sublime landscape. Turner had himself visited Staffa in August 1831, during a Scottish tour whose first professional purpose was to visit Sir Walter Scott at Abbotsford and discuss his commission to illustrate a new edition of Scott's *Poetical Works*.[96] From Abbotsford he toured the Border country, then explored the spectacular scenery of the north of Scotland and its western coast. His excursion to Staffa was probably made one day in the first week of September.[97]

At Tobermoray he took the 52-ton tourist paddle-steamer *Maid of Morven* to Staffa.[98] Turner vividly recalled that day's excursion in a letter of 1845 to the American James Lenox, who that year purchased the painting of 'Staffa'.[99] The excursion was to have included the island of Iona as well as Staffa, but 'a strong wind and head sea' delayed their landing on Staffa; the steamboat captain allowed them only one hour to scramble over the rocks to Fingal's Cave, the island's principal tourist attraction. When the passengers reassembled, the captain

*declared it doubtful about Iona. Such a rainy and bad-looking night coming on, a vote was proposed to the passengers: 'Iona at all hazards, or back to Tobermoray'. Majority against proceeding. To allay the displeased, the Captain promised to steam thrice round the island in the last trip. The sun getting towards the horizon, burst through the rain-cloud, angry, and for wind; and so it proved, for we were driven for shelter into Loch Ulver, and did not get back to Tober Moray before midnight.*

If steaming 'thrice round' Staffa in the wind and the rain allowed the other passengers to feel that they were getting their money's worth, it gave Turner ample chance to study the scene intently. The moment depicted in the painting is defined in his letter to Lenox: 'The sun getting towards the horizon, burst through the rain-cloud, angry, and for wind.' As John Gage notes, the halo which Turner has painted round the sun is a prognostic of rain (a phenomenon which Turner had discussed with Sir David Brewster earlier on his Edinburgh visit).[100] Dark smoke streams back from the steamboat's funnel towards the delicate orange-pinks with which Turner's sunset transforms the reality of Staffa's grey basaltic cliffs. In this long trail of smoke we can perhaps understand one reason why steamboats appealed so much to Turner. In a notebook of about 1808 he had written 'One word is sufficient to establish what is the greatest difficulty of the painters' art: to produce wavy air, as some call the wind... To give that wind he must give the cause as well as the effect... with mechanical hints of the strength of nature perpetually trammelled with mechanical shackles.'[101] The representation of smoke issuing from the funnel of a steamer immediately combined 'mechanical' cause and natural effect (as well as direction); to paint the wind in the sails of a ship demanded more artifice.

The steamboat itself is no heroic prototype, merely a commonplace (by 1831) vessel of the type used by several Clyde-based companies to provide regular services (during the summer) for tourists to Staffa and Iona. By placing it on the horizon, seemingly impervious to all the elements, steadily driving forwards into the rain-clouds, away from Staffa, Turner depicts it in a role which is quasi-heroic but unabashedly modern. Exhibiting 'Staffa' in 1832, Turner chose to append lines from canto IV of Sir Walter Scott's long poem *The Lord of the Isles* (first published in 1815),[102] a narrative far removed from the era of steamers, since it relates the fortunes of Robert Bruce after his return to Scotland in 1307. The lines

48 *'Staffa, Fingal's Cave'. Exhibited 1832. Oil on canvas, 90.9 x 121.4 cm. New Haven, Yale Center for British Art (Paul Mellon Collection). Turner visited Staffa in August 1831, taking the Maid of Morven tourist steamer, which may have looked much like this one. On Staffa he explored and sketched Fingal's Cave; but bad weather prevented the continuation of the trip to Iona. The painting was sold to Colonel Lenox of New York in 1845, and since then has rarely been seen in this country. Describing to Lenox the moment which inspired the picture, Turner wrote: 'The sun getting towards the horizon, burst through the rain-cloud, angry, and for wind.'*

Turner chose to accompany his picture describe the sea surging into Fingal's Cave, as he himself had seen and sketched it on his trip in the *Maid of Morven*, and as he was to depict it in the vignette frontispiece[103] to *The Lord of the Isles*:

> *. . . nor of a theme less solemn tells*
> *That mighty surge that ebbs and swells,*
> *And still, between each awful pause,*
> *From the high vault an answer draws.*

These lines would have been widely recognised as a description of the interior of Fingal's Cave (already on many a 'romantic' tourist's itinerary[104]); but Turner's selection of them for his picture may have more than one level of relevance. The interior of the cave is certainly not visible in his picture. If, as Janet Carolan and

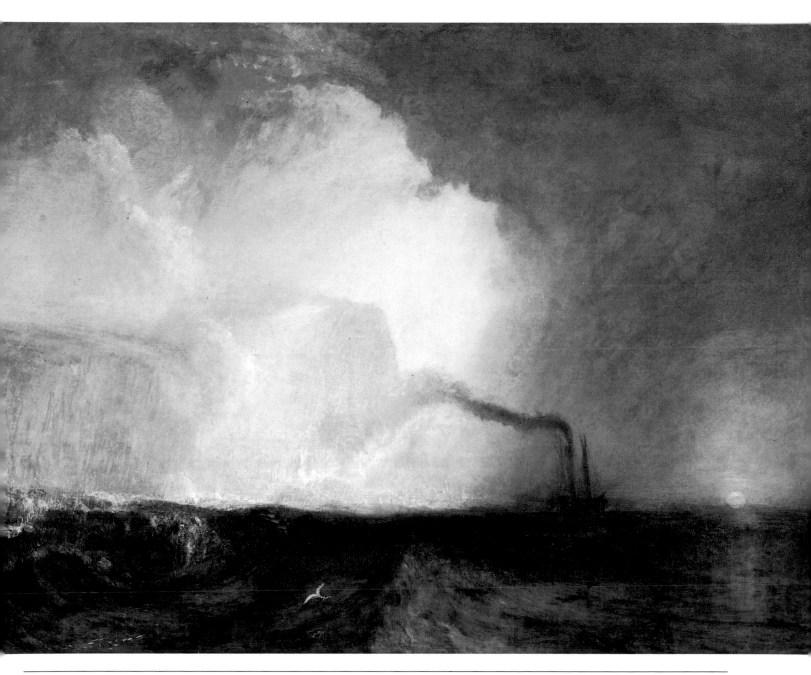

David Wallace-Hadrill believe, Turner is representing the south side of the island (looking north, from a viewpoint slightly east of south, with the mainland on the right),[105] then he may be indicating the position of Fingal's Cave by the darker, greyer patch of colour on the cliffs, where the steamer's smoke would drift down to water level. He may thus be using steamer smoke as a pointer to meaning here, as (later) in 'The Fighting Temeraire'; and if his viewpoint for 'Staffa' has been correctly interpreted, then his sun setting in the north is as heedless of the points of the compass as the sunset in the 'Temeraire'. Perhaps in his own mind Turner thought of Scott's lines as having a wider reference than to Fingal's Cave alone, and as appropriate to his own painting of 'a theme [no] less solemn', the modern steamer riding the surge that ebbs and swells, its dark smoke sending back, through a cave-like patch of light, an 'answer' to immemorial Staffa.

Turner's interest in steamers did not replace his love of sailing-ships. Patriotism and nostalgia prompted him to recall the active days of ships of the line long after the Battle of Trafalgar. Justly, one of his most celebrated watercolours is 'A First Rate taking in Stores' (PLATE 6),[106] dated 1818 and painted at Farnley Hall during a visit to his friend and patron Walter Fawkes. According to a family memoir, Fawkes said ('one morning at breakfast') to Turner: 'I want you to make me a drawing of the ordinary dimensions that will give some idea of the size of a man of war'.[107] Turner went to work immediately.

*He began by pouring wet paint on to the paper till it was saturated, he tore, he scratched, he scrubbed at it in a kind of frenzy and the whole thing was chaos – but gradually and as if by magic the lovely ship, with all its exquisite minutiae, came into being and by luncheon time the drawing was taken down in triumph.*

This passage, frequently quoted as a record of Turner's virtuoso technique, also shows how Turner (in this case in the middle of Yorkshire) could conjure up a detailed image from a store of knowledge. 'Loss of a man of war' and 'Man of war, making a signal for a pilot off the Tagus', two watercolours of about the same size as 'A First Rate', were painted for Fawkes at about the same time.[108] 'French Prizes entering an English Harbour, (?) Portsmouth' (PLATE 49),[109] in which spectators cheer as the union flag flies in triumph above the French ensign, seems to belong, at least in spirit, to the trio of post-war recollections painted for Fawkes.

Nearly a quarter of a century passed between 1815, when the Napoleonic Wars ended, and 1839, when 'The Fighting Temeraire' was exhibited. Turner did not forget those wars. The longest sequence of his draft verses (in a sketchbook of 1811[110]) includes 60 impassioned, unpolished lines on 'Victorys daring son', that 'high raised Nelsonian star' which fell at 'gory Trafalgar'. Peace did not stop Turner from brooding on the futility of war (for his post-war visit to the field of Waterloo, see Plate 68 and p. 98); nor did Napoleon's death in exile stop him from creating, years later, a spectral image (PLATE 67) of the man whom in 1811 he had called 'the scourge of Europe'.

Turner's verses on Nelson in his 1811 sketchbook had regretted that there was no monument to him to mark the nation's gratitude: he longed to see

*. . . his Cenotaph arise*
*On some bold promontory where the western main*

49 *'French Prizes entering an English Harbour, (?) Portsmouth', detail, c.1818. Watercolour and traces of pencil on paper, 28.3 x 39.7 cm. Inscribed 'J M W Turner RA' lower right. England, Private Collection. The union flag flies above the tricolore as British crews bring French prizes into harbour; a small crowd cheers from a saluting platform. The setting is not positively identifiable. Turner may be recreating some naval triumph during the Napoleonic wars, chiefly for its patriotic appeal.*

*Rich with his actions ever blesst by fame*
*Beheld him weather oft in naval tide*
*Our roaring Channels strong all[i]ance tide...*

Nelson monuments had been erected in Dublin (1808) and Montreal (1809), and a commemorative pediment designed by Benjamin West for Greenwich Hospital was completed in 1812.[111] Turner's deeply eloquent watercolour 'Yarmouth Sands' (PLATE 50), painted about 1830, shows the first Nelson Column to be erected in England, in 1817–19 – not overlooking the English Channel, as Turner had suggested, but in Nelson's native Norfolk. A stone column 43.9 metres high (only 30 cm shorter than the Nelson Column in Trafalgar Square, erected almost 25 years later) is crowned by Coade stone figures: six caryatid Victories supporting a globe on which Britannia stands (itself a rare event), extending her trident with one hand and an olive branch with the other. Britannia looks not out to sea but inland, perhaps towards Burnham Thorpe, Nelson's birthplace. The monument was designed by William Wilkins, himself an East Anglian and later the architect of the National Gallery.[112]

While the monument perpetuates Nelson's fame, sailors on the sands below deploy improvised ship models to re-enact the four resounding victories whose names are commemorated upon it: Cape St Vincent, Aboukir (The Nile), Copenhagen and Trafalgar. Women and boys look on, absorbing the Nelson legend. In the magnificently lofty sky above them, storm clouds drift away; Britannia rules unchallenged, and the 'nation's gratitude' to Nelson has found fitting expression in stone. Nelson had died in the moment of victory. In 'The Fighting Temeraire', Turner was to commemorate the passing of a part of the Trafalgar legend which had survived until the dawn of the Victorian era.

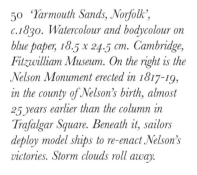

50 *'Yarmouth Sands, Norfolk', c.1830. Watercolour and bodycolour on blue paper, 18.5 x 24.5 cm. Cambridge, Fitzwilliam Museum. On the right is the Nelson Monument erected in 1817-19, in the county of Nelson's birth, almost 25 years earlier than the column in Trafalgar Square. Beneath it, sailors deploy model ships to re-enact Nelson's victories. Storm clouds roll away.*

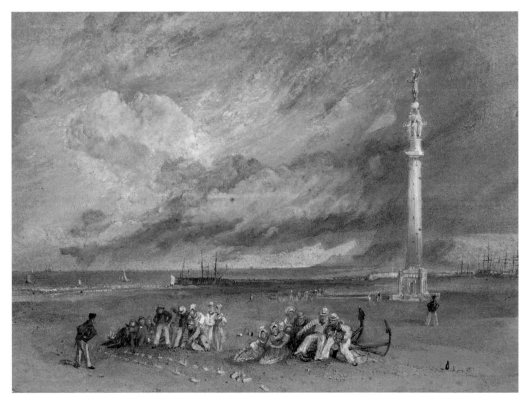

# PART III

## TURNER AND 'THE FIGHTING TEMERAIRE'

## 'THE FIGHTING TEMERAIRE TUGGED TO HER LAST BERTH TO BE BROKEN UP, 1838'

<p style="text-align:center">EXHIBITED AT THE ROYAL ACADEMY IN 1839, WITH THE LINES<br>
*The flag which braved the battle and the breeze,*<br>
*No longer owns her.*</p>

Ten days after 'The Fighting Temeraire' was first exhibited, the *Art-Union*'s reviewer acclaimed it as 'the most wonderful of all the works of the greatest master of the age'. Of all Turner's paintings, 'The Fighting Temeraire' has always been the most generally loved. In most spectators, it prompts a swift emotional response, and the wish to gaze long enough to explore its meaning. In most British spectators, it further touches chords of remembrance in which history is half-recollected, and pity, pride and patriotism are mingled. Sixty years after its first showing Cosmo Monkhouse wrote that the picture is 'penetrated with a sentiment which finds an echo in every heart', appealing not only to national feeling but to 'that larger sympathy with the fate of all created things'.[1] Yet for all its blazing sunset, this is by no means a blatant picture. Its meaning is complex, and not without ambiguity. A century and a half after it was painted, all we can be reasonably sure of is that it is a deeply thoughtful picture, painted by a man of feeling who does not dictate our response. The greatest works of art remain elusive, and there can be no authoritative ruling about the meaning of 'The Fighting Temeraire'. Seeing the picture for the first time, many contemporary critics instinctively reacted to its beauty and complexity by deeming it to be a poem: 'a nobly-composed poem', according to the *Art-Union*, and 'a very poetical conception', according to *Blackwood's*. More resoundingly, Thackeray was to liken the picture to 'a magnificent national ode or piece of music'.

<p style="text-align:center">&&&</p>

<p style="text-align:center">*A long Poem is a test of Invention which I take to be the*<br>
*Polar Star of Poetry, as Fancy is the Sails, and Imagination the Rudder.*<br>
JOHN KEATS, letter of 1817[2]</p>

Turner's painting of 'The Fighting Temeraire', exhibited at the Royal Academy eight months after the *Temeraire* herself was towed from harbour to be broken up, is so heartfelt that many believed (and others still believe) that Turner must have witnessed the very spectacle that he painted. That is unlikely. Firm evidence to show how the *Temeraire* must have appeared when she was 'tugged to her last berth' has been given on pp. 38–9; the most telling visual document in the case is William Beatson's awkwardly truthful lithograph, probably made very soon after the *Temeraire*'s arrival at the ship-breaker's wharf (PLATE 24).

The known facts about the *Temeraire*'s last journey should be briefly recapitulated here. By the time she was towed from Sheerness, the *Temeraire* had been reduced by the Admiralty to an empty hull. Her own masts had been removed; she had not been fitted with temporary masts; therefore she could carry neither rigging

*51 (page 72) Detail from 'The Fighting Temeraire'. For the sunset, Turner used a remarkable range of intensely coloured, fiery pigments – a chrome yellow and orange, lemon yellow, pure scarlet, vermilion and red lead – painted over a thinner warm understructure of earth colours. The making of the sunset is more fully discussed on pp. 121–2; its meaning has been variously interpreted.*

nor sails. Though her sheer bulk must have attracted attention, she was probably otherwise unrecognisable. Two tugs (*Samson* and *London*) were engaged over two days (5–6 September) in towing the *Temeraire* from Sheerness to Rotherhithe. The probable timing of the tow, making use of the spring tides which followed a full moon on 4 September, has been calculated (pp. 42–3). On both days, almost certainly, the tugs would have worked well within daylight hours; no river pilot of 1838 in his senses would have chosen to undertake the hazardous operation of navigating and berthing a 2,110-ton ship in a crowded commercial river after sunset, and by the light of tallow lanterns.

Almost certainly, Turner painted his picture entirely from imagination. If he did glimpse the tow at any point, he defied its realities. He depicts the *Temeraire* with her lower masts still in, partly rigged, with furled sails. He shows only one tug towing her (though a second tug if working behind her may not always have been visible); and his tug is of strange build (see pp. 82–3). Possibly Turner's setting is intended to suggest the confluence of the Medway and the Thames, off Sheerness; the distant buildings on the right bank (including storehouses, one with a clock- or bell-tower)[3] may be a recollection of Sheerness Dockyard, but are too indistinct to be identifiable; nor do they much resemble the glimpses of Sheerness in the backgrounds of 'The Confluence of the Thames and the Medway' or 'Sheerness from the Nore', each exhibited in 1808 (but each sold, and thus not easily available for reference in 1838).[4] But it is likely that Turner deliberately left the setting imprecise, given the direction in which he intended to place his sunset (see p. 92). On 5 and 6 September 1838 the moon was nearly full; in Turner's picture, the moon is nearly new.

Legends quickly evolved about where and when Turner witnessed the *Temeraire* under tow. The first and, regrettably, most lasting was pure invention on the part of Walter Thornbury, author of *The Life of J.M.W. Turner, RA*, first published in 1862. Thornbury was a journalist who specialised in assembling anecdotes without research; he had already published *Monarchs of the Main* (1855) and *Every Man His Own Trumpeter* (1858). Probably it was his contribution of an article on Turner to the *Encyclopaedia Britannica* (8th edition) which led Ruskin – unwisely, as he later realised[5] – to encourage Thornbury to write a *Life* of Turner. Thornbury was out of sympathy with his subject, whom he was to describe as 'a little, ignoble man, with sordid views and low tastes...'[6] He was also out of his depth with Turner's work, as some of his comments on 'The Fighting Temeraire' alone show: he referred to it as 'this Koh-i-Noor of a picture', and wrote that it stands out among Turner's works 'as a great flame-coloured Mexican cactus...would do in a simple nosegay of primroses'.[7] Thornbury's *Life* shocked Turner's friends and was treated with contempt by reviewers, notably by the *Quarterly Review*,[8] which devoted 32 pages to exposing the book's errors and its author's 'vicious fondness...for representing imaginary scenes', concluding that it was 'the most deplorable piece of bookmaking that has ever fallen in our way'. But because it purported to be the first full account of Turner's private life, the book proved popular enough for a second edition (1877); thus many of Thornbury's bogus stories passed into the collective public memory. Unabashed, Thornbury went on to publish *Tales for the Marines* in 1865.[9]

Thornbury's scenario for Turner 'seeing' the 'Fighting Temeraire' going to her doom is as follows:

*The subject was suggested to the painter by Stanfield [Clarkson Stanfield RA, chiefly a marine painter]. In 1838 Turner was with Stanfield and a party of brother artists on one of those holiday excursions in which he so delighted, probably to end with whitebait and champagne at Greenwich. Turner talked and joked his best, snatching now and then a moment to print on his quick brain some tone of sky, some gleam of water, some sprinkling light of oar, some glancing sunshine cross-barring a sail. Suddenly there moved down upon the artists' boat the grand old vessel that had been taken prisoner at the Nile, and that led the van at Trafalgar. She loomed through the evening haze pale and ghostly, and was being towed to her last moorings at Deptford by a little, fiery, puny steam-tug. 'There's a fine subject, Turner', said Stanfield. So Turner painted it . . .*[10]

Thornbury appears to have decided that he could make a good story by arranging for Turner to 'see' the *Temeraire* while he was on a jolly river outing with some 'brother artists': here he seems to have had in mind the annual excursions of members of the Royal Academy Club to Greenwich, which traditionally ended with whitebait suppers (but were usually in May). The crudest invention in Thornbury's account is the statement that 'the subject was suggested to the painter by Stanfield'. Clarkson Stanfield himself denied this story, declaring to his own and Turner's patron Munro of Novar that 'he should have been proud to have suggested this subject to Turner, but saying that he did so is an invention and a lie'.[11] But Thornbury's inventions were insidious, for instance prompting Turner's next and generally more sympathetic biographer Cosmo Monkhouse to write (of 'The Fighting Temeraire'): 'It is characteristic of Turner that the idea did not originate with him, but with Stanfield . . .'[12] Some howlers in Thornbury's account of the *Temeraire* are noted below.[13] Altogether, almost the only accurate observation in this passage is that Turner had 'a quick brain'.

Later writers chose to embellish Thornbury rather than to verify him. In an article entitled 'The Saucy Temeraire'[!] in *The Navy and Army Illustrated* (1896), Edward Fraser confidently pinpointed the 'spot' where Turner, who 'happened to be boating in Blackwall Reach off Greenwich Marshes', saw the *Temeraire* 'sweep past' under tow while enjoying 'a water picnic' with Clarkson Stanfield and some friends. In *Famous Fighters of the Fleet*, he went one further, including a route map with small symbols indicating that Turner 'saw' the '*Temeraire* in tow of two tugs' just before she rounded the Isle of Dogs.[14] In *Turner's Golden Visions*, C. Lewis Hind breezily relates essentially the same story – only this time Turner is in a steamer, and his companions are 'a party of the Academy Club', 'journeying to Greenwich, on their annual visit, when the steamer passed a tug with an old battleship in tow. "There's a fine subject for you, Turner", said Clarkson Stanfield. And Turner, who could take a hint from anybody, looked, chuckled, ruminated, no doubt made a pencil sketch, and the result was "The Fighting Temeraire".'[15] Thornbury's slap-happy style was deplorably infectious.

A different legend, seemingly still current, is that Turner sat on Cherry Garden Pier in Bermondsey to paint his picture.[16] More puzzling is the 'little anecdote' said to have been recounted by the sculptor William Frederick Woodington (1806–93) to Thomas Woolner RA (1825–92), and published in 1910 in Amy Woolner's *Life* of her father (thus reaching us at third hand):

*One day in 1838, Woodington, the sculptor of one of the reliefs on the base of the Nelson column, was on a steam boat returning from a trip to Margate; and in the midst of a great blazing sunset he saw the old Temeraire drawn along by a steam tug. The sight was so magnificent that it struck*

*him as being an unusually fine subject for a picture, and he noted all the points he thought would constitute its glory if presented on canvas. But he was not the only person on board who took professional notice of the splendid sight, for he saw Turner himself there, also noticing and busy making little sketches on cards... On the year following, going to the R.A. Ex: what was his amazement on beholding the veritable scene that had so delighted him again blazing before him in all its glory! He now saw that Turner had not been busy making those little sketches on cards for nothing; for here was a result beyond anything of the kind ever seen in paint before...*[17]

What is one to make of this? Was Woodington once Turner's fellow-passenger on some steamboat or other, and was he later so bowled over by seeing Turner's painting of 'The Fighting Temeraire' in a 'great blazing sunset' that he convinced himself that he himself had actually 'been there', sharing the sight with Turner? Or is this undated anecdote just a muddled recollection by Woolner (thirteen years old at the time of the tow) of conversations over many years with Woodington about Turner, whose work Woolner admired and collected?[18] No 'little sketches on cards' (nor any other preliminary sketches or studies) for 'The Fighting Temeraire' are known.

So, according to various legends, Turner 'saw' the *Temeraire* when he was on an excursion to Greenwich; while he was enjoying a water picnic in Blackwall Marshes; when he was on a steamer returning from Margate or while he sat on Cherry Garden Pier, Bermondsey. But it is possible that Turner was not even in England on 5–6 September, when the *Temeraire* was towed up. He was absent from the General Assembly of Royal Academicians on 6 September 1838 (the second day of the tow);[19] this fact is of some significance, since Turner's loyalty to the Royal Academy was so strong that unless he was abroad or ill he rarely missed either its General Assemblies or (when his turn to serve on its Council came up by rotation) its Council meetings. In 1838 the only meetings he missed were two consecutive Assemblies (16 August and 6 September) and two consecutive Council meetings (16 and 29 August).[20] Neither his sketchbooks nor his correspondence offer any clues to his whereabouts between 16 August and 20 October, when he next attended a Royal Academy Council meeting. He may well have been abroad. It had become his custom to travel on the Continent in search of fresh material during August and September; a short note to a friend on 2 August 1839 announces 'I am now on the Wing for the continent...',[21] and in a letter of 1846 he refers to 'my Summer's usual trip abroad'.[22] If he was not abroad, travel in Britain – or illness – may have prevented him from attending the Royal Academy meetings on 6 September and later. The only clue to Turner's whereabouts in September 1838 so far known is a pen and ink silhouette portrait of him, said to have been 'taken on board the *City of Canterbury* steamboat 23 September 1838'.[23]

Turner did not need to witness the subjects he painted. His greatest paintings are works of imagination rather than reality. He did not witness 'Dido building Carthage', 'Ulysses deriding Polyphemus' or 'Hannibal crossing the Alps'; but because 'The Fighting Temeraire' is (in prosaic terms) a modern marine subject, it was and is generally assumed that Turner must have painted it with the same degree of accuracy that most contemporary marine painters brought to their subjects. Turner had painted 'A First Rate taking in Stores' in 1818 for Walter Fawkes in the middle of Yorkshire (PLATE 6; and see p. 70). His knowledge of shipping by 1838 was sufficient for him to represent a man-of-war (especially such

a ghostly man-of-war as his 'Temeraire') without having to observe it on the spot.

Newspaper reports that the *Temeraire* had been sold out of the Navy to be broken up (see p. 45) were probably enough to fire Turner's imagination, making him want to create in paint a scene which in all probability he never saw. The *Temeraire*'s association with Nelson at 'gory Trafalgar', the battle which Turner had painted in 1806 (PLATE 10) and again in 1823 (PLATE 11), the battle whose 'thundring cannon' and 'crippled ships' he had attempted to commemorate in verse in his 1811 sketchbook, would have remained in Turner's mind without the prompting of newspaper reports; he may also have been one of the crowds who (according to *The Times*) flocked to see the *Temeraire* being slowly broken up at Rotherhithe.

Turner was certainly in London and on the spot, with a sketchbook, for the most sensational spectacle of the 1830s, the great fire which destroyed the old Houses of Parliament during the night of 16–17 October 1834. The crowds who watched the sight were so vast that the army was called in to help the police in controlling them. Turner, one of the crowd, is known to have witnessed the fire from a boat on the river, evidently also exploring different viewpoints on foot. The pencil notes he made during that hectic night are slight; but his concentrated observation of the raging of the fire later found expression in a range of intensely dramatic work. Turner's large watercolour 'The Burning of the Houses of Parliament' (PLATE 52) comes closest to an eye-witness record of actuality:

52 *'The Burning of the Houses of Parliament', 1834. Watercolour and bodycolour with scraping out and stopping out on paper, 30.2 x 44.4 cm. Turner Bequest: London, Tate Gallery. The fire which destroyed the old Houses of Parliament during the night of 16-17 October 1834 drew vast crowds. Turner is known to have spent part of the night watching the fire from a boat on the river, evidently exploring other viewpoints on foot. Here he depicts the fire raging in Old Palace Yard, as if he himself were one of the crowd watching the spectacle at perilously close quarters.*

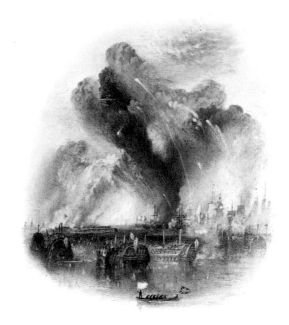

53 'The Battle of the Baltic', c.1835.
Watercolour over pencil on paper,
14 x 13 cm. Edinburgh, National
Gallery of Scotland. One of twenty
vignette illustrations to Moxon's edition
of The Poetical Works of Thomas
Campbell, 1837. Campbell's poem
'The Battle of the Baltic' celebrates the
Battle of Copenhagen, fought on
2 April 1801. Its opening lines are
'Of Nelson and the North/ Sing the
glorious day's renown'. Nelson, second
in command to Admiral Sir Hyde
Parker, famously turned a blind eye to
Parker's signals, led the fleet into battle,
and won the day. Turner depicts
plumes of gun-smoke, 'Like a hurricane
eclipse/ Of the sun.'

as the flames soar, crowds watch fire-fighters in Old Palace Yard, Westminster. Nine more generalised watercolour studies recall impressions of fire, leaping flames and their reflections on the river. Working swiftly and, as with 'The Fighting Temeraire', emphasising topicality in his titles, Turner produced two oil paintings, each entitled 'The Burning of the Houses of Lords and Commons, 16 October 1834' and exhibited the following spring. These may have encouraged a belief that Turner could document contemporary events when he chose to.[24]

Nelson's exploits were revived for Turner by a commission to illustrate Edward Moxon's edition of *The Poetical Works of Thomas Campbell*, published in 1837. Turner was asked to produce twenty watercolour vignettes[25] to illustrate sixteen poems, in a volume whose highly dramatic subjects have been summed up as 'cataclysms, blighted passions, drowned daughters and dispossessions'.[26] One of the selected poems was 'The Battle of the Baltic', which begins 'Of Nelson and the North/Sing the glorious day's renown'; originally entitled 'The Battle of Copenhagen', it celebrates Nelson's victory over the Danish fleet on 2 April 1801. Turner's vignette (PLATE 53) shows the Danish ships 'like leviathans afloat' in the foreground. Nelson had held his fire until 'ten of April morn by the chime'; then it rained down. The lurid plumes of gun-smoke ascending into the bright morning sky in Turner's vignette may illustrate an image from Campbell's poem (verse III) which would particularly have interested Turner:

> 'Hearts of oak!' our captain cried; when each gun
> From its adamantine lips
> Spread a death-shade round the ships,
> Like the hurricane eclipse
> Of the sun.

Turner worked on his vignettes for Campbell during 1835–6; the illustrated edition was published in 1837. One of Campbell's best-known poems – 'Ye Mariners of England', subtitled 'A Naval Ode' – was not selected for illustration (only a

quarter of the poems in the book were illustrated); but it was from its opening verse that Turner was to adapt lines to append to the title of 'The Fighting Temeraire' when he exhibited the picture in 1839. Campbell's verse reads:

*Ye Mariners of England!*       *And sweep through the deep,*
*That guard our native seas,*      *While the stormy winds do blow, –*
*Whose flag has braved, a thousand years,*    *While the battle rages loud and long,*
*The battle and the breeze –*       *And the stormy winds do blow.*
*Your glorious standard launch again*
*To match another foe!*

Campbell uses the word 'Mariners' (with a capital M) to mean England's guardian ships of the line, past and present, which have swept through the deep 'a thousand years' under the flag of the Royal Navy. When he exhibited 'The Fighting Temeraire' at the Royal Academy in 1839, Turner was to adapt the third and fourth lines of Campbell's verse to underline the fact that once the *Temeraire* had been sold out of the Navy, that flag no longer 'owned' her.

<p style="text-align:center">&&&</p>

*Her day now draweth to its close,*
*With solemn sunset crowned;*
*To death her crested beauty bows,*
*The night is folding round,*
*Our good ship Temeraire;*
*The fighting Temeraire!*
*She goeth to her last long home,*
*Our grand old Temeraire.*

GERALD MASSEY, 'The Fighting Temeraire tugged to her last berth', 1861[27]

Turner's decision to make a painting out of the subject of the 'The Fighting Temeraire' must have been swift. He may have begun work on it in the autumn of 1838. No preliminary sketches or studies for it are known.[28] His finished picture was shown in the next Royal Academy exhibition, which opened on 6 May 1839, exactly eight months after the *Temeraire* herself had been 'tugged' to her 'last berth'. But Turner is unlikely to have worked uninterruptedly on 'The Fighting Temeraire'. He had four other paintings to get ready for the 1839 exhibition: the contrasting pair 'Ancient Rome: Agrippina landing with the Ashes of Germanicus'[29] and 'Modern Rome – Campo Vaccino',[30] 'Pluto carrying off Proserpine'[31] and 'Cicero at his Villa',[32] each about 99 x 120 cm, approximately the same size as 'The Fighting Temeraire'; he may also have been reworking a much larger picture (140 x 200 cm) which he entitled 'The Fountain of Fallacy',[33] for the British Institution exhibition which opened in February 1839.

The force of feeling which Turner poured into 'The Fighting Temeraire' is abundantly evident. In his full title, 'The Fighting Temeraire tugged to her last berth to be broken up, 1838', almost every word is carefully selected and charged with emotion. 'Fighting' as an accolade for the *Temeraire* seems to have been Turner's own invention, but would have made immediate sense to anyone who

recalled the part the *Temeraire* had played at Trafalgar ('She came to Nelson's aid/The battle's brunt to bear', in the words of a popular song inspired by the picture). 'Tugged to her last berth' is an obviously emotional phrase, but it may be noted that Turner appears to have been a pioneer of the word 'tugged' (in the sense of 'towed by a tug'); his title is the first usage of the verb in this sense quoted in the *Oxford English Dictionary* (1971 edition). Below the title of the painting in the Royal Academy exhibition catalogue, Turner appended his own adaptation of lines from Campbell (already quoted here) to emphasise the sadly altered status of the once 'Fighting' *Temeraire*. Turner's inclusion of the date '1838' in his title deliberately draws attention to the recent nature of the event; while his picture hung in the Royal Academy (and for some time afterwards), the *Temeraire* herself could be seen by visitors to the ship-breaker's wharf at Rotherhithe.

*&&&*

*She goeth to her last long home,*
*Our grand old Temeraire*
GERALD MASSEY, ibid.

Turner depicts the *Temeraire* with her three lower masts in, partly rigged; but her sails are furled, and she moves with no power of her own. Her progress behind the tug's busy paddle-wheels is eerie, hardly displacing the water. Even more subtly, Turner conveys a sense of silence within the empty ship. Once she held some 750 men, and the air was loud with shouts, oaths, the whistles of command, 'the wind in the cordage and the wash of the sea';[34] now we sense that she moves soundlessly.

The *Temeraire*'s masts in Turner's image of her preserve much of her dignity; as she approaches, she might seem at first glance to have as much presence as the approaching man-of-war in the background of 'A First Rate taking in Stores' (PLATE 6). Turner relies largely on colour to inform us that the *Temeraire* is in fact a doomed ship, unreal and already ghostly. Her own black and yellow paint is nowhere visible; in Turner's eyes, the entire ship has taken on the pale gold of a vision. Deliberately, he does not try to give distinctness to more than a few details of the ship. He defines the curves of her bows, and the catheads on either side behind which her anchors are stowed. A few dark, sketchy brushstrokes along her side are enough to indicate her build and her now empty gunports – the foremost of them open, but only to the breeze.

A closer look shows that Turner has concentrated on one specific area of the *Temeraire* in which to symbolise the change which has overtaken the whole ship. This is most easily understood if a detail from Turner's picture (PLATE 54) is compared with a detail of the same area in the prisoner-of-war model of the *Temeraire* (PLATE 55). Both details show the area immediately above and below the bowsprit cap, itself clearly visible in Turner's picture as a wooden rectangle fixed to the point where the bowsprit (the strong spar angled forward over the bow) is extended upwards by the jib-boom. Fixed below the bowsprit cap is a perpendicular spar called the dolphin striker, which once supported stays to carry the rigging forward;

54                                          55                                                    56

Turner shows it hanging loose, its function gone, its lower end broken. The model of the *Temeraire* (PLATE 9, pp. 26–7), if studied in its entirety, illustrates the intricate interdependence of masts, yards and stays in a fully rigged ship; a detail shows the position and function of the dolphin striker in that overall pattern. The broken, useless spar in the forefront of the *Temeraire* epitomises the fact that the formerly complex, purposeful and beautiful design of the ship's rigging has been violated.[35]

But the most telling detail in the picture of the ship is a vacant space. A jackstaff would formerly have been fixed to the top of the bowsprit cap; it is now missing. When in harbour – and she had been in harbour for 26 years – the *Temeraire* would have flown the red, white and blue union flag from her jackstaff, as E.W. Cooke shows it in his watercolour of the *Temeraire* at Sheerness, painted five years earlier (PLATE 56). From the moment that she was sold out of the Navy, the *Temeraire* could no longer fly the flag. Where the union flag once flew, the tug's smoke now ascends. The full poignancy of the lines Turner adapted from Campbell can now be understood:

> *The flag which braved the battle and the breeze,*
> *No longer owns her.*

The angle at which the tug's smoke is emitted is crucially important in making this point. It must belch out from a funnel sufficiently far forward and sufficiently tall for the smoke to be seen as fiery as it leaves the funnel, and seemingly still acrid as it pours backwards over the bowsprit cap and through the *Temeraire's* masts. To achieve this effect, Turner ignores all contemporary steamer designs – and all his own first-hand observations of steamers – by placing the funnel foremost in the tug, in front of its mast (the standard design for a working steamer or tug is most clearly shown in the model of the *Monarch* (PLATE 23), in which a

'The flag which braved the battle and the breeze/ No longer owns her.' Details illustrating Turner's representation of the Temeraire's disarray after she had been prepared for sale out of the Navy.

54  Detail from 'The Fighting Temeraire'; Turner shows that the jackstaff from which the Temeraire formerly flew the union flag is missing (compare Plate 56). He also shows that the dolphin striker projecting downwards from the bowsprit cap, which once helped to carry the rigging forward, is now broken, and hangs uselessly.

55  Detail from the prisoner-of-war bone model of the Temeraire (Plate 9). This shows the place and function of the dolphin striker in the fully rigged ship; through it passed the martingale stay which braced the jib-boom, or bowsprit's extension.

56  Detail of the jackstaff and union flag from E.W. Cooke, 'The Temeraire stationed off Sheerness' (Plate 18); the detail is printed in reverse here for easier comparison with Plates 54-5. The complete picture depicts the Temeraire during the long years of harbour duties when, correctly, she flew the union flag from her jackstaff.

57 'The Magnificent Steam Ship The Great Western'. Aquatint, printed in colour with additional colouring by hand, image 46.5 x 69.5 cm, by R.J. & A.W. Reeve after Joseph Walter, published 1840, 'In Commemoration of the Establishment of Steam Navigation between Great Britain and America'. Bristol Museums and Art Gallery. Designed by Isambard Kingdom Brunel for the Great Western Steamship Company of Bristol, SS The Great Western, 1,340 tons, was 236 ft long, 59.8 ft broad over her paddle-boxes. In April 1838 she crossed to New York in fifteen days, but just missed the honour of being the first steamer to cross the Atlantic because a rival company chartered SS Sirius, half her size, to 'race' her; starting four days earlier, Sirius arrived a few hours earlier. The Great Western's crossing in 1838 inaugurated transatlantic passenger, mail and freight services by steam.

single mast is placed foremost, with the funnel aft of the paddle-boxes; in 'Staffa', too (PLATE 48), the steamer's mainmast is visible well in front of its funnel). Turner's 'mistake' in placing his tug's funnel before its mast is evidently deliberate: R. C. Leslie perceived it to be Turner's 'first, strong, almost prophetic idea of smoke, soot, iron and steam, coming to the front in all naval matters'.[36] (To Turner's annoyance, the positions of the tug's funnel and its mast were to be 'corrected' by J. T. Willmore in his engraving of 1845.) Arguments over Turner's alleged 'mistakes' over the position of the tug's mast and the direction of his sunset were revived nearly forty years after the exhibition of his painting, and have hardly ceased (see pp. 92–3).

A white flag with indecipherable emblem or lettering flies from the tug's exaggeratedly tall mast;[37] conspicuously higher than the *Temeraire*'s masts, it makes the absence of any flag on the *Temeraire* more pitiable. The tug itself (with figures of a few members of her crew indicated within it) is oddly bulbous, compared with the model of the *Monarch* and with drawings made to her known dimensions (64 ft 10 in. long and 13 ft 11 in. in the beam).[38] No dimensions of the *Samson* and the *London* (which actually towed the *Temeraire*) have been traced, but both tugs are likely to have been of similarly long and slender design, and to have resembled (for instance) the small steamboats working alongside *The Great Western* in 1838 (PLATE 57). It should be noted that although her funnel emits a good deal of fiery

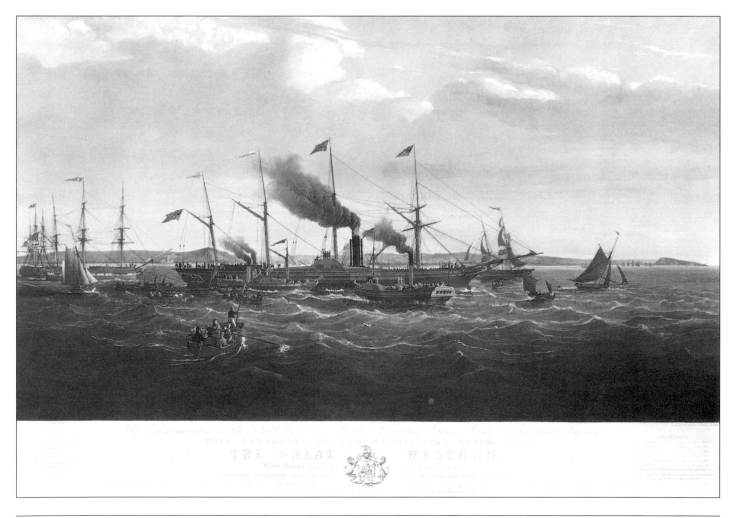

smoke, the tug is moving sedately; Turner would have realised that a small tug charged with the task of towing a huge inert weight safely up-river could not prudently – or possibly – have moved at great speed. Thornbury for once got this right, describing the tug as performing her task 'gently and lovingly', a phrase that bears out Turner's image. He shows the water churned from the tug's paddle-wheels as energetic; but the actual ripples beneath her prow are slight. Though some critics were to see the tug as 'a little, spiteful, diabolical steamer', proceeding with 'such malignant alacrity as might befit an executioner',[39] Turner's own attitude to the tug may be more ambiguous. He makes as much as he can out of the contrast between the two vessels, and the manner in which he does so means that our sympathies and his own lie with the *Temeraire*; but it is by no means certain that Turner himself thought of the tug as 'spiteful' or 'malignant'. He may rather have seen the tug as the agent of the times; not noble, like the *Temeraire*, but not necessarily ignoble; like the 'Staffa' steamer and many others that Turner himself had travelled on, trailing smoke rather than clouds of glory, but nevertheless efficient, of practical use and by now a part of modern life. The tug's black funnel may trumpet the supremacy of steam; but the colours with which Turner paints the tug itself are by no means ugly, and the fact that it too catches the sunset glow may suggest that it will also be transient. A little behind the tug, seemingly sailing in convoy, as in the group of vessels in 'Between Quilleboeuf and Villequier', is a commonplace Thames barge with a white sail. A critic for *The Times* in 1856 identified this as a 'dung barge' (for transporting manure). If this is what Turner intended, then further insult to the former ship of the line lies in the fact that she must now keep company with such a vessel.[40]

A magnificent sunset occupies almost half the picture. In the words of the *Art-Union*'s reviewer: 'It is a glorious sunset, and we are to suppose that by the time that the glowing disk shall rest upon the horizon, the Temeraire shall have been towed into her last resting-place.'[41] Long rays from the sun seem to slant almost yearningly towards the *Temeraire*; but she must follow a differently angled course. The making of the sunset (and of the picture as a whole) is discussed on pp. 121–2; its meaning has been variously interpreted as a symbol of the end of an era, or of departed glory, or the inevitability of death. As the sun sets, a crescent moon appears. The *Art-Union*'s reviewer wrote: 'On one side is the setting sun – emblem of the aged ship...; while on the other is the young moon – type of the petty steamer – about to assume its station in the sky.' Others found this concurrence symbolic of 'the old order changeth, giving place to new' (though steamboats could hardly be considered 'new' in 1838). The simultaneous appearance in the sky of sun and moon had long interested Turner; it is also depicted in 'Modern Rome', exhibited at the same time as 'The Fighting Temeraire', with a quotation adapted from Byron:

> *The moon is up and yet it is not night*
> *The sun as yet divides the day with her.*

In the background, Turner conjures up a mysterious effect of numerous sailing-ships receding into the far distance on either side of the path of the setting sun: Thackeray was to describe them as 'a countless navy that fades away'. As their tall masts recede, a solitary steamer makes its way forward. The dark prosaic

58  *Detail of the leading tug and sailing-ship in 'Between Quilleboeuf and Villequier' (Plate 42). The whole scene shows two remorqueurs (steam-tugs) navigating a safe course for sailing-ships round a hazardous bend of the Seine. A reviewer of Turner's Annual Tour – The Seine, 1834 probably had this scene in mind when he wrote: 'The tall black chimney, the black hull and the long wreath of smoke left lying on the air, present, on his river, an image of life, and of majestic life . . .'*

shape of the buoy in the shallows on the right is indispensable in tying the vast sunset down to the shallows and bringing us back to the realisation that life must go on.

Although no studies purposely made for the picture are known, some motifs in Turner's work are in different ways related to it. The steam-tugs towing small sailing-vessels in 'Between Quilleboeuf and Villequier' (detail, PLATE 58), observed on the Seine about 1830–2, have long been recognised as suggestive of the tug towing the much larger ship in 'The Fighting Temeraire', painted some eight years later.[42] Turner may have referred back to his Seine drawing to remind himself of the relationship between a tug and its convoy, but long habits of observation of British river traffic would have given him most of the information he needed for his new picture.

The tug and the *Temeraire* are dissimilar in almost every way – in size, design, grace and age; they are related to each other only by historical accident (and an unseen cable). Such relationships between two dissimilar but closely juxtaposed

unseen cable). Such relationships between two dissimilar but closely juxtaposed forms occur in several of Turner's Seine drawings, and in some later pictures. In both variations on 'Light Towers of the Hève' (PLATES 38, 39), steamboats are seen near sailing-ships. In 'Havre: Tower of François I$^{er}$, Twilight in the Port' the steamboat depicted near a venerable tower recalls Claude's juxtaposition of a ship and tower at a harbour's entrance in 'Seaport with the Embarkation of the Queen of Sheba', a picture which entered the National Gallery in 1824 and which Turner knew well.[43] The lighthouse and windmill juxtaposed against a numinous sunset in 'Yarmouth, Norfolk' (PLATE 59),[44] a watercolour probably painted not long after 'The Fighting Temeraire', echo the Claudean motif. In 'Lighthouse and Harbour' (?Margate) of about 1832 (PLATE 60),[45] the angle at which the lighthouse is depicted on its bluff suggests a ship moving towards us. This study may have prompted ideas for the setting of 'The Fighting Temeraire'. A dark buoy in the shallows on the right foreshadows the buoy in that painting, as do the low sun (or moon) and the masts of distant shipping. In hardly more than 20 x 18 cm, the essential composition of 'The Fighting Temeraire' may be

*59 'Yarmouth, Norfolk', c.1840. Watercolour and ink on paper, 24.5 x 36 cm. Dublin, National Gallery of Ireland. Turner concentrates attention on the juxtaposition of two different shapes, those of the lighthouse and windmill, seen at sunset. Colour transforms the crumbling jetty and lapping waves in an otherwise commonplace foreground.*

60 *'Lighthouse and Harbour', c.1832. Watercolour over pencil on paper, 21.1 x 18.4 cm. Port Sunlight, Lady Lever Art Gallery. Inscribed 'Mar-' in pencil, and long known as Margate, but not positively identifiable. A closely similar study is in the Whitworth Art Gallery, Manchester; both may be general ideas for a picture, perhaps contributing to the composition of 'The Fighting Temeraire'. The angle at which the lighthouse is depicted on its jetty or bluff anticipates the angle at which the tug and the Temeraire approach; the dark buoy on the right and the low sun (or moon) above distant ships are also echoed in 'The Fighting Temeraire'.*

The Fighting Temeraire . . . is a thing to be admired,
to be wondered at, but not to be criticised.

RALPH NICHOLSON WORNUM
*The Turner Gallery,* 1875

Almost all reviewers of the Royal Academy exhibition of 1839 singled out 'The Fighting Temeraire' for praise;[46] most of them added their own interpretations of its meaning. The first to comment was the *Morning Chronicle*'s reviewer on 7 May:

*There is something in the contemplation of such a scene which affects us almost as deeply as the death of a human being. It is impossible to gaze at the remains of this magnificent and venerable vessel without recollecting, to use the words of Campbell, 'how much she has done, and how much she has suffered for her country'. In his striking performance Mr. Turner has indulged his love of strong and powerfully-contrasted colours with great taste and propriety. A gorgeous horizon poetically intimates that the sun of the Temeraire is setting in glory.*

The *Spectator* of 11 May began by acclaiming the picture because 'its poetry is intelligible', then described it as

*a grand image of the last days of one of Britain's bulwarks: the huge hulk — looming vast in the distance in the midst of a faint gleam of moonlight, that invests with a halo the ghost of her former self — is towed by a steam-boat whose fiery glow and and activity and small size makes a fine contrast with the majestic stillness of the old line-of-battle ship, like a superannuated veteran led by a sprightly boy; the sun is setting on the opposite side of the picture, in a furnace-like blaze of light, making the river glow with its effulgence, and typifying the departing glories of the old Temeraire. The colouring is magical . . .*

The reviewer for *The Athenaeum* of 11 May was so moved that he came near to apologising, half-way through his account, for his own 'fanciful mode of interpretation':

*A sort of sacrificial solemnity is given to the scene, by the blood-red light cast upon the waters by the round descending sun, and by the paler gleam from the faint rising crescent moon, which silvers the majestic hull, and the towering masts, and the taper spars of the doomed vessel, gliding in the wake of the steam-boat — which latter (still following this fanciful mode of interpretation) almost gives to the picture the expression of such malignant alacrity as might befit an executioner.*

The *Literary Gazette* the same day stressed that Turner had treated his subject 'historically and allegorically. The sun of the glorious vessel is setting in a flood of light, such as we do not remember ever to have seen represented before, and such as, we think, no one but Mr. Turner could paint'. The *Art-Union* on 15 May singled out the picture as 'perhaps, the most wonderful of all the works of the greatest master of the age', and called it 'a nobly-composed poem'.

The most often-quoted comments on 'The Fighting Temeraire' are those of William Makepeace Thackeray, then aged 28, not yet known as a novelist but earning a precarious living as a freelance journalist in Paris and London. For three years (1838–40), Thackeray contributed semi-satirical reviews of the annual Royal Academy exhibition to *Fraser's Magazine*,[47] under the pseudonym of Michael Angelo Titmarsh ('Strictures on Pictures, a Letter from Michael Angelo Titmarsh, Esq.', June 1838; 'A Second Letter on the Fine Arts by Michael Angelo Titmarsh, Esq.', June 1839, and 'A Pictorial Rhapsody by Michael Angelo Titmarsh', June–July 1840). The 'Second Letter' of 1839 (addressed to 'My dear Bricabrac') begins facetiously; but Thackeray's own deeply emotional response to the picture soon takes over:

*If you want to know what is the best picture in the room . . . I must request you to turn your attention to a noble river-piece by J.M.W. Turner, Esq., RA, 'The Fighting Temeraire' — as grand a picture as ever figured on the walls of any academy, or came from the easel of any painter. The old Temeraire is dragged to her last home by a little, spiteful, diabolical steamer. A mighty red sun, amidst a host of flaring clouds, sinks to rest on one side of the picture, and illumines a river that seems interminable, and a countless navy that fades away into such a wonderful distance as never was painted before. The little demon of a steamer is belching out a volume (why do I say a volume? not a hundred volumes could express it) of foul, lurid, red-hot malignant smoke, paddling furiously, and lashing up the water round about it; while behind it (a cold gray moon looking down on it), slow, sad and majestic, follows the brave old ship, with death, as it were, written on her . . .*[40]

61 *Detail from 'The Fighting Temeraire'. This gives some idea of the enormous bulk of the 2,110-ton Temeraire. Since she had no motive power of her own during the tow, her two 20-40 hp tugs could hardly proceed at speed. Turner has been accused of giving a fancifully 'webbed' appearance to the wooden rails around the heads (below the now missing figurehead); but comparison with Cooke's etching of Dreadnought (Plate 16), the Temeraire's sister-ship, shows that Turner has observed their design with reasonable accuracy, perhaps slightly exaggerating their curve to suggest an old ship of a past age.*

Of all the picture's contemporary critics, Thackeray most openly affirms that the painting strikes a powerfully patriotic chord. Such noble old ships, he urged, should not be sacrificed but preserved as relics for Englishmen to worship.

*Think of them when alive, and braving the battle and the breeze, they carried Nelson and his heroes victorious by the Cape of St. Vincent, in the dark waters of Aboukir, and through the fatal conflict of Trafalgar... We Cockneys feel our hearts leap up when we recall them to memory; and every clerk in Threadneedle Street feels the strength of a Nelson, when he thinks of the mighty actions performed by him.*

*It is absurd, you will say..., to grow so politically enthusiastic about a four-foot canvass, representing a ship, a steamer, a river, and a sunset. But herein surely lies the power of the great artist. He makes you see and think of a great deal more than the objects before you...*

The *Art-Union* reviewer had called the picture 'a nobly-composed poem'. Thackeray likened it to 'a magnificent national ode or piece of music', producing the same instinctive response in Englishmen as 'God Save the King': 'Some such thrill of excitement... makes us glow and rejoice over Mr. Turner and his "Fighting Temeraire".' But Thackeray reverted to his 'Titmarsh' style of facetiousness for Turner's other pictures in the 1839 exhibition ('Fancy pea-green skies, crimson-lake trees, and orange and purple grass – fancy cataracts, rainbows, suns, moons and thunderbolts – shake them well up, with a quantity of gamboge, and you will have a fancy picture by Turner.')

*Blackwood's Magazine*, usually extremely hostile to Turner's later works ('we would not purchase them for twopence the dozen'), in this case announced: 'We retract. It is very beautiful – a very poetical conception; here is genius... It is a work of great effect and feeling, and worthy of Turner when he was Turner'.[49] *The Times* considered that all Turner's exhibits in 1839 displayed 'extraordinary and extravagant colouring. They are full of imagination, but bear little or no resemblance to nature'. The *Gentleman's Magazine* alone completely ignored the picture, instead selecting Turner's 'Pluto carrying off Proserpine' for passing comment: 'No. 360:... highly poetical and less extravagant in colour than the rest... Altogether Mr. Turner is this year perhaps not quite so felicitous as usual'.[50]

<p style="text-align:center">&&&</p>

*Look at the thing that tows the venerable hulk; but for the chimney you could not resolve it into a steam-tug. We remember that when the picture was in the hands of the engraver, the latter was in the utmost embarrassment with regard to this passage in the picture, and ventured to make the thing like a steam-boat – which excited in the artist a paroxysm of wrath.*

<p style="text-align:center">THE ART JOURNAL, 1856</p>

In 1845 J. T. Willmore's steel engraving of Turner's picture was published by J. Hogarth. Instead of following Turner's own carefully-chosen title, the engraving was published as 'The Old Téméraire'.[51] Some unknown 'experts' had decided that the ship was in fact the earlier *Téméraire*, the French prize after which the *Temeraire* had been named (Thornbury claims that when the 'authentic history' of 'the French battle-ship' was known and 'the truth' was stated to Turner, 'he seemed almost in tears when he gave up his pet title, and said "Call her, then, The Old Téméraire"'[52]). The engraved title appeared to confer authority on the

62 *J.T. Willmore after J.M.W. Turner: 'The Old Téméraire'. Line engraving on steel, image 17.8 x 26 cm; first published 1845. Edinburgh, National Gallery of Scotland. Ignoring Turner's own title, the publishers have introduced French accents into the Temeraire's name. To Turner's annoyance, Willmore 'corrected' a deliberate 'mistake' in his painting. In defiance of all contemporary steamboat design, Turner placed his tug's funnel before its mast to emphasise the dominance of steam; Willmore reversed their positions. After Turner's death, the plate was altered to revert to Turner's own positioning of funnel and mast.*

French version of the ship's name; the accents persisted for over a century.

Willmore had engraved many plates after Turner, including fourteen of the *Picturesque Views in England and Wales* and several of the 'Rivers of France' series; he also engraved some of Turner's oil paintings, including 'Ancient Italy',[53] exhibited with 'The Fighting Temeraire' in 1838. Turner usually kept a close watch on his engravers' work, but in this case he seems to have left Willmore to get on with it. The engraving is a fairly pedestrian work, perhaps most interesting in its second state, before the addition of the sunset, since this indirectly reveals how immeasurably large a part the sunset plays in Turner's painting.

In the finished engraving (PLATE 62), Willmore 'clarified' many details which Turner had deliberately left indistinct. R.C. Leslie told Ruskin thirty years later that 'the rigging of the ship in this engraving was trimmed up and generally made intelligible to the engraver by some mechanical marine artist or other…the rigging is certainly not as Turner painted it'.[54] As well as extra rigging, Willmore added a crow's nest, extra gun-ports and, for good measure, cables running out through the *Temeraire's* hawseholes. No cables by which the tug could tow the *Temeraire* are visible in Turner's picture. Other changes show how the poetry of his painting is diminished by the engraver's determination to define details which Turner had chosen to leave indistinct.[55] Turner had given just enough body to several sketchy figures on board the tug to establish that it was manned by a crew. Willmore defined these figures so that they are distinctly hatted, clothed and chatting. Worse, he introduced a few figures on the forecastle of the *Temeraire*, thus prompting the nonsensical idea that these are 'the crew that navigated her up the Thames until she was taken in tow by the steam-tug'.[56] An engraving of 1885 by A. Prior expands this notion, introducing a crew of at least fifty men on the

THE OLD TÉMÉRAIRE.

63 'Calais Sands, Low Water, Poissards collecting Bait'. Exhibited RA 1830. Oil on canvas, 73 x 107 cm. Bury Art Gallery and Museum. Over long, level, still-wet sands, fisherwomen dig for lobworms at ebb-tide. As in 'The Fighting Temeraire', sunset dominates about half the picture; but this sunset is in quieter, more wistful mood. By 1830, the language of Turner's sunsets was endlessly varied and powerfully expressive.

*Temeraire*, and about thirty in the tug. Ruskin particularly disliked the manner in which Willmore broke up the surface of the water 'into sparkling ripples, a grievous mistake [which] has destroyed the dignity and value of the conception'.[57]

But Willmore's boldest alteration was to transpose the tug's funnel and its mast. This 'correction' appears to have been made without Turner's knowledge. The *Art Journal* for 1856 (quoted above) recalled that it excited 'a paroxysm of wrath' in Turner;[58] and one can see why. Willmore has shortened Turner's funnel, tamed its fiery mouth by the addition of a pie-frill and placed it well back in the tug. Turner's long plume of fiery smoke flowing back and gradually fading into the *Temeraire's* masts now becomes a short burst likely to set her masts on fire. Turner's 'paroxysm of wrath' had eventual effect, though not until after his death. When Willmore's plate was reprinted in 1851 in *The Turner Gallery* (one of sixty plates, later frequently re-issued), it had been silently altered. From 1851 on, the recorrected engraving shows the tug's funnel foremost, as Turner had painted it (and the cables have been burnished out). Willmore, whose name remained on the plate, presumably himself re-worked it – but whether he did so at Turner's insistence is not known.[59]

In a commentary on 'The Fighting Temeraire' for a reprint of thirty *Turner Gallery* plates in 1877, James Dafforne detected

*a glaring error in it, as regards the position of the sun ... A ship coming up the Thames from the Nore would have her stern nearly due east; and it is in the east that Turner has made his sun to set. By no possible wearing and tacking, even if under sail, would a vessel on a river, whose course is westerly, have the setting sun behind her. But the true points of the compass occupied no place in the artist's mind when he painted his gorgeous picture ...*

This sparked off a lively but inconclusive correspondence in *The Times* during December 1877 over the likely setting in Turner's picture, 'the true points of the compass' and the unreliability of artists.[60] Two correspondents recalled (forty years on)

having watched part of the tow. J. Hogarth (probably the print-publisher) stated that he had seen the *Temeraire* towed out of the Medway, and that 'in the numerous windings of the two rivers' (Medway and Thames), Turner 'may very well have obtained a view looking west'. 'F.C.P.' recalled watching from 'near Blackwall' as the *Temeraire* 'lazily approached, towed by one of the clumsy steamtugs of those days', and asserted that the scene was 'precisely that which Turner subsequently faithfully translated to canvas', except for the 'sky effects', where 'the painter appears to have used justifiable licence'. Continuing arguments about Turner's accuracy provoked Hind to exasperation in 1910 ('Pages and pages have been written about the picture with scornful comments that the sun and masts are in the wrong place, and I know not what else').[61] Discussing the picture in 1910, W.L. Wyllie ARA, the marine painter, saw in it 'no attempt to paint a single thing as it really appears':[62] but he was better qualified than most critics to appreciate it as a work of imagination in which reality played small part.

'Calais Sands, Low Water, Poissards collecting Bait',[63] painted eight or nine years earlier than 'The Fighting Temeraire', includes a sunset which also dominates about half the picture, but to more wistful effect. The foreground subject is mundane and timeless; at ebb-tide, fisherwomen (Turner calls them 'poissards') dig with sand-forks for lobworms, collecting them in the creels on their backs for the next day's fishing bait. Turner regards them tenderly; but his sunset (which they are too preoccupied to notice) is chiefly designed to celebrate the appeal to the painter of the long level stretch of wet sand, and to lead the eye to the dark shape of Fort Rouge on the horizon. It has the effect of translating an unsensational scene into momentary luminosity; and like the sunset in 'The Fighting Temeraire', it has been variously interpreted, most commonly as elegaic.

Within five years of exhibiting 'The Fighting Temeraire', Turner showed four paintings – 'Peace – Burial at Sea', 'War. The Exile and the Rock Limpet', 'Snowstorm – Steam-boat off a Harbour's Mouth' and 'Rain, Steam, and Speed'– which in different ways recall some of the feelings expressed in that picture.

&&&

64 *'Sun setting among dark clouds'. Watercolour on paper, 27.3 x 47 cm. Turner Bequest: London, Tate Gallery. From a sketchbook probably used in the mid-1820s, which included many other studies of sunsets, similar only in their intent observation and in the swiftness with which they were recorded. The effect of part of the sombre cloud bank seeming to be flung momentarily upwards by dying light is echoed in 'Bridge and Monument' (R 807), one of the 'Little Liber' mezzotints which Turner himself printed, as well as designed.*

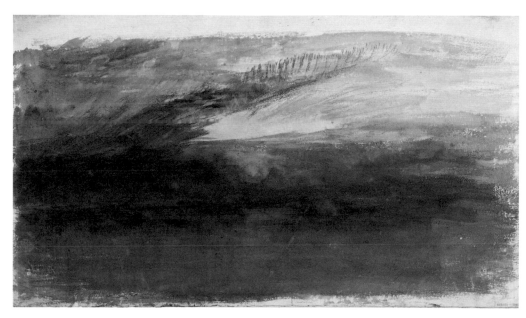

*Only one ship is seeking us, a black-*
*Sailed unfamiliar, towing at her back*
*A huge and birdless silence. In her wake*
*No waters breed or break.*

PHILIP LARKIN, 'Next, Please', 1951[64]

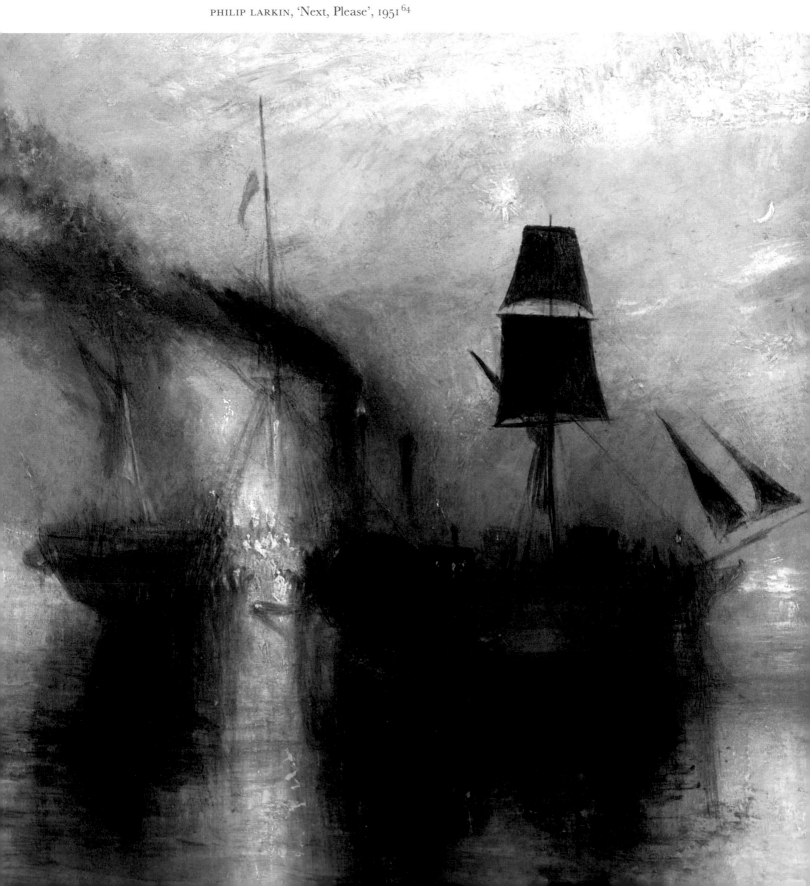

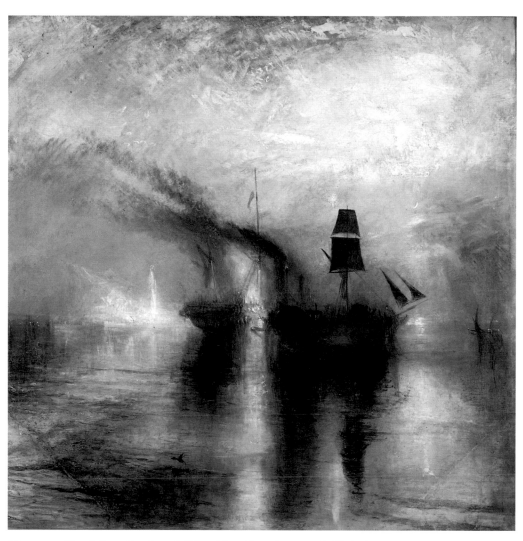

65 'Peace – Burial at Sea'. Exhibited RA 1842. Oil on canvas, 87 x 86.5 cm, corners cut. Turner Bequest: London, Tate Gallery. Turner's friend Sir David Wilkie RA, returning from a sketching tour, died suddenly on board the SS Oriental and was buried at sea in Gibraltar Bay. Turner could not have witnessed the event; his painting is created out of sorrow and imagination. When Clarkson Stanfield queried the colour of the sails, Turner is said to have replied: 'I only wish I had any colour to make them blacker.'

66 (left) Detail of 'Peace – Burial at Sea' (Plate 65). By torchlight, Wilkie's coffin is lowered into the sea from SS Oriental (ORIEN... is lettered on the paddle-box casing). The Times described Turner's steamer as 'an object resembling a burnt and blackened fish-kettle'. A black mourning carriage on the deck perhaps signifies Turner's regret that he was not himself present as a mourner. The presence of a carriage aboard a steamer is no fanciful detail (compare Plate 35). Steamboats still used sails when needed to assist steam-power.

'Peace – Burial at Sea', exhibited in 1842 (PLATE 65)[65] is in every sense a *memento mori*. The black-sailed ship depicted here is the *Oriental* steamer, seen off Gibraltar; from its decks, on 1 June 1841, the body of Turner's friend and fellow Royal Academician Sir David Wilkie was committed to the deep. Wilkie, then aged 56 and, like Turner, a traveller, had been on a sketching tour in the Middle East; having boarded the SS *Oriental* at Alexandria for the homeward journey, he fell suddenly ill, and within a few days was dead. The captain of the *Oriental* put back to Gibraltar and asked permission to bury the body ashore, but for fear of unknown contagion, 'the authorities would not allow the body to be landed'. Burial at sea was the only alternative, and the ship's carpenter hastily made a coffin. For eight hours the *Oriental* drove at 'full speed' away from Gibraltar; then her captain's log records: '8.30 p.m. In lat. 36.20 and long. 6.42 stopped engines, and committed to the deep the body of Sir David Wilkie.'[66]

Turner probably first learned of Wilkie's death and the manner of his burial through newspaper reports. *The Times* of 11 June was fairly accurate, stressing the Governor of Gibraltar's refusal to allow the body to be buried either on or anywhere near Gibraltar: 'Therefore the last sad office of committing the body to the deep was performed in the most solemn and impressive manner, as the *Oriental* stood out of the Bay on her way to England.'[67] This report was probably all Turner had – and all he needed – to determine him to commemorate his friend in the painting which he was to exhibit less than a year later under the title 'Peace – Burial at Sea'. Depicting an episode which he could not have witnessed, it was created out of sorrow and imagination. Representing the *Oriental* steamship (detail, PLATE 66) was not difficult for him; by 1841 he had travelled on many such vessels. He suggests rather than defines its build, its three masts, and the lettering of its name on the paddle-box casing (ORIEN . . . is enough for his purposes: John Cousen, who engraved the picture for *The Turner Gallery* in 1859, sharpened all such details[68]). He interprets 8.30 p.m. in June off Gibraltar, not unreasonably, as almost sunset, with no warmth left in an agitated sky. But it is one moment on which he concentrates: the moment when Wilkie's coffin is suspended by ropes above the sea, before being lowered into it. Red-gold light stronger than ship's torchlight could produce is concentrated here, as if to celebrate the achievements of the dead artist, and as if darkness will fall when his body is committed. Turner exhibited the picture with two lines written by himself:

*The midnight torch gleamed o'er the steamer's side,*
*And Merit's corse was yielded to the tide. – Fallacies of Hope*

When the picture was exhibited, *The Times* described the steamer as 'an object resembling a burnt and blackened fish-kettle'.[69] According to George Jones, Clarkson Stanfield remonstrated with Turner about the blackness of the steamer's sails, saying that the colour and effect were untrue, but Turner merely replied, 'I only wish I had any colour to make them blacker.'[70] Ruskin virtually wrote the picture off as 'Spoiled by Turner's endeavour to give funereal and unnatural blackness to the sails'.[71] These literal-minded critics do not appear to have noticed a detail noted by John McCoubrey:[72] an unmistakeable black carriage on the deck of the *Oriental*. The presence of a carriage on a steamer is no fantasy on Turner's part (several steamship companies, pioneers of roll-on roll-off, offered to transport passengers' carriages to the Continent: note the carriages aboard the *Lord Melville* steamer in Plate 35). Nor was the presence of an empty carriage on a funeral occasion fantasy; in England it had become a custom among people of rank to send their coaches to represent them at funerals. Writing to George Jones after Sir Thomas Lawrence's funeral in 1830, Turner had noted that its 'pomp' was 'swelled up by the carriages of the great, without the persons themselves';[73] he is unlikely to have forgotten this, and may have 'sent' a funeral carriage aboard the *Oriental* to represent himself, and perhaps George Jones. Jones, a friend of both Turner and Wilkie, exhibited his own watercolour version of the subject in the same exhibition.[74]

&&&

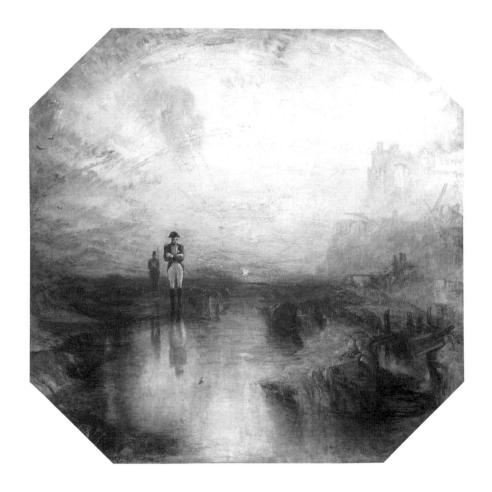

*The scourge of Europe hence exults unseen*
*In deep futurrity on this Island green...*
TURNER, 'The Fallacies of Hope' *c.*1811 [75]

*He thought to quell the stubborn hearts of oak,*
*Madman!...*
TENNYSON 'Buonaparte', 1832 [76]

67 *'War. The Exile and the Rock Limpet'. Exhibited RA 1842. Oil on canvas, 79.5 x 79.5 cm. Turner Bequest: London, Tate Gallery. Over twenty years after Napoleon's death, Turner wills him to be in perpetual exile, inhabiting a blood-red landscape, its sea shrunk to a shallow pool whose smallest visible creature, the rock limpet, has more freedom than the would-be world emperor. Instead, and in contrast with Wilkie's lonely burial at sea (Plate 65), Napoleon's ashes had six months earlier been ceremonially enshrined in Les Invalides.*

'War. The Exile and the Rock Limpet' (PLATE 67)[77] and 'Peace – Burial at Sea' (PLATE 65) are usually described as pendants, an art-historical term meaning a pair of subjects designed to be complementary or contrasting. In size and in their unusually square shape they are certainly a pair; they were both exhibited at the Royal Academy in 1842 and in choosing their titles Turner deliberately links 'Peace' with 'War'. *The Athenaeum* called them 'a pair of...provoking enigmas'. The burial at sea of a friend and fellow-artist who had died prematurely (aged 56) is not a conventional idea of 'Peace'; nor is the image of Napoleon, who died in exile in 1821, a conventional image, by 1842, of 'War'. But there is irony in Turner's titles, perhaps reflecting the fact that Napoleon's ashes had been repatriated and ceremonially enshrined in Les Invalides only six months before Wilkie's lonely death and burial at sea;[78] this, too, Turner could have read in newspaper reports.

In the Royal Academy exhibition of 1842, 'Peace' was generally admired, and 'War' derided. Both paintings remained with Turner, appropriately enough, for both are private pictures. Turner was aware that 'War. The Exile and the Rock Limpet' was 'not understood'.[79] How could it be? Turner did not spell out the meaning of his pictures, nor did he ever seek publication for his random verses 'The Fallacies of Hope', the source of the quotations for these two (and many

other) exhibited works; the public could not explore the workings of his mind there. Turner's feelings about Napoleon went back a long way: at least as far as the Battle of Trafalgar in 1805. Verses written in a sketchbook of 1811 express his deep hatred of Napoleon; though they become rather incoherent, the first two lines, quoted above, are arguably more forceful (and certainly more pictorial) than the opening of the young Tennyson's 'Buonaparte', also quoted above.

Two years after the Peace of 1815, Turner toured the site of the Battle of Waterloo, making numerous sketches; one is inscribed '4000 killed here', another '1000 killed here'. At the Royal Academy the following year he exhibited 'The Field of Waterloo',[80] which looks past the heroics of 'Battle's magnificently stern array' to the inevitable extinction which followed for many that night. The painting has been described by David Brown as a 'dark and terrible picture of women searching for their loved ones among the mingled dead – French cuirassiers and Scottish infantrymen – by the baleful light of flares'. Turner appended a quotation from Byron's *Childe Harold*: 'friend, foe, in one red burial blent!' His watercolour of the subject (PLATE 68), no less powerful, was purchased by Walter Fawkes. Later, when illustrating Sir Walter Scott's *Life of Napoleon Buonaparte*, Turner 'saw' Napoleon depart in the vignette 'The Bellerophon, Plymouth Sound' (PLATE 69): in this he reduces 'the scourge of Europe' to a tiny captive on the deck of the British man-of-war which transported him to exile on St Helena.[81] But Napoleon evidently remained in his mind as a malign image.

68 *'The Field of Waterloo', c.1817. Watercolour on paper, 28.8 x 40.5 cm. Cambridge, Fitzwilliam Museum. Oblivious of any glamour in war – splendid uniforms and spirited cavalry – Turner conveys his sense of its futility and waste. He had visited the site of the Battle of Waterloo in August 1817, making pencil sketches, some annotated, e.g. '4000 killed here', '1000 killed here'. Now he imagines a heap of corpses, taking his cue from Byron's line, 'Rider and horse – friend, foe, in one red burial blent!' The watercolour was purchased by Walter Fawkes. Turner exhibited a large oil painting of 'The Field of Waterloo' at the Royal Academy in 1818.*

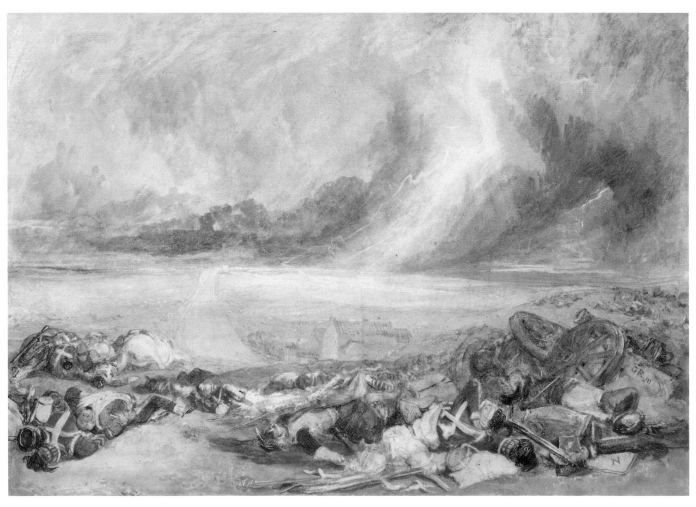

69　'The Bellerophon, Plymouth Sound', c.1833. Vignette, watercolour on paper, 13 x 10 cm. Executors of the 2nd Viscount Camrose. Designed as the final illustration to Sir Walter Scott's Life of Napoleon Buonaparte; engraved on the title-page of Vol. XVI in Scott's Prose Works, 1834-6. In 1805 the Bellerophon had fought under Nelson at Trafalgar; now she is to embark for St Helena, carrying Napoleon into lifelong exile. Turner's reverence for Nelson and his hatred of Napoleon were inter-twined. Here he portrays the 74-gun British ship in all her strength, reducing Napoleon to a tiny but recognisable figure, impotent upon her quarterdeck.

Exhibiting 'War. The Exile and the Rock Limpet', Turner appended the following lines:

> *Ah! thy tent-formed shell is like*
> *A soldier's nightly bivouac, alone*
> *Amidst a sea of blood –*
> *But you can join your comrades. – Fallacies of Hope*

The rock limpet, perhaps the smallest living creature which might be distinguishable in a blood-red picture, enjoys a freedom denied to the erstwhile Emperor. In his image of Napoleon, Turner ignores the by now stereotyped figure, corpulent and frowning, repeatedly depicted by Benjamin Robert Haydon and others; instead he depicts a wraith or spectre (Napoleon had died over twenty years earlier), less credible in substance than the limpet, but though captive, still brooding. So might Turner have painted Macbeth; indeed, in painting 'War' his mind may have been full of echoes of such lines as

> *. . . I am in blood*
> *Stepp'd in so far, that should I wade no more,*
> *Returning were as tedious as go o'er.* [82]

Ideas of sunset probably link the two pictures. In 'Peace', Wilkie's body is committed to the deep in a fading sunset of pale gleams in a soft grey sky; in 'War', the most lurid sunset Turner ever painted, sunset brings the antithesis of peace to Napoleon, intensifying his image as a man of blood. Behind Napoleon, in a prisoner-and-escort variation of Turner's juxtaposition motif, stands a British rifleman. Turner may have recalled that in life Napoleon had been particularly galled by restrictions (imposed in October 1816) on his movements after sunset ('Au coucher du soleil, l'enceinte du jardin autour de Longwood, sera regardée comme étant les limites; à cette heure, des sentinelles seront placées à l'entour...').[83] The painting, widely mocked at the time of its exhibition (*Punch* re-titled it 'The Duke of Wellington and the Shrimp'), invites at least as many possible interpretations as does 'The Fighting Temeraire'.

'Snow Storm – Steam-boat off a Harbour's Mouth' (PLATE 70),[84] also exhibited at the Royal Academy in 1842, was acclaimed by Ruskin as 'one of the very grandest statements of sea-motion, mist, and light that has ever been put on canvas, even by Turner. Of course it was not understood; his finest works never are...'.[85] The protagonist in this drama is an unidentified steamboat tossed in a snow-storm; as the rest of Turner's title states, her crew are 'making signals in shallow water, and going by the lead' (i.e. taking soundings). Turner added to the title the rather ambiguous statement 'The author was in this storm on the night the Ariel left Harwich.' Charles Ninnis suggests that Turner's inspiration may have been the devastating storm which began on 13 November 1840, sweeping the south-east coast, causing shipwrecks and loss of life;[86] local and national newspapers reported its toll for weeks afterwards. Ninnis further suggests that Turner himself may have witnessed the storm at Margate and, since no ship named *Ariel* appears to have been involved in the storm, that Turner may have had in mind the loss of the *Fairy* (misremembering its name), which had set out from Harwich the day before the storm broke, and was lost with all hands.

But while Turner's subject is 'a storm-tossed boat' in the romantic tradition,[87] it is not certainly a ship on the verge of being wrecked, as his 'Shipwreck' of 1796 is.

70 *'Snow Storm – Steam-boat off a Harbour's Mouth, making signals in shallow water, and going by the lead. The author was in this storm on the night the Ariel left Harwich'.* Exhibited RA 1842. Oil on canvas, 91.5 x 122 cm. Turner Bequest: London, Tate Gallery. Turner may have been in such a storm, but this steamboat is not thought to be the Ariel. One critic termed the picture 'soapsuds and whitewash'; but Ruskin perceived it to be 'one of the very grandest statements of sea-motion, mist, and light, that has ever been put on canvas, even by Turner'.

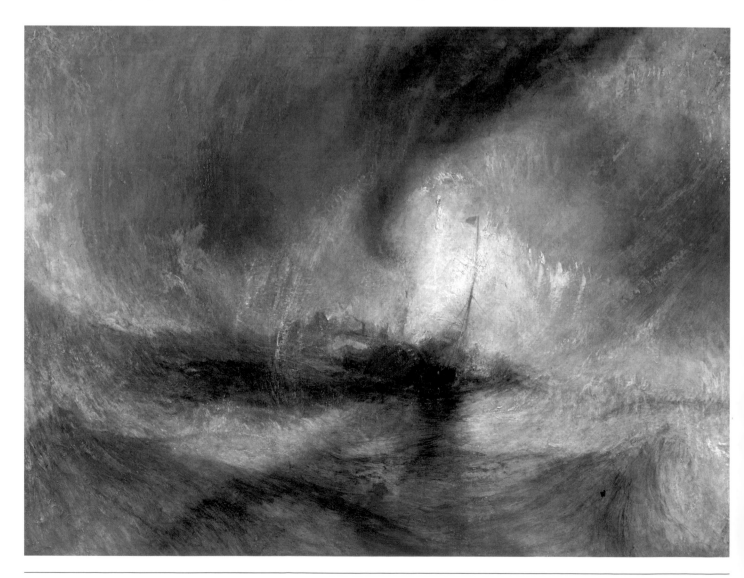

The wording of his title, '…Steam-boat – making signals in shallow water, and going by the lead' suggests that great caution is being used in a potentially dangerous situation, and in this sense, 'Snow Storm – Steam-boat…' might be seen as a pendant to the highly dramatic picture which Turner had exhibited two years earlier, 'Rockets and Blue Lights (Close at Hand) to warn Steam-boats of Shoal-Water'.[88] Superficially, Turner's image of the steamboat (especially in the more detailed engraving of his subject by Robert Brandard[89]) is not unlike 'The James Watt Steam Ship in a Storm, 23 November 1824', engraved in aquatint after J. Ross, or Joseph Walter's 'The SS *Great Western* on her Fifth Passage from Bristol to New York in November 1838',[90] weathering a violent 48-hour gale in which she maintained an average speed of three knots. By now engravings of steamboats were commonplace. It is Turner's treatment of the wild sea and the whirling snow which lifts his subject into the realm of sublime danger.

Contemporary reviewers were unkind. *The Athenaeum*'s reviewer declared, 'Where the steam-boat is – where the harbour begins, or where it ends – which are the signals, and which the author in the *Ariel* – are matters past our finding out.'[91] Ruskin noted that Turner was hurt by a criticism that the picture was nothing but 'soapsuds and whitewash': 'I heard him muttering to himself at intervals, "soapsuds and whitewash! What would they have? I wonder what they think the sea's like? I wish they'd been in it."'[92]

<div align="center">&&&</div>

*Turner…has made a picture with real rain, behind which is real sunshine, and you expect a rainbow every minute. Meanwhile there comes a train down upon you, really moving at the rate of fifty miles an hour…All these wonders are performed with means not less wonderful than the effects are. The rain…is composed of dabs of dirty putty slapped on to the canvass with a trowel; the sunshine scintillates out of very thick, smeary lumps of chrome yellow… And as for the manner in which the 'Speed' is done, of that the less said the better, – only it is a positive fact that there is a steamcoach going fifty miles an hour. The world has never seen anything like this picture.*

<div align="center">W.M.THACKERAY</div>

<div align="center">'May Gambols; or, Titmarsh in the Picture Galleries', *Fraser's Magazine*, 1844[93]</div>

'The railways have furnished Turner with a new field for the exhibition of his eccentric style', remarked *The Times* when 'Rain, Steam, and Speed' (PLATE 71)[94] was exhibited in 1844. Turner specified 'The Great Western Railway' in its title, and chose as its setting the great double-arched Maidenhead Railway Bridge built in 1837–8 by Isambard Kingdom Brunel, chief engineer to the Great Western Railway since 1833. The train is proceeding on a broad-gauge double track away from London, on a newly completed extension to the West of England; we know that the engine would have been one of the 'Firefly' class designed by Daniel Gooch, Brunel's locomotive engineer, and that although the average speed on the Great Western in 1844 was 33 m.p.h., the Great Western expresses often clocked up 55–60 m.p.h. on the long level stretch between Paddington and Swindon, on which the bridge is situated.[95] Thus we have far more 'facts' (of the kind Mr Gradgrind demanded[96]) about 'Rain, Steam, and Speed' than about the vessel and harbour in 'Snowstorm – Steam-boat off a

Harbour's Mouth', or about time and place in 'The Fighting Temeraire'. Gage stresses that 'as the title of the picture itself makes clear, Turner was painting not a view of the Great Western Railway, but an allegory of the forces of nature'.[97] As an emblem of natural speed, he painted a hare running in front of the engine (and, as Gage observes, likely to outpace the train, not be crushed by it[98]); now difficult to see in the painting, the hare is clearly defined in the engraving made by Robert Brandard for *The Turner Gallery*.[99] 'Rain, Steam, and Speed' should not be seen as a document of the Railway Age. The work of a painter now in his seventieth year who did not avert his eyes from contemporary life (Ruskin suggested that Turner chose to paint a railway engine 'to show what he could do even with an ugly subject'[100]), it is above all a masterpiece of painting and colour. The vigorous brushwork (which Thackeray had likened to 'dabs of dirty putty' and 'thick, smeary lumps of...yellow') communicates the excitement of its subject, with the landscape either side seeming to dissolve into fleeting impressions as the

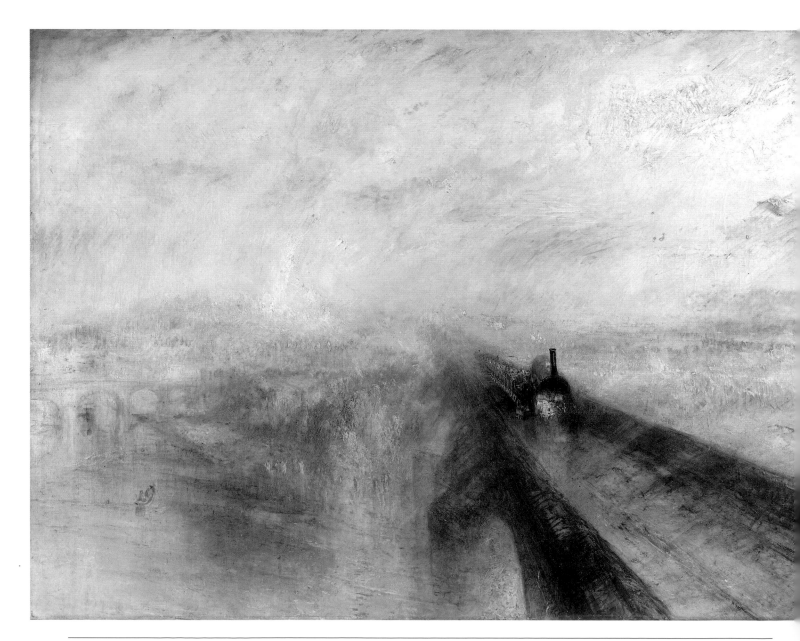

71  *(left) 'Rain, Steam, and Speed –
The Great Western Railway'.
Exhibited RA 1844. Oil on canvas,
90.8 x 121.8 cm. Turner Bequest:
London, National Gallery. The Rail-
way Age is in full progress. At a dramatic
angle, Turner depicts a passenger train
heading towards us over the Maiden-
head Railway Bridge, designed by
Isambard Kingdom Brunel for the
Great Western Railway. Brunel, the
GWR's chief engineer since 1833, pio-
neered the broad-guage track seen here.
The train is probably travelling at about
50 m.p.h. As an emblem of natural
speed, Turner shows a hare running in
front of the train. The hare, now diffi-
cult to see, is likely to outpace the train.*

72  *Detail of the tug in 'The Fighting
Temeraire'. Ignoring the conventions of
contemporary steamboat design, Turner
places his tug's funnel foremost, before
the mast, in order to emphasise the
dominance of steam and to maximise
the effect of fiery tug smoke belching
upwards and flowing backwards
through the Temeraire's masts.*

73  *Detail of 'Rain, Steam, and Speed'
(Plate 71). The engine is a reasonably
accurate portrait of the 'Firefly' class of
engines designed for the GWR by
Daniel Gooch, Brunel's locomotive
engineer. This train evidently carries
only third class passengers, who sit on
benches in open trucks; coaches were
provided for first class passengers.*

train passes. Is the engine 'ugly' or merely as serviceable as the engineers of the early 1840s could make it? Comparison between the details in Plates 72 and 73 suggest that viewed in either light, it is first cousin to the *Temeraire*'s tug.

'The Fighting Temeraire' and 'Rain, Steam, and Speed' were painted in an age of rapidly increasing mechanisation. Turner's achievements in paint in the 1830s and 1840s are contemporary with the achievements of the greatest engineer of his age, Isambard Kingdom Brunel (1806–59). The year of the *Temeraire*'s last journey was also the year in which Brunel's SS *The Great Western*, built for the Great Western Steamship Company of Bristol and the largest steamer afloat, inaugurated regular transatlantic crossings. On 17 August 1838, the day after the *Temeraire* was sold out of the Royal Navy, *The Great Western*'s arrival in New York was fully reported in the *Shipping and Mercantile Gazette*, which declared that 'The whole of the mercantile world…will from this moment adopt the new conveyance'; merchandise, mail and passengers, it confidently predicted, will all go by steam.

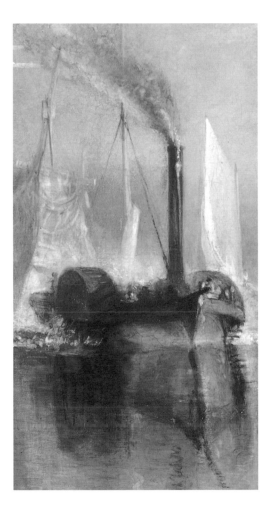

While Isambard Kingdom Brunel built bridges, steamships and railway engines, his father Marc Isambard Brunel was constructing (1824–42) the Thames Tunnel between Rotherhithe and Wapping, the first tunnel ever built under a navigable river. Repeatedly delayed by lack of funds and by disasters, work in progress from the Rotherhithe end was open to spectators in June 1838

(see advertisement, PLATE 74); the *Temeraire* passed almost above the tunnelling operations as she neared her end. Her last berth was less than a quarter of a mile away from the Engine House at Rotherhithe which provided the power to drain the tunnel; while the *Temeraire* was breaking up, visiting the shaft at the tunnel's start offered a competing attraction for crowds of visitors. Sir Marc Brunel's Engine House at the Rotherhithe end still stands; East London Underground trains go through his tunnel (wait for the slight downward lurch as your train enters the tunnel). The Thames Tunnel was formally opened by Queen Victoria in 1843, by then beginning the seventh year of her reign.[101]

On 27 September 1825 Stephenson's *Locomotion* engine hauled the first steam train on any public railway in the world. The *Rocket* which officially opened the Liverpool–Manchester railway line in 1830 ran over William Huskisson MP, but this fatal disaster did not stop railways rapidly spreading their network throughout Britain. The London–Birmingham railway was built between 1834 and 1838. The Great Western Railway, hailed by a contemporary as 'the most gigantic work not only in Great Britain, not only in Europe, but in the entire world', for which Brunel boldly chose the broad seven-foot gauge, was over 200 miles long by the time Turner's passenger train passes over it in 'Rain, Steam, and Speed'.[102]

Share offers tempted countless individuals into backing 'progress' (and accept-

74 *Broadsheet issued by the Thames Tunnel Office, September 1839, 41 x 26 cm (upper half reproduced). London, Guildhall Library. The public is invited to view the progress of the Thames Tunnel, under construction between Rotherhithe and Wapping: entrance near the church at Rotherhithe, admission one shilling. While the Temeraire was being broken up at Beatson's wharf only a quarter of a mile away, the tunnel ('brilliantly lighted by gas') offered a rival attraction to Rotherhithe visitors. Designed by Marc Isambard Brunel, begun in 1824 and completed in 1842, the Thames Tunnel was the first tunnel ever built under a navigable river. The broadsheet illustrates the iron 'shield' in whose cells miners doggedly excavated beneath the Thames; as the shield inched forward, bricklayers followed to construct the tunnel's arches.*

## THE THAMES TUNNEL,

### IS OPEN TO THE PUBLIC EVERY DAY (except Sunday) from Nine in the Morning, until dark.

Admittance 1s. each. The Entrance is near the Church at Rotherhithe, on the Surrey side of the River, and the Tunnel is brilliantly lighted with Gas.

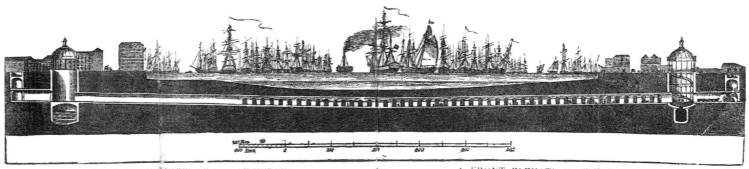

PERSPECTIVE VIEW OF both ARCHWAYS.          A FRONT ELEVATION OF THE SHIELD.

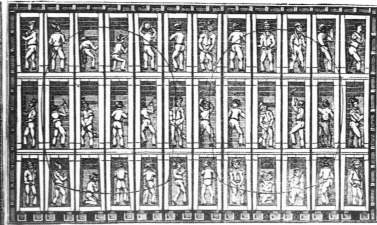

ing its risks). John Beatson, the moderately successful Rotherhithe ship-breaker, for instance, owned shares in the London Gas Company, the Deptford, Rotherhithe & Bermondsey Gas & Light Company and the Margate & London New Steam Packet Company, as well as in the Thames Steam Towing Company, from which he hired tugs to tow the *Temeraire*. Turner preferred to invest his own pretty considerable fortune in 'the funds', Government stock.

Political unrest was widely evident during 1838; as the *Annual Register* put it in September 1838, 'a very uneasy spirit began to display itself among the "working classes"'. The People's Charter drawn up by The Working Men's Association demanded such reforms as manhood suffrage, vote by ballot, annual parliaments and payment of members. Its supporters, soon known as the Chartists, held public meetings; one of the first, styled the Great Meeting of the London Radical Reformers and held in Palace Yard, Westminster, on 18 September 1838, was dismissed by the *Annual Register* as 'furious nonsense', but later meetings in the Midlands led to riots. Under the leadership of Richard Cobden, Anti-Corn Law Leagues were established in Manchester and London in 1838–9.

In 1839, the year in which Turner exhibited 'The Fighting Temeraire' at the Royal Academy, Cézanne was born. Wilkie exhibited 'Grace before Meat', Francis Grant 'The Melton Hunt Breakfast' and Landseer 'Dignity and Impudence'. In Paris, at the Salon, Delacroix exhibited 'Hamlet and Horatio at the Graveyard'. W. H. Fox Talbot produced a photographic negative and Daguerre perfected the 'daguerreotype'. Berlioz published his *Grande Messe des Morts*; Chopin composed his *24 Preludes* (Op. 28). Charles Dickens's *Nicholas Nickleby* came out in book form (it had been serialised the previous year), Stendhal published *La Chartreuse de Parme* and Charles Darwin published his *Journal of Researches into the Geology and Natural History of the Various Countries visited by H.M.S. Beagle*. Queen Victoria offered marriage to Prince Albert; the first Grand National was run; the Eglinton Tournament was rained off. The pedal bicycle was perfected and the London–Birmingham Railway (112 miles) was opened. Like any year in any age, it was heterogeneous (far more so than can be suggested here); but undoubtedly it belonged to the era of steam.

&&&

*No considerations of money or favour can induce me
to lend my Darling again...*
Draft of a letter from J. M. W. Turner to anon, undated

Turner had no wish to part with 'The Fighting Temeraire'. He had lent the painting (for a fee) in 1844 to the print-publisher J. Hogarth, publisher of Willmore's engraving, and it was publicly exhibited in Mr Hogarth's premises, 60 Great Portland Street, in September 1844.[103] At some later date, Turner was evidently again approached, perhaps by his patron Elhanan Bicknell, who was involved in financing print-publishers, for the loan (or perhaps renewal of the loan) of his painting. The only record of his reply is a draft of an unfinished letter, written in pencil (PLATE 75) in a small sketchbook of about 1845;[104] imperfectly legible, it appears to read:

*Dear Sir*

>*I have receiv[e]d your note at last via Margate and am so ill that [I] despond to write*

>*I differ most materially with you – and no consid[eratio]ns of money or favour can induce me to lend my Darling again*

>*Untill I have my 50 Proof India before the letters, we are two –*

'My Darling' almost certainly refers to 'The Fighting Temeraire'. Having lent it once for the purposes of Willmore's engraving, Turner was not disposed to lend it again, or certainly not until his material reward for lending it (including 50 proofs of the engraving on India paper) are guaranteed. It became the custom to castigate Turner for striking a keen bargain for the use of his work: but since print-publishers hoped to profit from it, why shouldn't he?

Turner appears to have made little or no attempt to sell 'The Fighting Temeraire'. The picture was the size for which he might have charged 200 or 250 guineas.[105] Thornbury (unreliably) quotes 'a correspondent' who called on Turner and 'urged him *again and again*' to accept a cheque for 300 guineas, but could not induce him 'either to accept my offer, or to put *any price* upon the Temeraire'.[106] C.R. Leslie, who in 1845 had arranged the sale of 'Staffa' (PLATE 48) to his fellow-American Colonel James Lenox (for £500) records that Lenox also tried to buy 'The Fighting Temeraire'; this was presumably in 1848, when Lenox called on Turner with the dealer Thomas Griffith and reputedly offered him £5,000, and then a blank cheque, for the picture. Leslie records that by then Turner had determined not to sell it, and that he 'refused large offers for his "Temeraire", because he intended to leave it to the nation'.[107] In a draft codicil of about 1846–9 to his will, Turner entertained the idea of leaving each of his executors the 'choice of a Picture 3 feet by 4 feet excepting. Temeraire. Port Ruysdael',[108] but evidently thought better of it.[109]

Meanwhile his 'Darling' remained in his own gallery in Queen Anne Street, frequently included among the 24 or so pictures usually on display there. A memorial picture of Turner's gallery, painted perhaps a year after Turner's death by George Jones, his old friend and one of his executors, clearly shows 'The Fighting Temeraire' propped against the wall on the left (PLATE 76), below 'The Tenth Plague of Egypt'.[110] Lady Trevelyan, who visited the gallery in about 1844, recalled that

*on faded walls hardly weather tight – and among bits of furniture thick with dust like a place that has been forsaken for years, were those brilliant pictures all glowing with sunshine and colour – glittering lagunes of Venice foaming seas and fairy sunsets, all shining out of the dirt and neglect as if they were endless – the great Carthage at one end of the room – and the glorious Temeraire lighting up another corner – & Turner himself careless & kind and queer to look upon … The Man & the place were so strange and so touching no one cd forget who had ever seen & felt it.*[111]

Lady Eastlake also saw the picture hanging there in 1846, noting 'The Temeraire a grand sunset effect…'.[112] The figure in George Jones's picture is presumably Turner himself, showing his pictures to lady visitors without great enthusiasm, and keeping a beady eye open for their well-meaning interference: when Lady Eastlake offered her cambric hankerchief to rub out 'sundry spots' on 'The Wallhalla', 'the old man edged us away, and stood before his picture like a hen in a fury'.

75 *Draft of an unfinished letter from Turner, c.1845, refusing to lend a painting – almost certainly 'The Fighting Temeraire' – to an unidentified engraver or print-publisher. MS, pencil, on the verso of the first leaf of a small sketchbook, 11.2 x 7 cm. London, British Museum. The message of the second sentence is very clear; it reads: 'I differ most materially with you – and no consid[eratio]ns of money or favour can induce me to lend my Darling again.'*

*76 George Jones RA (1786-1869): 'Lady Visitors in Turner's Gallery', c.1851-2. Oil on millboard, 14.4 x 22.6 cm. Oxford, Ashmolean Museum. George Jones, one of Turner's oldest friends (and one of his executors), probably painted this shortly after Turner's death. The gallery is in Turner's London house, 47 Queen Ann Street, where he habitually showed about twenty paintings hanging on or propped up against dark red walls. 'The Fighting Temeraire', usually among those on view, is shown here leaning against the wall on our left, below 'The Tenth Plague of Egypt'. The male figure may represent Turner himself.*

Turner died on 19 December 1851, specifically leaving two paintings – 'Dido building Carthage' and 'Sun rising through Vapour' – to the National Gallery, on condition that they should hang next to Claude's 'Seaport with the Embarkation of the Queen of Sheba' and 'The Mill' ('Landscape with the Marriage of Isaac and Rebekah'); they still hang together. He also left his 'finished pictures' to the nation, on condition that they should be housed within ten years in a building to be added to the National Gallery and to be called 'Turner's Gallery'; and he made provision for the foundation of almshouses for 'decayed artists', to be called 'Turner's Charity'. The complex questions posed by his last will and by its codicils are referred to here in Neil MacGregor's Foreword, and have been discussed at length elsewhere.[113] Turner's will was contested by his relatives and became the subject of litigation over the next four years. The dispute was eventually resolved by an out of court settlement, confirmed by a decree of the Court of Chancery, 19 March 1856, whereby the nation (in effect the National Gallery) was deemed to be the heir of all paintings and drawings by Turner which had remained with him at his death, whether finished or unfinished. The National Gallery Trustees had reckoned on a bequest of 100 finished oil paintings; they now found they were to receive not only 100 'finished pictures' but also 182 'unfinished pictures' and 19,049 'drawings and sketches in colour and in pencil'. Turner's relatives (to whom he had left nothing) got the bulk of his fortune in the

funds and any works not by Turner himself (including engravings after his works). The provision for 'Turner's Charity', represented in the dispute by the Attorney-General, was ruled out on a legal technicality, but in recognition of Turner's generous intentions towards needy artists, £20,000 was allotted to the Royal Academy.

'The Fighting Temeraire' officially entered the National Gallery's collection in September 1856. In fact, with the rest of the works which were to be known as the Turner Bequest, it had already been held in safe-keeping in the National Gallery for two years. While litigation took its labyrinthine course, Turner's executors and the National Gallery staff were equally concerned that Turner's works would suffer by remaining in the damp and dusty conditions of his empty house, 47 Queen Anne Street.[114] With legal blessing, it was agreed that all his works – over 280 paintings and over 19,000 drawings and watercolours – should be moved for safety from Queen Anne Street to the National Gallery. This massive move, presumably effected by a fleet of horse-drawn vans (no bills for transport survive), took place between 31 August and 7 October 1854. Turner's works were then kept under lock and key in three empty ground-floor rooms in the National Gallery; by a gentleman's agreement, his executors held one set of keys, the National Gallery the other. After the Court of Chancery's decree, only one small piece of business remained to be transacted before what now became known (perhaps inaccurately) as the Turner Bequest could pass into the control of the Trustees of the National Gallery: the Trustees had to reimburse Turner's executors for half the carrier's bill for transporting Turner's works to the National Gallery. On 25 September 1856 a Treasury official was hastily despatched to Trafalgar Square with £181.10s. That day it fell to Ralph Nicholson Wornum, Keeper and Secretary of the National Gallery, to hand over this sum, to receive in return the key held by Turner's executors and to unlock the Turner Bequest for posterity. With the careful suppression of excitement proper to the true civil servant, Wornum noted in the margin of his report: 'Turner Collection delivered over to the Trustees'.[115]

The National Gallery curatorial staff – there were only two of them, the Director, Sir Charles Eastlake, and the Keeper, R. N. Wornum – had already examined the works; now they began the business of accession and display. While Ruskin volunteered to select the first hundred watercolours for exhibition,[116] Eastlake and Wornum selected paintings in good enough condition to be hung at once and those which needed conservation and reframing. 'The Fighting Temeraire', which Turner had once called 'my Darling', now became NG 524. As it was in exceptionally good condition, it was scheduled to hang in the first group of Turner oils to be shown. But there was no room to hang the Turners in the National Gallery. The Trafalgar Square building, shared by the National Gallery and the Royal Academy until the Academy moved to Burlington House in 1868, was bursting at the seams; neither institution had enough space. Robert Vernon's gift in December 1847 of 157 British paintings and seven sculptures[117] had quadrupled the National Gallery's holdings of British works, and there had been other gifts and bequests. A Gallery 'outhouse' was urgently needed. A temporary solution was offered in Marlborough House, Pall Mall (not far from the National Gallery, and largely vacant since the death of Queen Adelaide in 1849). From 1850 to 1859 the Vernon Gift and the Gallery's

other modern British pictures were shown there, in rooms which became known as the Vernon Gallery.

It was in those rooms that the National Gallery first exhibited works from the Turner Bequest. Independently, Ruskin published *Notes on the Turner Gallery at Marlborough House, 1856*, which was in such demand that it was reprinted five times before the end of 1857. Ruskin saw 'The Fighting Temeraire' as the last work in 'Turner's period of central power, entirely developed and entirely unabated', a period which he dated as 1829–39.[118] He then drew parallels between 'Ulysses deriding Polyphemus', exhibited in 1829 (NG 508) and 'The Fighting Temeraire', exhibited in 1839. As well as drawing the fairly obvious contrasts between 'Ulysses', a picture of sunrise and of a ship 'entering on its voyage', and the 'Temeraire', a picture of sunset and 'of a ship closing its course for ever', Ruskin saw both pictures as unconsciously illustrating Turner's own life at the beginning and end of the decade, with 'Ulysses' reflecting his 'life in its triumph' and the 'Temeraire' his 'life in its decline'. Going further, Ruskin suggests that Turner is himself 'the old "fighting Temeraire"... returning to die by the shore of the Thames: the cold mists gathering over his strength, and all men crying out against him...'; but this fancy seems largely to derive from Ruskin's belief that Turner's powers declined after 1839.

Within six weeks of the nation's final inheritance of the Turner Bequest, twenty of his paintings were hanging in the upper apartments of Marlborough House. They were arranged chronologically, from 'Moonlight, a Study at Millbank', exhibited in 1797,[119] to 'The Sun of Venice going to Sea', exhibited in 1843.[120] The Turner display in Marlborough House prompted two different sorts of reaction: first and foremost, more openly expressed admiration for Turner's works than had generally been given to them in his lifetime ('Time is developing Turner most satisfactorily – age is maturing and mellowing his works', declared the *Art Journal*[121]) and, secondly, insistence that more space was needed for the National Gallery to display its pictures.[122] *The Times*'s reviewer on 10 and 13 November (almost certainly Tom Taylor, dramatist and editor of *Punch*) devoted several columns to 'The Turner Gallery at Marlborough House',[123] singling out two pictures as of 'a different class of excellence from all the rest': one was 'Childe Harold's Pilgrimage', the other 'The Fighting Temeraire', the ship herself being described as 'an emblem of greatness in decline, borne to its end by restless, fuming, fretting forces, which it cares not to resist and is too great to question'.

By the spring of 1857 between sixty and seventy paintings by Turner were on display in Marlborough House. But within two years the National Gallery had to give up its rooms there, since Marlborough House was to become the residence (upon his eighteenth birthday) of the Prince of Wales. Another relay of horse-drawn vans drew up outside the National Gallery; by 12 October 1859, 103 paintings and 97 drawings by Turner had been transported to the South Kensington Museum. In September 1861 they were on the move again, this time hurriedly, back to the National Gallery. A Select Committee of the House of Lords, reporting on 30 July 1861, had drawn attention to the fact that Turner had stipulated that a gallery should be built for his works within ten years of his death (in December 1851), and recommended that Turner's works should return to the National Gallery pending the erection of a Turner Gallery.

The National Gallery, wholly dependent upon funds from the Treasury, had no money to build a special Turner Gallery; nor was there much likelihood that Parliament would vote a grant for this purpose. The Trustees did what they could. The West Room (the largest in the National Gallery) was 'stript of the Dutch and Flemish pictures' to make room for Turner. In a crowded hang, one hundred of his paintings were installed there. Some had to be taken out of their frames to fit in, others were hung on screens; nine further paintings were hung in 'the office adjoining'. Wornum reported to the Trustees: 'I have placed both in the great room and in the vestibule between it and the office, a large tablet, with the words "Turner's Gallery" inscribed upon them.'[124] But Wornum's well-meaning 'large tablet' could never have been intended as more than a temporary expedient.

By 1877, paintings and drawings by Turner occupied three galleries (then numbered IV–VI). Plans of the hang are included in Henry Blackburn's *Pictorial Notes in the National Gallery: The British School* (1877). In Bertha Garnett's painting 'A Corner of the Turner Room in the National Gallery', dated 1883 (PLATE 77), 'The Fighting Temeraire' can be seen hanging on the north wall of the principal Turner room (VI). A student's copy of it is visible on the easel turned towards us. Immediately above the real 'Fighting Temeraire' is 'Whalers boiling Blubber', and above that is 'The Sun of Venice going to Sea'. The four large pictures on the right are 'The Vision of Medea' above 'Childe Harold's Pilgrimage' and 'Decline of the Carthaginian Empire' above 'The Bay of Baiae'.[125]

77 Bertha Mary Garnett (exh. 1882-1904): 'A Corner of the Turner Room in the National Gallery'. Exhibited Liverpool Academy 1883. Signed and dated 1883. Oil on canvas, 25.2 x 35.8 cm. London, National Gallery archives. The 'Turner Room' depicted was Room VI, the large gallery immediately ahead of the Trafalgar Square entrance, before reconstruction. As Garnett shows, paintings were hung very closely, sometimes frame to frame. 'The Fighting Temeraire' hangs on the north wall; a student (perhaps Garnett herself) has left a copy of it on an easel. On either side of 'The Fighting Temeraire' are 'Dido directing the Equipage of the Fleet' and 'Childe Harold's Pilgrimage'; conspicuous on the west wall is 'Snow Storm: Hannibal and his Army crossing the Alps'.

78 *An unidentified artist inspired by Turner and 'The Fighting Temeraire', c.1860. Drypoint, 21.6 x 14 cm; lettered 'S. Haydon' (in reverse) and 'D. Maclise del' within plate. London, National Portrait Gallery Archives Collection. The engraver is probably Samuel Jones Bouverie Haydon (1815-91). Here he combines a study of an unknown artist by Daniel Maclise (1806-70) with his own sketch of 'The Fighting Temeraire', adding Turner's name radiating upwards from its sunset, as an inspiration to artists. Maclise's study was once uncertainly called '? Turner'; but Maclise (who had known Turner) can hardly have intended this dapper long-legged artist to represent the stocky figure of Turner himself.*

On Fridays and Saturdays – 'Private Days', when the National Gallery entrance door under the portico was closed – copyists were admitted. They included painters, engravers, Royal Academy students and 'others'; the 'others', amateurs who had first to prove their seriousness by a specimen of their own work, included many ladies whose earnest endeavours were mildly caricatured in the *Illustrated London News*.[126] For half a century after it entered the National Gallery, 'The Fighting Temeraire' was one of the most frequently copied of all paintings of the British School.[127] It remained among the top ten until the end of the century; but changing tastes during the Victorian era inclined more copyists to prefer such pictures as Landseer's 'Dignity and Impudence', C.R. Leslie's 'Uncle Toby and the Widow Wadman' and Wilkie's 'The Blind Fiddler'.[128] The total number of copies of the 'Fighting Temeraire' painted by copyists in the National Gallery in the 38 years between 1856 and 1893 amounted to 256, a fact which must largely account for the seemingly endless progress of 'Fighting Temeraires' through the saleroom.

'The Fighting Temeraire' is too subtly painted to be copied convincingly (although evidently inspiring the efforts of the unknown artist in PLATE 78). The patriotism implicit in the picture may have inspired the paintings entitled 'The Wooden Walls of England' which both Clarkson Stanfield and Henry Dawson produced in the 1850s. It certainly inspired Albert Goodwin, early in the First World War, to paint two small watercolour copies of the picture; he noted on 10 November 1914 that 'With all the battles of land and sea the subject is in keeping'. More sensitively, Francis Danby echoes something of the poetry of Turner's picture in his images of ships at sunset, particularly 'Dead Calm – Sunset, at the Bight of Exmouth', painted in 1855. W. L. Wyllie's painting 'The Last Voyage of H.M.S. Victory, 16 January 1921' is more directly indebted to 'The Fighting Temeraire'. But by and large, professional artists probably sensed that 'The Fighting Temeraire' was (in Wornum's phrase) 'a thing to be admired', not emulated.[129]

&&&

*Now the sunset breezes shiver*
*Temeraire! Temeraire!*
*And she's fading down the river.*
*Temeraire! Temeraire!*

*Now the sunset breezes shiver*
*And she's fading down the river,*
*But in England's song for ever*
*She's the Fighting Temeraire.*

HENRY NEWBOLT, 'The Fighting Temeraire', 1898

Poems and ballads directly inspired by the Battle of Trafalgar had concentrated, understandably, on Nelson and the *Victory*. The large collection of 'Trafalgar' poems published by Sir Henry Newbolt contains only one mention of the *Temeraire*,[130] in a roll of names of the first ships to break the French line:

*Royal Sovereign was the first broke the line of the foe*
*The Victory, Belleisle, and the Temeraire also.*

It was only after Turner made the *Temeraire* the subject of his painting that the *Temeraire* herself became a subject for poetry. For the post-Trafalgar generation, Turner's picture revived the *Temeraire*'s fame; it also inspired at least five poems, from authors as different from each other as the wealthy politician and man of letters Richard Monckton Milnes, the popular song-writer J. Duff, the self-educated Christian Socialist Gerald Massey, the American novelist and poet Herman Melville and the barrister and patriotic poet Sir Henry Newbolt. These poems are reprinted on pp. 139–140.

The earliest is an elegant sonnet by Richard Monckton Milnes MP, entitled 'On Turner's Picture, of the Temeraire man-of-war towed into port by a steamer for the purpose of being broken up' (no improvement on Turner's own trenchant title). Milnes's sonnet, published in his third slim volume of verse in 1840, was directly inspired by Turner's painting, which Milnes presumably saw in the Royal Academy exhibition of 1839.[131] 'See', his first word, invites contemplation of Turner's picture; thereafter every line reflects the poet's emotional response to it:

> *See how that small concentrate fiery force*
> *Is grappling with the glory of the main,*
> *That follows, like some grave heroic corse,*
> *Dragged by a suttler from the heap of slain…*

The 'solemn presence' of the painted ship prompts remorse at her fate; but even as 'the sunset gilds the darke'ning air', the poet predicts undying fame for this 'Home of great thoughts, memorial Temeraire!' Milnes's poem is written wholly under the spell of Turner's image. The sunset of his poem is Turner's sunset; the feeling of remorse at the ship's inglorious end is one of the multiple reactions Turner invites us to share, while the prophecy of the *Temeraire*'s undying fame is a tribute to the power of Turner's picture:

> *And, while the sunset gilds the darke'ning air,*
> *We will fill up thy shadowy lines with fame,*
> *And, tomb or temple, hail thee still the same,*
> *Home of great thoughts, memorial Temeraire!*

'The Brave Old Temeraire' (PLATE 79), with words by J. Duff, enjoyed a far wider circulation, especially as it was set to music by John William Hobbs, well-known in his day for many a patriotic song (including 'My ancestors were Englishmen' and 'Hurrah! for the Saxon race'). Duff was presumably a partner in Duff & Stewart, music publishers of 147 Oxford Street, London, who published the sheet-music of 'The Brave Old Temeraire' in 1857,[132] with a highly coloured but oddly compressed version of Thomas Packer's chromolithograph of the picture on its cover.[133] Though Duff's words are fairly banal, Hobbs's music (marked *maestoso* and *declamatory*) gives them sonority. The first two verses are given here: the reader must try to hear for himself the 'Temeraire! Temeraire!' refrain – now full of boldness, now of pathos – after each verse. Subtitled 'National Song', 'The Brave Old Temeraire' enjoyed lasting popularity. In 1888 a contributor to *Notes and Queries* noted that the music for this 'capital song' can 'be had of any music-seller';[134] and

79 *Front wrapper of 'The Brave Old Temeraire' sheet music, 24.2 x 18 cm. London, Judy Egerton. Words by J. Duff, music by J.W. Hobbs, copyright 1857, published London, Duff & Stewart, probably 1857-8. The wrapper reproduces a chromolithograph by T. Packer of 'The Fighting Temeraire' published in 1858, here compressed to an upright shape. The song remained popular for almost a century.*

in 1893 Duff's last two verses were exalted to an inscription engraved upon a royal wedding-present (see p. 119). The opening verses are:

> *Behold! how changed is yonder ship*     *As when she came to Nelson's aid,*
> *The wreck of former pride;*     *The battle's brunt to bear,*
> *Methinks I see her as of old,*     *And nobly sought to lead the van*
> *The glory of the tide!*     *The brave old Temeraire.*

Gerald Massey, a self-educated man and one of Samuel Smiles's heroes, devoted himself first to the cause of Chartism and later to Christian Socialism. Between 1854 and 1869 he published six volumes of poems, admired by Alexander Smith (who likened him to Burns), Ruskin (who regarded Massey's work as 'a helpful and precious gift to the working classes') and Tennyson (who added that he thought Massey 'made our good old English crack and sweat for it occasionally').[135] 'The Fighting Temeraire tugged to her last berth', first published in 1861,[136] shows all Massey's strengths and weaknesses. The sixth of its ten verses

is quoted on p. 80. The refrain 'She goeth to her last long home' lifts the poem above its generally thumping metre, while the lines 'Weary and war-worn, ripe for rest/ She glideth to her grave' include an echo of Ruskin (see p. 111).

Herman Melville's long poem 'The Temeraire' is more forceful and more individual. Melville, the American novelist, poet and author of *Moby-Dick* (1851), was in London in the spring of 1857, a few months after works from the Turner Bequest were first exhibited in Marlborough House. After visiting 'the Vernon and Turner galleries', Melville jotted down the titles of the works which had most impressed him.[137] They were all by Turner: 'Sunset scenes of Turner "Burial of Wilkie". "The Shipwreck", "The Fighting — taken to her last birth[sic]".' Though he couldn't at the time recall the exact title of 'The Fighting Temeraire', the picture remained vividly in his mind, and at some point he purchased an impression of Willmore's engraving of it.

A naval battle during the American Civil War prompted Melville to link the fate of the 'Fighting Temeraire' with that of the *Merrimac*, a once great wooden Confederate ship, which was roundly defeated in 1862 by the *Minotaur*, a new purpose-built Yankee ironclad. In an astonishing 64-line poem first published in 1866,[138] Melville links his own reaction to the defeat of the *Merrimac* with Turner's representation (almost a quarter of a century earlier) of the end of the *Temeraire*; fusing the two episodes, Melville sees Turner's picture as prophetic of the fate of all 'navies old and oaken' when, in the name of progress, 'rivets clinch the iron-clads' and 'men learn a deadlier lore'. Its last verses (already partly quoted on p. 40) are given here:

> O, Titan Temeraire,
> Your stern-lights fade away;
> Your bulwarks to the years must yield,
> And heart-of-oak decay.
> A pigmy steam-tug tows you,
> Gigantic, to the shore –
> Dismantled of your guns and spars,
> And sweeping wings of war.
> The rivets clinch the iron-clads,
> Men learn a deadlier lore;
> But fame has nailed your battle-flags –
> Your ghost it sails before,
> O, the navies old and oaken,
> O, the Temeraire no more!

Better-known, though less indebted to Turner, are the swinging rhythms of Sir Henry Newbolt's 'The Fighting Temeraire', included in many an anthology and dictionary of quotations. First published in 1897 in *Admirals All*, which included the even more popular 'Drake's Drum', Newbolt's poem largely relies on effects of repetition, particularly of the refrain 'Temeraire! Temeraire!' Four of its six verses (beginning 'It was noontide ringing/ And the battle just begun . . .') hark back to the Temeraire's role in the Battle of Trafalgar; the fifth verse prophesies 'renown for ever clinging/ To the great days done'. Only the last verse (quoted on p. 111), with its image of the ship 'fading down the river' at sunset, hints at some debt to Turner. Within a year of publication, Newbolt's poem was set to

80  *Quarter-piece figures from the Temeraire's stern galleries. Presumably made c.1798. Oak carvings; size unknown, but evidently massive, perhaps about 8 ft high. Destroyed in air raids over Plymouth, 1944; from an old photograph in the collection of Castles of Plymouth Ltd. The figures can be seen in place in William Beatson's etching of the Temeraire at his brother's ship-breaking wharf (Plate 24), at the junction of the stern galleries (officers' walks) and the quarter galleries at either side (captain's and officers' latrines). They stood on the lower gallery tier, as if bearing the weight of the gallery above. Reserved by John Beatson for his own firm, they later supported the mantelpiece of relics at Castle's Shipbreaking Co. Ltd, Baltic Wharf, Millbank, before being moved 'for safety' to Plymouth on the outbreak of World War II.*

music by Florian Pascal and published with a small monochrome reproduction of Turner's painting on the cover; it was republished in 1911, with stirring settings (by various composers) for popular Newbolt verses such as 'Drake's Drum' and 'The Playing Fields'. A new setting by Granville Bantock, published in 1940 and originally arranged for a single voice, was republished in 1973, this time rearranged for a four-part harmony of voices, (two tenors and two basses, singing *moderato con spirito*): in this version, 'The Fighting Temeraire' can probably be heard to this day in some glee club or village hall.[139]

All five poems rely in differing degrees on the delicate rhythm of the name 'Temeraire'. It is difficult to imagine poets extracting quite such varied music from the name 'Dreadnought'. The Royal Navy was to re-use the name *Temeraire* for two later warships.[140] The first of these was an ironclad of 8,540 tons launched at Chatham in 1876. The second, a twentieth-century *Temeraire*, of 18,600 tons, was launched at Devonport in 1907, one of a new Dreadnought class of warships. In the names of some of her sister-ships – *Dreadnought*, *Bellerophon* and *Neptune*, as well as in her own – echoes of Trafalgar were carried into service during the First World War.

&&&

> *. . . while in brass*
> *Some work their honors, some in glass,*
> *Some paint, some chisel out of stone*
> *And pray to Clio for melodious tones*
> *Some dare the restless billows to provoke*
> *And float secure to fame in British Oak . . .*

<div align="center">

J.M.W. TURNER

in his *Perspective* sketchbook, about 1809

</div>

Within weeks of the *Temeraire*'s arrival at Beatson's wharf in the autumn of 1838, a brisk demand for souvenirs of her was reported in *The Times*,[141] though in a half-facetious style which suggests some invention: '"Here's the poor old *Temeraire* come to the knackers at last", exclaimed a jolly old tar who had lost his starboard leg at Trafalgar. . ."I hope I shall have enough timber for a new wooden leg out of her." His request was complied with, and a new piece of oak was given to him for the purpose.'

But Beatson was not in the ship-breaking business to give away timber. He kept some prize objects for himself. When stripping the ship before sale, the Admiralty had removed anything which could be re-used; but they were concerned with fittings of practical use, not sentiment. They ignored a brass plate engraved with Nelson's famous signal 'England Expects Every Man Will Do His Duty' inset in the quarter-deck; Beatson kept this for himself.[142] As a talisman for his firm, he also kept a pair of carved caryatids (PLATE 80) – muscular figures doomed, like Atlas, to stoop forever under heavy loads – which had decorated the *Temeraire*'s stern galleries. These were eventually inherited from Beatson's firm (together with stocks of *Temeraire* timbers) by Messrs H. Castle & Sons, of Baltic Wharf, Millbank (near the Tate Gallery), and incorporated, with assorted

relics of ship-breaking including a head of Queen Victoria, into Castle & Sons' mantelpiece at Millbank; a photograph of this curious structure then served as the firm's advertisement. After the outbreak of war in 1939 the firm moved 'for safety' to Plymouth; an air raid in 1944 destroyed their premises and, presumably, the mantelpiece of relics.[143] But such is the enduring quality of the *Temeraire* that one would not be surprised if her carved caryatids eventually reappeared.

Most of the *Temeraire*'s timbers were destined for prosaic use – for serviceable furniture, boat-building and repair, and building and flooring houses and shops. Ship-breakers' stocks by the middle of the nineteenth century included more teak than oak; *Temeraire* oak was therefore at a premium, and continued to provide souvenirs well into the 1890s. Given the *Temeraire*'s associations with Trafalgar, 'England Expects...' was engraved on brass plaques affixed to many of the objects made from her timbers; and while the objects commonly made for the usual ship-souvenir trade were snuff-boxes and other small knick-knacks, objects made from the *Temeraire* were mostly of a more solemn nature.

Documented objects made from timbers of the *Temeraire* make a bizarre assortment. Pride of place must go to the altar-table, altar-rails and two sanctuary chairs which are now in the parish church of St Mary, Rotherhithe, near the wharf where the *Temeraire* was broken up. Presented by the Beatson family in or about 1850 to the newly built St Paul's Chapel of Ease in Rotherhithe, designed by William Butterfield and built by William Beatson, the ship-breaker's brother,[144] the *Temeraire* church furniture was transferred to St Mary's when St Paul's Chapel was demolished around 1955 to make room for a school. Plate 82 illustrates one of the chairs. Pugin-esque in style, their backs high-pointed above a carved trefoil symbolising the Trinity, each chair bears a lettered brass plate.

The *Temeraire*'s most far-flung relic is a chair of state presented in 1892 to the Whanganui Regional Museum, New Zealand, by its founder, Samuel Henry Drew, who had married Catherine Beatson, the ship-breaker's daughter, and settled in New Zealand.[145] The *Temeraire* chair in Whanganui is late Victorian in style and partly upholstered in leather; on its back is carved

<div align="center">

ENGLAND EXPECTS EVERY MAN TO DO HIS DUTY

OCT 21 1805

TRAFALGAR

TEMERAIRE

</div>

A similar chair belongs to Lloyd's Register of Shipping, London; another was recently presented to the Royal Naval Museum, Portsmouth. Oak from 'the stern post of his Majesty's ship Temeraire' provided the mount for a barometer made by W. & S. Jones of 30 Holborn, London (PLATE 81), according to an inscribed silver disc below the scale; one of the silver medals issued by Matthew Boulton to commemorate the victory at Trafalgar has been inset below it for good measure. This is in the National Maritime Museum, with another barometer, a gavel and some miscellaneous 'timbers'.

Oak from the *Temeraire* was used for two very different objects illustrated here. Sir Edwin Landseer's life-size portrait of a much-loved Newfoundland dog, 'Neptune, The Property of W. Ellis Gosling Esq.', was painted in 1824, fourteen years before the *Temeraire* was broken up.[146] Years after the dog's death, his still sorrowing owner re-framed 'Neptune' in *Temeraire* oak, with a commemorative

81 *Barometer made by William and Samuel Jones, c.1840, mounted on oak from the stern-post of the Temeraire, 39 x 10 cm. London, National Maritime Museum. An engraved silver disc inset in the mount reads 'This oak formed part of the stern post of his Majesty's ship Temeraire 98 that bore so distinguished a part in Nelson's Victory off Cape Trafalgar 21st Oct 1805'; below it is a Trafalgar commemorative medal.*

82 *Altar chair made from the timbers of the Temeraire and presented by John Beatson, ship-breaker, to St Paul's Chapel of Ease, Rotherhithe, c.1850. Oak, 162 x 65 x 53 cm. London, St Mary's, Rotherhithe. This is one of two altar chairs presented by John Beatson, with an altar-table and altar-rails, all made from the timbers of the Temeraire, to St Paul's Chapel of Ease, Rotherhithe, possibly built by his brother, and consecrated in 1850. A century later, after the chapel's demolition, the Temeraire church furniture was moved to the Parish Church of St Mary, Rotherhithe.*

THIS CHAIR

MADE OF ENGLISH OAK
ONCE FORMED A PART OF H.M. NOBLE SHIP

TEMERAIRE

(104 Guns)
Built at Chatham in 1798
BORE A DISTINGUISHED PART IN THE BATTLE OF
TRAFALGAR 1805
Broken up at Rotherhithe 1838
*ENGLAND EXPECTS EVERY MAN TO DO HIS DUTY*

brass tablet linking Neptune with Nelson's seamen as equally ready to do their duty (PLATE 83). Even more loaded with appropriate sentiment was the gift of an oak stand for what is probably the largest of all prisoner-of-war bone ship models, in the collection of the Company of Watermen and Lightermen. This model (of an unidentified two decker) was presented to the Company in 1841, and placed in their almshouses at Penge. Two years later, a freeman of the Company presented a stand for it 'made of timber, part of H.M. ship *Temeraire*, Nelson's second at the battle of Trafalgar', stating that his gift marked his own gratitude for the contribution which 'many a poor waterman' had made to England's glory. He despatched the stand to the Company's almshouses 'with a hearty wish' for the happiness of its inmates, and the hope that 'its walls may in the day of adversity be to them, what the wooden walls of Old England have been to her, a safe and permanent protection.[147] The model and its stand are now in pride of place in Watermen's Hall in the City of London.

83 *Sir Edwin Landseer RA (1803-73): 'Neptune, the Property of W. Ellis Gosling Esq.', framed in Temeraire oak. Oil on canvas, 150 x 197 cm. By courtesy of Spink & Son Ltd. Neptune, a Newfoundland dog, sat to Landseer in 1824 for a life-size portrait exhibited that year at the Royal Academy, but died soon after. Years later, his still-mournful owner ordered a new frame to be made from the beams of the Temeraire for 'my favourite dog Neptune', and affixed to it a brass tablet jointly commemorating the dog, the Temeraire and the Battle of Trafalgar.*

The smallest memento of 'The Fighting Temeraire' was a medal commissioned in 1876 by the Art-Union of London,[148] a flourishing society with over 16,000 members at home and abroad. For an annual subscription of one guinea, members received each year an engraving commissioned by the Art-Union (Daniel Maclise's two masterpieces 'The Death of Nelson' and 'The Meeting of Wellington and Blucher' were currently circulating all over the world in the form of Art-Union engravings). The Art-Union also conducted an annual lottery, in which the prizes were sums of money to be spent on specially commissioned or selected works of art. In 1876, there were 951 prizes, ranging from paintings to the value of £300 down to a small Turner medal, the latest in a long series of medals commissioned to celebrate great British artists.[149]

The Turner medal offered to members in 1876 (PLATE 84) was executed by Leonard Wyon, chief engraver at the Royal Mint.[150] On its obverse side is the profile portrait of Turner which Daniel Maclise had designed and Wyon had engraved in 1859 for the Royal Academy's Turner Prize Medal.[151] For the medal's reverse, the Art-Union wanted an instantly recognisable motif from one of Turner's most popular paintings. For this, Wyon went to 'The Fighting Temeraire'. Even when reduced to a two-inch metallic orbit, the *Temeraire* and her tug need no lettering around the rim to identify them. The medallist's crisp details, such as the spokes of the tug's paddle-wheel and the smoke from its funnel, are sharper than the painter's; without Turner's sunset and his eerily still foreground, symbolism gives way to a hint of everyday life on a commercial river. Thirty Turner medals were struck in silver and offered as prizes in 1876; the Art-Union's *Report* that year lists the winners, some of whom lived as far away as Barcelona and Ballarat.[152]

84 *Medal commemorating Turner and 'The Fighting Temeraire', 1876. Engraved by Leonard Charles Wyon. Bronze, diameter 5.5 cm. London, British Museum. The medal is one of a series commemorating British artists commissioned by the Art-Union of London for its members. The portrait is after Daniel Maclise's design for the Royal Academy Turner Prize Medal, engraved by L. C. Wyon; for the reverse, a detail from 'The Fighting Temeraire' was chosen as Turner's most popular subject. One gold, 30 silver and a large unknown number of bronze Turner medals were struck.*

The most resounding relic of the *Temeraire* is undoubtedly the gong-stand made by H. Castle & Sons in 1893 as a gift to the Duke of York (later King George V) and Princess May of Teck on the occasion of their marriage on 6 July 1893 (PLATE 85). Carved on the oak arch from which the bronze gong is suspended is the motto NEMO ME IMPUNE LACESSIT ('No one provokes me with impunity'). The motto of the Order of the Thistle, of which the Duke of York had been made a Knight the day before his marriage,[153] it is also appropriate to the *Temeraire*'s part in the action at Trafalgar. The upright sides

85 'The Temeraire Gong Stand/ A
Souvenir of the Wooden Walls of Old
England'. Presented by H. Castle &
Sons to HRH Captain the Duke of
York RN (later King George V) on his
marriage with Princess May of Teck,
1893. The Royal Collection. Made of
oak from the Temeraire, overall size
109 x 127 x 37 cm, with two inscribed
brass shields recording the gift and
quoting the last two verses of the Duff-
Hobbs popular song 'The Brave Old
Temeraire'. The carved figures helping
to support the gong are small replicas of
the Temeraire's stern gallery caryatids
(see Plate 80).

are carved with replicas of the all-enduring Atlas-like caryatids (PLATE 80) which had begun their service on the *Temeraire*'s stern galleries, later supporting Castle & Sons' mantelpiece before being destroyed in the last war. Relics of relics, they live on in the royal gong-stand.

The Duke of York, noted as a stickler for punctuality, had been a serving officer in the Royal Navy until the year before his marriage; he may be presumed to have relished regular summons to dinner by an echo from the *Temeraire*. The stand carries two inscribed shields. The upper one reads:

THE TEMERAIRE GONG STAND A SOUVENIR OF THE WOODEN
WALLS OF OLD ENGLAND GRACIOUSLY ACCEPTED BY
H.R.H. CAPTAIN THE DUKE OF YORK RN ON HIS MARRIAGE WITH
THE PRINCESS MAY 1893 FROM THEIR ROYAL HIGHNESSES MOST
HUMBLE AND OBEDIENT SERVANTS H. CASTLE & SONS.

As a final epitaph to the *Temeraire*, the last two verses of the popular Duff–Hobbs song are engraved on the lower shield of the royal gong-stand:

*Our friends depart and are forgot
As time rolls fleetly by;
In after years none, none are left
For them to heave a sigh.*

*But hist'ry's page will ever mark
The glories she did share,
And gild the sunset of her fate,
The brave old Temeraire.*

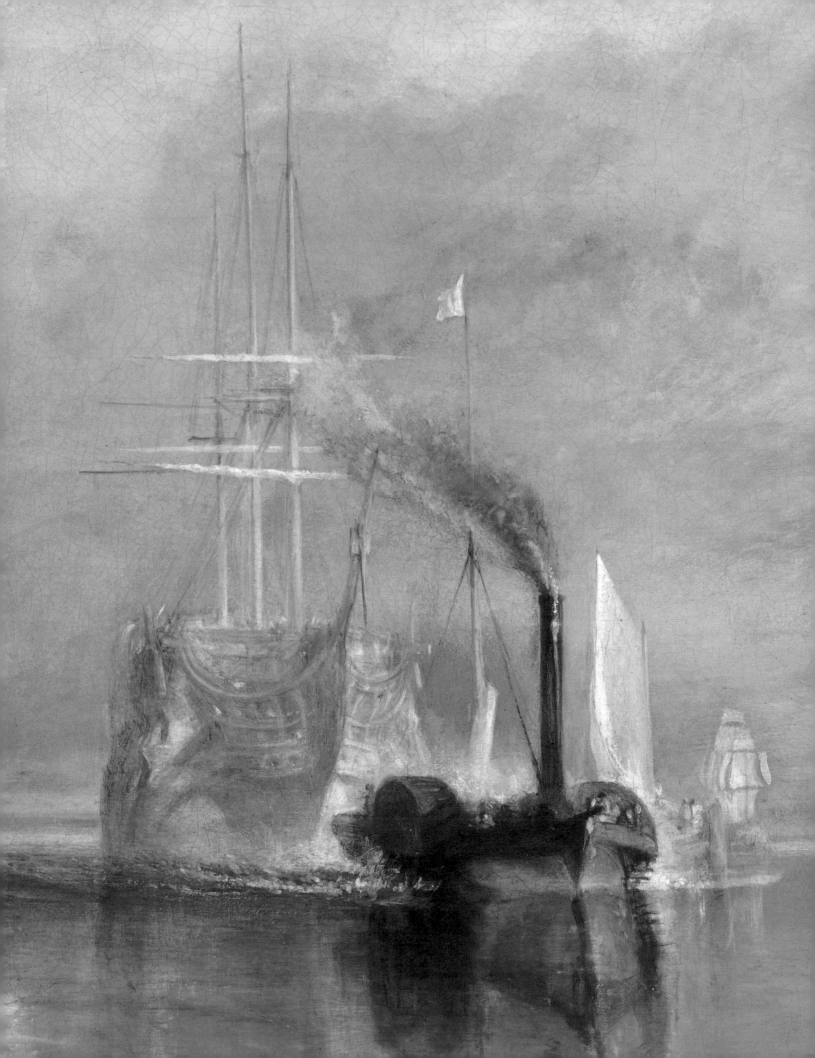

# THE MAKING OF
## 'THE FIGHTING TEMERAIRE'

## BY MARTIN WYLD AND ASHOK ROY

'The Fighting Temeraire' is usually considered to be one of the best preserved of Turner's later paintings as well as being one of the most striking images. It has never been cleaned, apart from the removal of surface dirt, and it was not lined until 1963, by which time the vulnerability of Turner's materials was well known.[1] Many paintings in the Turner Bequest were known to be in a poor state; Charles Eastlake, after examining the pictures in Turner's house in Queen Anne Street in 1854, nearly three years after the artist's death, wrote: 'The effects of damp and dust were more or less apparent on all; the surface of some was cracked, and the canvas, in many instances, was injured.'[2]

Turner's inventive use of unconventional materials, for example experimental megilp-like paint vehicles[3] containing various drying oils, resins as well as waxes, fats and mixed media techniques, has led to many of his finished paintings (as opposed to the more simply painted sketches) having a greater heat sensitivity and a higher solubility than those of most of his contemporaries. The hot irons traditionally used for lining and the solvents used for cleaning have damaged many of Turner's works; a comparison of 'Dido building Carthage' NG 498) and its pendant, 'The Decline of the Carthaginian Empire' (Tate Gallery N 00499), shows how much the former has suffered from its neglect and early treatment. 'The Fighting Temeraire' on the other hand probably owes its largely sound state of preservation to a relatively straightforward technique and the use of a conventional paint medium based on walnut oil rather than one of Turner's idiosyncratic mixtures.[4]

The manuscript catalogue of the National Gallery's collection in 1859 refers to an examination of 'The Fighting Temeraire' in 1859: 'Under glass, good state but slightly B cracked on Steam Boat; and pigment change around the Sun.' 'B cracked' is presumably an abbreviation for 'bitumen cracked', bitumen by 1860 being used as a scapegoat for a variety of paint-film defects and drying faults not necessarily connected with the actual use as pigment or medium of this non-drying dark material.[5]

'Pigment change around the Sun' was probably meant to imply fading of red and yellow pigments used to achieve the sunset effects, but this short note in one way over emphasises the changes, since the picture, for Turner, is remarkably well-preserved in this important passage. Turner's interest in yellow light and its capture in pigment was much commented upon, sometimes derisively.[6] The stability of his yellows was, in consequence, critically important to him. But access to as great a range as possible in hue was also essential and resulted in Turner's use and experimentation with not only a variety of yellow pigments but also their accompanying tones of orange, red and pink.[7] In 'The Fighting Temeraire' the principal brilliant yellow is a chromate colour based on barium (lemon yellow). In marked contrast to the more commonplace form of chrome yellow – lead chromate yellow – true lemon yellow was noted and prized for its permanence.[8] Turner was one of the earliest users of lemon yellow, experimenting

with it in 'Ulysses deriding Polyphemus' of 1829, where it occurs in the yellowest parts of the sunset. In 'The Fighting Temeraire', areas of sunlit sky rendered with this pigment can be taken as substantially unaltered, although there are places where thin modifying scumbles applied as finishing touches using a less stable pigment have become greyish or silvery as well as denser than originally planned, and there the sunlit clouds are perhaps not quite Turner's intended effect.

There are other subtle transformations in the paint. In his desire to construct every nuance and shade of light in paint, two kinds of brilliant, dense red pigment are used in the sunset effects. One is a traditional pigment, vermilion, largely reliable in behaviour, laid on in small virtually pure slabs of colour, but also mixed as a tint, while the second brilliant red was a variant of vermilion newly invented by the chemist Humphry Davy. This new material was iodine scarlet (mercuric iodide, discovered 1812), known simply as scarlet, or, sometimes, scarlet lake, a pigment certainly beautiful when fresh, but of frightening fugitiveness. The appeal to Turner of scarlet iodide of mercury must have been the remarkable intensity of colour, the distinctive hue and a lower density in comparison with vermilion, since he seems to have used this unstable pigment more than its early reputation merited.[9] The deep salmon-pink clouds adjoining the darker red sky contain this scarlet compound, but at least it has survived sufficiently well for the general effect still to be appreciated. The more muted tones of the sunset contain earth pigments, particularly Venetian red, which does not change with time.

'The Fighting Temeraire' may have been displayed well into the twentieth century with the same glass mentioned in the manuscript catalogue, and this would have helped preserve the painting and also reduce the deterioration of sensitive pigments.

By 1963 the canvas had become brittle and the turnovers at the edges of the stretcher were splitting, leading to some loose paint at the corners. The picture was lined for the first time and replaced on the original stretcher with its two vertical crossbars. A further reason for the lining was that the stretcher marks, caused by the slightly slack canvas resting against the stretcher, were becoming prominent.

Even a cursory study of 'The Fighting Temeraire' shows the variety of ways in which Turner applied paint to his smooth, off-white canvas priming, which in this case, fortunately, seems conventional in constitution.[10] The composition was blocked-in probably without much preliminary drawing, except for some intermediate shorthand indications in translucent dark paint of the reflections of the tug's funnel, paddle-wheels and bows; perhaps these were modifications made in connection with a reworking of an earlier design in this area (see below). The first stages were carried out in thinned oil paint[11] of which quite little is now visible except for the pinkish brown underpaints in the upper part of the sky and cooler preliminary layers glimpsed through the more thickly applied strokes in the water. Some idea of the process of evolution of 'The Fighting Temeraire' can be gained from Turner's early unfinished sketch 'Shipping at the mouth of the Thames' (1806–7, Tate Gallery N 02702), which shows the tonal values of sky and sea blocked-in in just this way. Some of the upper layers of paint for the cobalt blue sky in 'The Fighting Temeraire', particularly near the horizon and where there are no clouds or sunset effects, are finished in this same thin fluid technique. There are much heavier impasto effects, particularly in the sunset and clouds, where the thickly laid paint appears to have been applied with a loaded brush

87 X-radiograph of 'The Fighting Temeraire', made in 1994, which shows that Turner first painted a sailing boat where the tug was finally placed. The sail is clearly visible in the X-radiograph because it contains white lead; other pigments which register include lemon yellow, vermilion and iodine scarlet.

rather than with a palette knife, although other pictures show clear evidence of Turner's enthusiasm for this method.

The X-radiograph (PLATE 87) shows one puzzling feature. A large sail, much higher and wider than that now visible behind the tugboat, seems to have been placed where the tugboat's mast, rigging and funnel now lie. The scale of this sail implies that the boat to which it belonged was in the foreground of the picture. If it were part of the composition of 'The Fighting Temeraire', such a sailing-boat would have been well in front of the tugboat. It is difficult to reconcile this with the subject of the painting; the drama of the scene would have been diminished if the nearest and therefore (to the viewer) largest vessel had been a sailing-boat.

It is possible that for painting 'The Fighting Temeraire' Turner used a discarded canvas on which he had already laid in a sailing-boat as part of another composition. The X-radiograph shows the painted-out sail but not the hull of the boat to which it belonged. The sail shows clearly because it is painted largely in lead white, but must have been a light yellowish orange colour, since the concealed paint contains some added red and yellow ochre, depicting a sail very like that in the small 'Sailing Boat off Deal' of about 1835 (National Museum of Wales, Cardiff[12]). The suppressed hull, if it had been taken to any degree of finish, must have been painted in pigments which do not absorb X-rays strongly. The X-ray image of the whole picture demonstrates the differences in density: the finished hulls of the *Temeraire* and tug do not register strongly. The thicker paint of the sunset, the moon, the clouds, the spray from the tugboat's paddle-wheels and the smoke from its funnel, the sail behind, the spars of the *Temeraire* and the reflections in the water are all visible because they contain either lead white or other X-ray dense pigments such as lemon yellow, vermilion and iodine scarlet. The ghostly hull of the *Temeraire*, on the other hand, is rendered in the thinnest veils of grey and translucent brown pigment drawn over a thinly sketched understructure of ivory-coloured paint.

# NOTES

## ABBREVIATIONS

The three most frequently recurring abbreviations used in this work refer to catalogues of Turner's works, as follows:

B & J 1984: Martin Butlin and Evelyn Joll
*The Paintings of J.M.W. Turner*
2 Vols (Text; Plates)
Revised edn, London 1984

R: W.G. Rawlinson
*The Engraved Work of J. M. W. Turner, R.A.*
2 Vols, London 1908–13

W: Andrew Wilton
*The Life and Work of J. M. W. Turner*
London 1979, (including a catalogue of watercolours, pp. 297–490)

## OTHER ABBREVIATIONS

ARA   Associate Member of the Royal Academy
Exh.   Exhibited
NG   National Gallery
RA   Royal Academy, Royal Academician
*TS*   *Turner Studies*, Vols I–II, 1981–91

## PART I

## HIS MAJESTY'S SHIP TEMERAIRE

**1** Sir William Blackstone (1723–80, first professor of English law, Oxford, 1758–66), *Commentaries on the Laws of England*, Book I.13, London 1765, p. 405.

**2** The words, from the masque *Alfred* by James Thomson and David Mallet, are probably by Thomson.

**3** For examples, see *Concise Catalogue of Oil Paintings in the National Maritime Museum*, London 1986, under the artists' names.

**4** The siege lasted for five years, 1779–83.

**5** The portrait is discussed and reproduced in Nicholas Penny, ed., *Reynolds*, exhibition catalogue, Royal Academy, London 1986, p. 38.

**6** B & J 1984, cat. no. 10, p. 7.

**7** Thomas Campbell, *The Complete Poetical Works*, J.L. Robertson, ed., Oxford edition, Oxford 1907, pp. 212–13. Campbell adds a note explaining that the poem, which he entitles 'The Launch of a First-Rate', was in fact inspired by the launch of *The London*, a [smaller] two-decker of 92 guns, at Chatham on 29 September 1840, at which he was present.

**8** Henslow's 'Draught' is reproduced and

discussed in Lyon 1993, p. 106. See also Lavery 1989, pp. 58–61.

**9** The *Temeraire*'s official category is 'Dreadnought/Neptune class of 1788: Second Rate, 98 guns, three-decker', where '1788' refers to the Admiralty's approval of Henslow's design on 6 March 1788. Ships were often modified at later stages: the *Temeraire* had 104 guns by 1805, while her sister-ship *Ocean*, begun as a 98, was lengthened in 1805 to carry 110 guns, but later cut down to an 80.

**10** Lavery 1984, p. 163.

**11** See Lavery 1984, pp. 71–86.

**12** *David Copperfield*, first published in monthly numbers, 1849–50, Penguin edition, Harmondsworth 1986, Chapter 13, p. 238.

**13** B & J 1984, cat. no. 75; see their plate 85 for the complete picture.

**14** See *A note on the name of the Temeraire, accents etc*, p. 13. Accents on the name of the *Temeraire* were not used during that ship's forty years of service. They were mistakenly introduced after the exhibition of Turner's painting, when the identity of the ship was confused with that of *Le Téméraire*, an earlier French prize; because of this confusion, Willmore's engraving of Turner's picture in 1845 was titled 'The Old Téméraire'.

**15** See D. M. Little and G. M. Kahrl, *The Letters of David Garrick*, II, Oxford 1963, p. 601, notes 1–2; according to Little and Kahrl, Garrick himself referred to his song in 1768 as 'Hearts of Oak'. In William Boyce's sheet–music, first published in 1760 and entitled merely 'A Song sung by Mr Champnis in Harlequin's Invasion', the chorus begins 'Heart of Oak...'; see sheet in the 'Collection of English Ballads' made by anon. before 1790 (British Library, Music Library, G307/74). In [Thomas] Dibdin and Others, *Sea Songs and Ballads*, 1863, 'Hearts of Oak' is given on pp. 187–8.

**16** Rogers's *Poems* were first published in 1812. For Turner's illustrations to the 1834 edition, see Piggott 1993, pp. 21–2, 40–4, 82–5; 'An Old Oak Dead' is cat. 45, p. 98, repr. p. 105. This is the second of Turner's two illustrations to 'An Old Oak'; the first (Piggott p. 98, no. 44, repr. p. 105) depicts the old oak standing in the middle of the green, with merry villagers dancing beneath it.

**17** See Brian Lavery, *Building the Wooden Walls*, 1991, pp. 56–7; also Gardiner and Lavery, ed., 1992, p. 121: 'The amount of timber required for a major warship was astounding: in England, where the unit was called a "load" (50 cu. ft. or the equivalent of one large tree), by the 1750s a 100-gun First Rate would take up 5,750 loads, a 74 about 3,500 and even a 50-gun ship would consume 2,450.'

**18** Letter to James Boswell, 8 March 1768, ed. D. M. Little and G. M. Kahrl, no. 493, pp. 600–1.

**19** *The Poems of Tennyson*, ed. Christopher Ricks, Vol. I, 1987, no. 117, pp. 275–6. 'National Song' was published in 1830, and not subsequently published by the author. 'The Lady of Shallot' was first published in 1832.

**20** From his speech in June 1635 to the Privy Council, as quoted in the *Dictionary of National Biography*, Vol. 4, p. 1286.

**21** Blackstone, op. cit., p. 405.

**22** Conversation with James Boswell, 16 March 1759, *Boswell's Life of Johnson*, ed. G.B. Hill, revised L.F. Powell, Vol. I, London 1934, p. 348.

**23** Lavery 1989, p. 131.

**24** Melville's poem was first published in *Battle Pieces and Aspects of War*, New York 1866.

**25** Nor recognised in the National Maritime Museum, Greenwich. To 'lighten' a ship is to reduce its load: possibly Melville means that the ship has 'lunged' from its launching cradles.

**26** Lavery 1984, p. 46.

**27** Estimated from Adm. 95/7, quoted by Uden 1961, p. 61.

**28** Her successive captains are listed in Uden 1961, pp. 68–9. Adm. 51/1256: Log, Capt. Peter Puget, 28 March–26 July 1799.

**29** Quoted in Lavery 1989, p. 245; the figures for the size of the Channel fleet are also taken from Lavery, ibid.

**30** i.e. men received from other ships.

**31** PRO, Adm. 51/1418, pt. 8.

**32** See *The Trial of the Mutineers, Late of His Majesty's Ship Temeraire...*,1802, in which 'Portraits of the Mutineers' is repr. as frontispiece. The letter signed 'The Temeraires' is given on p. 19; the phrase 'launched into etern-ity' is quoted from part ii, p. 15. Beginning on 2 January 1802, the accused were tried in two groups, each hearing lasting three to four days. They were tried by six admirals and six captains.

**33** The model was restored in 1950 by Laurence A. Pritchard; for his technical comments and criticisms (drawn on by the author), see 'Prisoner-of-War Bone Model of H.M.S. Temeraire', *The Mariner's Mirror*, Vol. 3, no. 2, April 1950, pp. 111–16. See also Ewart C. Freeston, *Prisoner of War Ship Models, 1775-1825*, London 1973, reprinted 1987, p. 116; see also pp. 106–8.

**34** A figurehead of some sort is clearer in W. Miller's engraving of Clarkson's Stanfield's 'Battle of Trafalgar' than in the painting itself (exh. 1836; repr. in Pieter van der Merwe, *Clarkson Stanfield*, exhibition catalogue, Tyne and Wear County Council Museums, Bonn, Rheinisches Landesmuseum, and Sunderland

Museum and Art Gallery 1979, plate VII). Figureheads are discussed and illustrated in John Franklin, ed. Gardiner, 1992, chapter 12, 'Ship Decoration', pp. 164–71.

**35** As reported by Lady Harvey, letter of 5 November 1805 to General Grosvenor from Portsmouth Harbour; quoted from Harvey MSS by A. Sakula, 'Admiral Sir Eliab Harvey of the Temeraire', *Journal of the Royal Naval Medical Service*, Vol. 65, 1979, p. 164.

**36** Captain Sir Eliab Harvey (1758–1830) is noticed in the *Dictionary of National Biography*, various dictionaries of naval biography, in Sakula, op. cit. and in L. Namier and J. Brooke, *History of Parliament, House of Commons 1754–1790*, Vol. II, London 1964, pp. 595–6. He was MP for Malden 1780–4, and for Essex 1802–12 and from 1820 until his death in 1830. His portrait by Beechey (in the National Maritime Museum, Greenwich) is repr. NMM 1988, p. 64 (d).

**37** This story, recounted in various forms and given authority by its inclusion in W.L. Clowes, *The Royal Navy*, Vol. 5, London 1900, p. 134, was popularised by Henry Newbolt in 'The Quarter-Gunner's Yarn' (*The Island Race*, London 1898, pp. 7–11): 'The Victory led, to her flag it was due,/Tho' the Temeraires thought themselves Admirals too,/But Lord Nelson he hailed them with masterful grace,/"Cap'n Harvey, I'll thank you to keep in your place".'

**38** *Annual Register for the Year 1805*, 1807, p. 235.

**39** Adm. 51/1530, Part V: Temeraire log, 10 July–5 December 1805. The author gratefully acknowledges permission from the Public Records Office to publish long extracts.

**40** Letter to Louisa Harvey, 23 October 1805, quoted by Sakula, op. cit., p. 163.

**41** Ibid.

**42** Published in *The Annual Register…1805*, op. cit., pp. 541–5. Collingwood had taken command of the Trafalgar fleet on Nelson's death.

**43** Ibid., p. 543.

**44** Hansard, *Parliamentary Debates*, 29 January 1806, p. 107.

**45** The compiler is indebted to Thomas Woodcock, Somerset Herald, The College of Arms, for tracing the registration of the grant of supporters to Sir Eliab Harvey at the College of Arms, Grants Vol. 35, 132, and also for tracing two illustrations of Harvey's arms in Bath Books, MSS, College of Arms, Vol. 10, 103 (with supporters) and Vol. 23, 21 (without supporters).

**46** *Poetical Works*, ed. F. Page, revised J. Jump, Oxford 1970, p. 770: canto IX, stanza iv. The particular 'brain-spattering' which Byron deplored (here and earlier in 'Don Juan') was that at the Battle of Waterloo, for which he castigated Wellington, ending canto IX, stanza iv with the lines 'And I shall be delighted to

know who/Save you and yours, have gain'd by Waterloo'. Canto IX, written in 1819, was published in 1823.

**47** Clowes, op. cit., p. 131; and see R.H. Mackenzie, *The Trafalgar Roll*, London 1913, pp. 46–56, for details of officers who served in the *Temeraire* at Trafalgar.

**48** Letter to his wife, 25 October 1805, quoted by Sakula, op. cit., p. 163.

**49** B & J 1984, p. 46, cat. no. 58, plate 68. Turner later reworked part of his picture, then exhibited it at the British Institute in 1808 (359).

**50** *The Diary of Joseph Farington* (3 June 1806), ed. Kathryn Cave, Vol. 7, New Haven and London 1982, p. 2777.

**51** Review in *Publications of Art*, 1808, quoted in B & J 1984, p. 46.

**52** David Hill, *Turner's Birds*, Oxford 1988, p. 10 and note 5, p. 26.

**53** B & J 1984, cat. no. 59, plate 69. For a full critical note on the picture, partly drawn on here, see Eric Shanes, *TS*, Vol. 6, no. 2, 1986, pp. 68–70.

**54** The author is indebted to Brian Lavery for pointing out (in correspondence) that the only battle in which the *Victory* served as Nelson's flagship was Trafalgar.

**55** Adm. 95/46, f. 156.

**56** Lyon 1993, pp. 105–7.

**57** B & J 1984, cat. no. 119, plate 126.

**58** Cooke's watercolour is fully documented. The compiler is indebted to John Munday for the following information, traced in his research on E.W. Cooke in the Cooke family papers (private collection), MSS 33: (i) entry in Cooke's diary, 1 July 1838: 'Made drawing of Temeraire off Sheerness during day…', followed the next day by 'Finished drawing and framed it…'; (ii) pen and ink sketch of the finished drawing, no. 35 in Cooke's record book, annotated 'The Temeraire 90 – off Sheerness – with the Admiral in his gig &c – 1st July 1833'.

**59** Lavery 1989, p. 124.

**60** Quotations are from the last logs kept for the *Temeraire* by Captain Kennedy (Adm. 51/3742) and by W. Bradshaw, Master (Adm. 52/4016, Part V).

**61** Adm. 51/3742.

**62** SS *Lightning*, the Navy's second steamboat, ordered 1823, is repr. D.K. Brown, *British Paddle Warships*, London 1993, p. 7.

**63** See Lyon 1993, where 'fates' given below details of individual ships include the years in which they were broken up, etc. The calculation in Hawes 1972, p. 26, that eighteen 'Trafalgar' ships had been broken up by 1837 appears to include ships which had been burnt or wrecked. The *Victory*, launched in 1765, much restored and now in Portsmouth

Dockyard (where she is open to the public), remains in commission as a ship of the Royal Navy (Lavery 1989, p. 323, ill.).

**64** Adm. 92/8, pp. 232, 243.

**65** Adm. 51/3328: Hill's log, *Ocean* July–December 1838.

**66** Hill sent over a final party 'to clear the lump of the Temeraire's stores' on 4 September, the day before the *Temeraire* was towed away from Sheerness. The interval between Beatson's purchase of the *Temeraire* on 16 August 1838 and the final clearance of her stores on 4 September may partly explain why the tow did not begin until 5 September.

**67** E. Fraser, *Famous Fighters of the Fleet*, London 1904, p. 283. In his Introduction, Fraser describes himself as a 'landsman who presumes to write of nautical matters' (a warning to this and other authors).

**68** M. Davies, *National Gallery Catalogues. The British School*, London 1946, p. 150; 2nd edn, 1959, p. 97.

**69** B & J 1984, cat. no. 377, p. 299.

**70** Postle 1988, pp. 248–50.

**71** Shanes 1988, p. 59; Shanes 1990, p. 41.

**72** Adm. 92/8, p. 251: summary of out-letter from the Surveyor of the Navy, 1 August 1838: 'As it will be necessary that the Temeraire should be fitted with Jury Masts before she is removed to Plymouth to be taken to Pieces, I would recommend that the Superintendant at Sheerness be directed accordingly.' The author is indebted to Pieter van der Merwe for bringing this letter to her attention; and see Uden 1961, p. 56.

**73** A letter of 22 July 1878 from Henry Liggins, a keen amateur naval historian, to Charles Eastlake, Director of the NG (NG Archives, dossier 524), confirms that 'the masts &c. were not in her [the *Temeraire*] when she was towed up'. He adds 'they were removed at Sheerness 28 August 1838'. His letter is the source of Davies's statement (1946, p. 150; 1959, p. 97) that the masts were removed at Sheerness. But some of Liggins's dates (including the date of 28 September for the *Temeraire*'s departure from Sheerness) are wrong. The chief purpose – and use – of Liggins's letter was to correct errors deriving from Thornbury in the then current NG catalogue.

**74** The following notes are taken from E.J. Beck, *Memorials to serve for a History of the Parish of St Mary, Rotherhithe*, London 1907, p. 170, and from [A.J. Beatson], *Genealogical Account of the Family of Beatson*, Edinburgh [1860], p. 13. William Beatson (1802–58) came from a Scottish (Co. Fife) family. He succeeded his father David Beatson in the management of the Rotherhithe ship-breaking business. His great-uncle Robert Beatson LL.D. (1742–1818) is noticed in the *Dictionary of National Biography* as the author of several historical works,

including *Military and Naval Memoirs of Great Britain from 1707 to the present time*, 1790. William Beatson's younger brother John (b. 1806), who recorded the *Temeraire*'s arrival at the family wharf in a lithograph (Plate 24) later built St Paul's Chapel of Ease, Rotherhithe.

**75** James Thornton Loveday, Surveyor of Risks, Phoenix Fire Office, London, *Loveday's London Waterside Surveys...showing the whole of the Wharves and Granaries with Buildings connected therewith situated on the bank of the Thames*, 1857, no. 54 (hand-coloured copy, Southwark Local Studies Library).

**76** The journal used here, Southwark Local Studies Library MS 1684, is inscribed by Beatson inside the front cover 'John Beatson adjoining the Surry Canal Entrance/ Rotherhithe/June 29 1835–31 Dec. 1839'. The ledger is Southwark Local Studies Library MS 4639; in this (p. 456) Beatson details his account with the Lords Commissioners of the Admiralty. The author is indebted to her colleague Neal Soleil, NG Accounts Dept, for expert help on the spot with MSS 1684 and 4639.

**77** Beatson MS 4639, p. 456.

**78** *Shipping and Commercial Gazette*, 15 September 1838, p. [4], echoed in other newspapers.

**79** Beatson MS 1684, p. 654, entry no. 328.

**80** This report appears almost verbatim, three months later, in the columns of *The Public Ledger and Newfoundland General Register* for 28 December 1838, XVI, no. 1637, p. [4]. This proves to be the source (at second hand) for the report quoted by E. H. Fairbrother, *Notes and Queries*, 13th ser., I, 3 November 1923, pp. 348–9, who gave his source only as 'PRO C.O. 199/4'.

**81** The author is indebted to Anne Cowne, Information Administrator, Lloyd's Register of Shipping, Fenchurch Street, London, for piloting her through the registers. *Lloyd's Register* for 1 July 1838–30 June 1839 includes entries for both *Samson* and *London* (unpag., alphabetically arranged). The entry for the *London* records her owners as the London [sic] Steam Towing Co., presumed to be an error for (or identical with) the Thames Steam Towing Co., especially as the master of both the *London* and the *Samson* is named as T. Train. Both the *Samson* and the *London* remain in *Lloyd's Register* until 1843.

**82** Beatson MS 1684, p. 652, entry no. 456: hire of stores and payment of deposit; ibid., p. 740, entry no. 456. Beatson returned stores to Woolwich Yard on 1 February 1839, and his deposit was repaid in full.

**83** Tim Nicholson, *Take the Strain: The Alexandra Towing Company and the British Tugboat Business, 1833–1987*, Liverpool 1990, pp. 20–1.

**84** Beatson MS 4639, p. 347: shares held since 1834.

**85** For Beatson's account with William Scott, see MS 4639, f. 409.

**86** Beatson MS 1684, p. 655, entry no. 409.

**87** *Nautical Almanac*, 1838: information kindly communicated by Pieter van der Merwe.

**88** *The Times*, Thursday 13 September 1838, p. 6 column f: 'On Thursday last she [the *Temeraire*] was towed up the river…', i.e. Thursday 6 September. *The Times* reporter was either uninterested in or unaware of the fact that as the tow took two days, it presumably started from Sheerness the previous day, 5 September. Entries in Beatson's journal are consistent with the operation beginning on 5 September.

**89** Van der Merwe notes that the 1838 data were supplied by the Tidal Branch of the Ministry of Defence Hydrographic Department, Taunton, to which modern tide-table variations were then applied; he adds: 'The Thames is somewhat different today but this is unlikely to introduce a significant effect given that the timings are only approximate.'

**90** F.C. P[ickernell], in a letter to *The Times*, 20 December 1877, p. 6 column e.

**91** *Gentleman's Magazine*, new ser., X , p. 456.

**92** *The Times*, p. 6 column f.

**93** Reported in the *Morning Chronicle*, 7 September 1838, p. [4].

**94** Nicholson, op. cit., p. 22 (plates [3] and [4] following p. 24); see also Frank Bowen, *A Hundred Years of Towage, 1837–1933*, Gravesend 1933, p. 19.

**95** See P.N. Thomas, *British Steam Tugs*, London 1983, pp. 13–14.

**96** *The Times*, 12 October 1838, p. 7 column a.

**97** Repr. Beck 1907, op. cit., following p. 212.

**98** *Poetical Works*, ed. F. Page, revised J. Jump, Oxford 1970, p. 253, lines 70–4.

**99** *Shipping and Mercantile Gazette*, 15 September 1838, op. cit. The first point the paper makes is that the *Temeraire* is the largest ship ever sold by the Admiralty to be broken up, i.e. not broken up in its own dockyards. The second point has not been investigated here; probably the *Shipping and Mercantile Gazette* knew what it was talking about.

**100** *The Times*, p. 7 column a.

## PART II
## J. M. W. TURNER, RA

**1** RA 1790 (644); W 10.

**2** W 138; repr. in colour Wilton 1987, p. 9.

**3** B & J 1984, cat. no. 1, plate 1.

**4** The phrase is John Constable's. After sitting next to Turner at an RA dinner in September 1813, Constable wrote: 'I always expected to find him what I did – he is uncouth but has a wonderfull range of mind' (letter to Maria Bicknell, 30 September 1813, *John Constable's Correspondence*, ed. R.B. Beckett, Vol. II, Ipswich 1964, p. 110). John Gage includes Constable's phrase in the title of his book *J.M.W. Turner: 'A Wonderful Range of Mind'*, New Haven and London 1987.

**5** Ruskin, *Works*, Vol. 13, p. 379.

**6** See Wilton 1987, p. 19, and p. 18, fig. 17.

**7** See Bachrach 1994, pp. 12–13.

**8** Known as 'The Bridgewater Seapiece': B & J 1984, cat. no. 14, plate 11; Bachrach 1994, pp. 28–9, repr.

**9** *Diary*, Vol. 4, ed. K. Garlick and K. Macintyre, London 1982, pp. 1544, 1541.

**10** Known as 'The Egremont Seapiece': B & J 1984, cat. no. 18, plate 14.

**11** B & J 1984, cat. no. 48, plate 58; Bachrach 1994, p. 30, repr.

**12** B & J 1984, cat. no. 52, plate 62; Bachrach 1994, p. 33, repr.

**13** B & J 1984, cat. no. 54, plate 64.

**14** B & J 1984, cat. no. 109, plate 118.

**15** See Wilton 1990, *passim*; for 'The Fallacies of Hope', see particularly pp. 61–8. For Turner's verses, transcribed by Rosalind Mallord Turner, see ibid., pp. 149–81.

**16** B & J 1984, cat. no. 252, plate 255.

**17** Schetky offered to lend Turner a sketch of the *Temeraire* in the action; in a letter of 23 December 1823 (Gage 1980, no. 101, p. 90) thanking him for the offer, Turner explained that he could 'bring in very little, if any, of her hull, because of the Redoutable', but that he would be grateful for a sketch of the *Victory* and *Neptune*, and for particulars of other ships. See Winifred Greenaway, 'The Marine Man, J.C. Schetky', *TS*, Vol. 7, no. 2, 1987, p. 22.

**18** See B & J 1984, p. 140. 'A View of Windsor Castle', acquired for the Royal Collection in 1987, exh. The Queen's Gallery, Buckingham Palace, *A Royal Miscellany from the Royal Library, Windsor Castle*, pp. 23–4, no. 21, repr.

**19** B & J 1984, cat. no. 350, plate 354.

**20** See Bachrach 1994, p. 59.

**21** Cyrus Redding (1785–1870) published three slightly varying accounts of this excursion: (i) in an obituary notice of Turner, *Fraser's Magazine*, XLV, February 1852, pp. 152–3; (ii) in *Fifty Years' Recollections, Literary and Personal...*, London 1858, Vol. I, pp. 199–200, from which the passages quoted above are taken; (iii) in *Past Celebrities whom I have Known*, London 1866, Vol. I, pp. 48–50.

**22** Wilton 1987, p. 104.

23 *Autobiographical Recollections of the late Charles Robert Leslie, R.A.*, ed. Tom Taylor, London 1860, Vol. I, p. 205.

24 See Richard Seddon, 'Turner and Cotman: Two Portraits by Cornelius Varley', *Burlington Magazine*, LXXXVII, 1945, p. 202, plate B; Michael Pidgley, 'Cornelius Varley and the Graphic Telescope', *Burlington Magazine*, CXIV, 1972, p. 782, note 12; R.J.B. Walker, 'The Portraits of J.M.W. Turner: A Check-List', *TS*, Vol. 3, no. 1, 1983, p. 25, no. 14, repr. In 1990 a bronze portrait medal derived from Cornelius Varley's portrait and designed by Philip Nathan (who gives Turnera more windswept appearance and a huge greatcoat collar) was issued by the British Art Medal Society (repr. *TS News*, no. 56, November 1990).

25 For Turner's engraved work, see generally Rawlinson 1908–13; Lyles and Perkins 1990; Herrmann 1990; Shanes 1990; Piggott 1993.

26 See Cecilia Powell, *Turner's Rivers of Europe*, exhibition catalogue, Tate Gallery, London 1991, p. 11 and *passim*.

27 B & J 1984, cat. no. 330, plate 331.

28 B & J 1984, cat. no. 337, plate 339.

29 Herrmann 1990, p. 139.

30 Wilton 1979, p. 186.

31 For *The Ports of England*: W 756; Shanes 1990, p. 135.

32 For *Picturesque Views in England and Wales*: W 838; Shanes 1990, p. 276 repr.

33 See 'Winchelsea, Sussex, and the Military Canal', for *Views in Hastings*: W 430; Shanes 1990, p. 32 repr.; 'Martello Towers, near Bexhill, Sussex', for *Picturesque Views on the Southern Coast of England*: W 460; Shanes 1990, p. 267 repr.

34 For *The Ports of England*: W 755; Shanes 1990, p. 134 repr.

35 For *Picturesque Views in England and Wales*: W 847; Shanes 1990, p. 218 repr.

36 Identified in Warrell 1991, p. 48, no. 41, repr. in colour p. 20.

37 For *Picturesque Views in England and Wales*: W 813; Shanes 1990, p. 189 repr.

38 For *Picturesque Views in England and Wales*: W 835; Shanes 1990, p. 211 repr.

39 For *Picturesque Views in England and Wales*: W 787; Shanes 1990, p. 166 repr. (private collection, UK).

40 e.g. 'Longships Lighthouse, Land's End, Cornwall', for *Picturesque Views in England and Wales*: W 864; Shanes 1990, p. 243; 'Lowestoffe Lighthouse', for proposed 'East Coast of England': W 896; Shanes 1990, p. 151 repr. See also 'The Eddystone Lighthouse': W 506; Shanes 1990, p. 268, and 'The Bell Rock Lighthouse': W 502, now coll.

National Gallery of Scotland, Edinburgh, repr. Campbell 1993, p. 71, no. 65a.

41 For *The Rivers of England*: W 739; Shanes 1990, p. 109 repr.

42 For *The Southern Coast*: W 452; Shanes 1990, p. 47 repr.

43 For *The Southern Coast*: W 484; Shanes 1990, p. 72 repr.

44 For *The Ports of England*: W 751; Shanes 1990, p. 130 repr.

45 For *Marine Views*: W 503; Shanes 1990, p. 124 repr., with a discussion of the Greek costumes worn by some of the customers.

46 B & J 1984, cat. no. 360, plate 363.

47 For *Picturesque Views in England and Wales*: W 858; Shanes 1990, p. 237 repr.; Milner 1990, pp. 53–5, repr.

48 Transcribed by R.M. Turner in Wilton 1990, p. 158.

49 Ruskin, *Works*, Vol. 13, p. 435.

50 For *Marine Views*: W 505; Shanes 1990, p. 122 repr.

51 For *The Ports of England*: W 753: Shanes 1990, p. 132 repr.

52 Geoffrey Body, *British Paddle Steamers*, Newton Abbott 1972, pp. 18–30.

53 For a projected series of 'Views in London and its environs': W 515; Shanes 1990, p. 272 repr. For the project and its failure, see Shanes 1990, p. 11; it was to have included 'View of London from Greenwich', Shanes 1990, p. 246, 'Old London Bridge and its vicinity', Shanes 1990, p. 129 repr., and 'The Custom House', Shanes 1990, p. 128 repr.

54 Shanes 1990, no. 247 (untraced); sold Christie's 13 November 1990 (lot 118, repr. in colour), now private collection, USA. Information here is taken from Pieter van der Merwe, '"Calais in Twelve Hours": Turner's "Tower of London" and the early cross-Channel steam-packets', *TS News*, no. 57, March 1991, pp. 11–13.

55 For this drawing (W 513; Shanes 1990, no. 246; then untraced) rediscovered by Andrew Wyld in 1994 in the Metropolitan Museum of Art, New York, see Eric Shanes, 'A busily majestic prospect rediscovered', *Apollo*, CXL, no. 392, October 1994, pp. 28–9 (repr. in colour).

56 Ruskin uses the phrase 'the "New Forest" of mast and yard that follows the winding of the Thames' (*Works*, Vol. 13, p. 28), though not specifically of this drawing.

57 Wilton 1987, pp. 201–2.

58 An old photograph of the house (collection Margate Public Library) is reproduced in Bernard Falk, *Turner the Painter: His Hidden Life*, London 1938, facing p. 206. For Turner at Margate, see Brown 1987, pp. 7, 10.

59 Body, op. cit., p.29.

60 W.C. Oulton, *Picture of Margate*, 1820 [n.p.].

61 R.B. West, Steward of the *Eclipse, Aquatic Itinerary, or Excursions from London to Margate*, London 1819, pp. 9–12; Body, op. cit., p. 31.

62 B & J 1984, cat. no. 464, plate 465.

63 For *The Southern Coast*: W 470; Shanes 1990, p. 61 repr.

64 For *The Ports of England*, Ashmolean Museum, Oxford: W 757; Shanes 1990, p. 136 repr.

65 For this project see particularly Alfrey 1982, pp. 188–9, 192–3, and his notes to works in the 1982–3 exhibition, which relate the finished drawings to sketches and studies. For Turner's drawings of the Rhine, Meuse and Mosel (and projects to publish them), see Powell, op. cit., *passim*

66 *Gentleman's Magazine*, CIII, part ii, December 1833, p. 530.

67 W.S. Rodner, 'Turner and Steamboats on the Seine', *TS*, Vol. 7, no. 2, 1987, pp. 36–41, to which this author is much indebted.

68 W 957; Alfrey 1982, p. 344 no. 79, fig. 715.

69 Rodner, op. cit., pp. 36, 41 note 7.

70 W 951; Rodner, op. cit., p. 38; Piggott 1993, p. 50, p. 86 no. 29, repr.

71 W 1001, where related studies are noted.

72 W 952; Alfrey 1982, p. 424 no. 117, repr.; Rodner, op. cit., p. 38 fig. 4.

73 W 953; Alfrey 1982, p. 396 no. 90, repr.; Rodner, op. cit., p. 38 fig. 5.

74 Alfrey 1982, p. 396.

75 W 960; Alfrey 1982, p. 421 no. 110, repr.

76 Quoted by Herrmann 1990, p. 167.

77 W 968; Alfrey 1982, p. 436 no. 128, fig. 898.

78 See Rodner, op. cit., p. 40.

79 W 969; B & J 1984, cat. no. 353, plate 357.

80 Alfrey 1982, p. 346 no. 81, repr.

81 Possibly the earliest connection was made by M.B. Huish, *The Seine and the Loire. Illustrated after drawings by J.M.W. Turner R.A.*, 1895 [n.p.]. Alfrey 1982, p. 436, observes that 'The juxtaposition of steamships and sailing vessels inevitably suggests the processes of change, the old displaced by the new'.

82 Anon., 'The Poetical Works of Thomas Campbell', *Quarterly Review*, LVII, December 1836, pp. 349–61. Rodner, op. cit., p. 40 note 37, notes that the reviewer was William Henry Smith.

83 Ibid., pp. 348–9.

84 Thomas Campbell, 'Lines on the View from St Leonards', 1831, lines 75–6, *Poetical Works*, London 1907, p. 290.

85 *Gentleman's Magazine*, CIII, part ii,

December 1833, p. 530; *Turner's Annual Tour – 1834* was published towards the end of 1833.

**86** Ruskin, *Works*, Vol. 13, p. 470: 'I bought the whole book from his good Margate housekeeper, in whose house, at Chelsea, he died'. Ruskin sold forty 'sketches and drawings' by Turner at Christie's, 15 April 1869 (lots 1–40); lots 13–22, all Margate drawings, probably came from this sketchbook, though Ruskin specified this only in his catalogue notes for lots 14–17.

**87** E. Yardley, 'A Margate Sketchbook Reassembled?' *TS*, Vol. 4, no. 2, 1984, pp. 53–6, eight ills.

**88** W 1392; Courtauld 1980 (14); Yardley, op. cit., p. 55.

**89** 1869 Ruskin sale (lot 16); Yardley, op. cit., p. 54.

**90** 1869 Ruskin sale (lot 14); W 1397; Yardley, op. cit., p. 53.

**91** 1869 Ruskin sale (lot 18); Yardley, op. cit., p. 54.

**92** [Andrew Wyld] *English Watercolours and Drawings*, exhibition catalogue, Agnew's, London 1993 [n.p.], no. 34, repr. 7.

**93** Andrew Wilton, 'A Rediscovered Turner Sketchbook', *TS*, Vol. 6, no. 2, 1986, p. 10.

**94** Ruskin, *Works*, Vol. 13, pp. 280–1.

**95** B & J 1984, cat. no. 347, plate 350.

**96** Published by Robert Cadell, Edinburgh 1833–4, with 24 illustrations by Turner; see Piggott 1993, pp. 53–6, 99. For Turner's Scottish tour of 1831, see *Turner in Scotland*, exhibition catalogue, Aberdeen Art Gallery and Museum 1982, p. 50 (including map).

**97** The author is much indebted to Janet Carolan and David Wallace-Hadrill for information (in correspondence) about the likely date of Turner's trip to Staffa, steamboat services for tourists to Staffa, the likely viewpoint in Turner's painting and the suggestion that Turner has indicated the location of Fingal's Cave in it by a dark patch on the cliffs. For their own work on Turner's Scottish tour in 1831, see 'Turner in Argyll in 1831: Inverary to Oban', *TS*, Vol. 11, no. 1, 1991, pp. 20–9, and 'Turner at Novar House, Evanton, 1831', *TS News*, no. 68, December 1994, pp. 14–15.

**98** See *Steamboat Companion; or Stranger's Guide to the Western Isles & Highlands of Scotland*, Lumsden & Son, 3rd edn, Glasgow 1831, of which Turner could have had a copy. An Appendix (p. 277) lists the names and tonnage of 62 'Steam-Vessels Employed in the Trade of the Clyde' (to Liverpool, Dublin and Belfast as well as many Scottish ports) including the *Maid of Morven*, 52 tons.

**99** Gage 1980, no. 288, pp. 209–10.

**100** John Gage, 'The Distinctness of

Turner', *Journal of the Royal Society of Arts*, CXXIII, 1974–5, p. 449.

**101** Quoted by Gage 1974–5, op. cit., p. 451.

**102** Walter Scott, *Poetical Works*, Vol. 10, Edinburgh 1833, p. 149, canto IV:X.

**103** Piggott 1993, pp. 56, 58, Appendix B, no. 85, repr. p. 19.

**104** Sir Joseph Banks's discovery of Fingal's Cave in 1772 had been publicised in Thomas Pennant, *A Tour in Scotland, and Voyage to the Hebrides*, 1772, 2nd edn, London 1776. William Daniell included four illustrations of the cave in the 1817 volume of his eight-volume *Voyage Round Great Britain*, London 1814–25 (one repr. Lyles 1992, p. 45).

**105** Gage 1974–5, op. cit., p. 449, seems to suggest that Fingal's Cave is not only invisible in Turner's picture but that Turner's view is of the opposite side of the island.

**106** W 499. Frequently reproduced; see particularly Martin Butlin, *Turner Watercolours*, London 1974, p. 34 plate 8; Gage 1987, p. 160, plate 238 and detail (which has inspired our Plate 58) plate 239.

**107** Edith Mary Fawkes (recounting the eyewitness account of Walter Fawkes's son Hawkesworth), 'Turner at Farnley', MS, typescript copy in NG Library. For Turner's friendship with Walter Fawkes, see David Hill, *Turner's Birds*, Oxford 1988.

**108** W 500, 501: Wilton 1979, p. 357, suggests that the three may have been executed *en suite*.

**109** W 487. Known since at least 1902 as 'Plymouth Harbour: Towing in French Prizes', and sold under that title at Christie's, 14 November 1989 (lot 131, repr.). Robert Upstone, 'Picture Note 1: "Portsmouth Harbour: The Entry of the French Prizes"', *TS*, Vol. 10, no. 1, 1990, pp. 54–5, argues that the setting is Portsmouth, with spectators on the Great or Saluting Platform just outside the entrance to Portsmouth Harbour. In correspondence with the author, Katy Ball, Assistant Local History Officer, Guildhall, Portsmouth, doubts whether Portsmouth is depicted, primarily because of 'the absence of any land in the painting': a view from the Saluting Platform at Portsmouth (which, she points out, has always been 'quite plain and flat'), would have shown that 'almost immediately opposite is Fort Blockhouse and the sea walls on the Gosport side of the harbour'. Plymouth seems a likelier identification; but Turner's setting may be generalised, or drawn from imperfect recollection.

**110** 'Devonshire Coast No. 1' sketchbook, transcribed by R. M. Turner in Wilton 1990, pp. 170–6; quotations are from ff. 180v, 174v, 176v.

**111** Alison Kelly, *Mrs Coade's Stone*, Upton-upon-Severn 1990, pp. 224–7, with unnumbered ills. on these pages.

**112** R.W. Liscombe, *William Wilkins, 1778–1839*, Cambridge 1980, pp. 114–17, plate 45; Kelly, op. cit., pp. 237–8, detail of Britannia and the Victories repr. p. 238. See also N. Pevsner, *The Buildings of England, East Norfolk and Norwich*, 1973, pp. 153–4.

*PART III*

*TURNER AND 'THE FIGHTING TEMERAIRE'*

**1** W. Cosmo Monkhouse, *Turner*, London 1879, p. 120.

**2** *The Letters of John Keats*, ed. Maurice Buxton Forman, Oxford 1947, p. 53; letter to Benjamin Bailey, of 8 October 1817.

**3** Conceivably the buildings with the clock-tower is the Quadrangle Storehouse built in 1822; see Jonathan G. Coad, *The Royal Dockyards 1690–1850*, London 1989, plate 119.

**4** B & J 1984, cat. nos 75, 76, plates 85, 86.

**5** On receiving a copy of the book, Ruskin wrote to his father, 1 December 1861, 'That is a dreadful book of Thornbury's – in every sense – utterly bad in taste and writing…', *Works*, Vol. 13, p. 554.

**6** W. Thornbury, Preface to *The Life of J.M.W. Turner*, 2nd edn, London 1877, p. v.

**7** W. Thornbury, *Life of J.M.W. Turner*, London 1862, Vol. 1, pp. 337–8, 342.

**8** *Quarterly Review*, III, 1862, pp. 450–82.

**9** He also published other anecdotal works, including *Haunted London*, London 1865, and *Old and New London*, London 1873–8.

**10** Thornbury, op. cit., Vol. 2, pp. 335–6.

**11** Stanfield's denial was noted by H. A. J. Munro of Novar, one of Turner's principal patrons, in his copy of Thornbury's *Life* (now coll. Francis Haskell), Vol. 1, p. 335. B & J 1984, p. 229, mention Munro's note; the author is indebted to Pieter van der Merwe for giving her its wording.

**12** Monkhouse, op. cit., p. 120.

**13** Thornbury entitles Turner's painting (exh. 1839) 'The Old Téméraire', the title given to the engraving, published in 1845. The *Temeraire* did not take part in the Battle of the Nile (1 August 1798), fought a month before she was launched. In 1838 she was broken up at Rotherhithe, not Deptford.

**14** E. Fraser, *Famous Fighters of the Fleet*, London 1904, p. 215.

**15** C.L. Hind, *Turner's Golden Visions*, London 1910, pp. 193–4.

**16** Ann Saunders, *The Art and Architecture of London*, Oxford 1984, p. 415: 'The way to

Rotherhithe passes Cherry Garden Pier, now desolate, where Turner sat to paint The Fighting Temeraire as she was towed to her last mooring.'

**17** Amy Woolner, *Thomas Woolner, R.A....His Life in Letters*, London 1917, pp. 260–1.

**18** Eleven watercolours by Turner (including 'Sunset on shore') were in Woolner's sale, Christie's, 21 May 1895, among lots 85–99.

**19** The author is indebted to Helen Valentine, Assistant Librarian, RA Library, for establishing that General Assemblies of the RA began at 8 p.m. If Turner had witnessed the towing of the *Temeraire* up-river that day, he would have had plenty of time to go on to the RA in the evening.

**20** MSS, RA Library: General Assembly Minutes, GA IV, and Council Minutes, C VIII. Turner was present at the next Council meeting on 20 October 1838 and the next General Assembly on 5 November 1838.

**21** Gage 1980, p. 174 no. 227.

**22** Gage 1980, p. 216 no. 302.

**23** By anon.; presented by James Lahee (presumably the copper-plate printer; see Gage 1980, p. 263) to the NG 1860; now Tate Gallery, British School nineteenth century, N 02730 (TG 2730); Finberg 1961, p. 370; R.J.B. Walker, 'The Portraits of J.M.W. Turner: A Check-List', *TS*, Vol. 3, no. 1, 1983, p. 28 no. 28.

**24** See K. Solender, *Dreadful Fire! Burning of the Houses of Parliament*, exhibition catalogue, Cleveland Museum of Art, 1984, passim. For the nine watercolour studies, all from the same sketchbook (TB CCLXXXIII 1–9), Tate Gallery, see Lyles 1992, pp. 71–3, plates 50–2; Wilton 1979, p. 218. The two oil paintings are (1) Philadelphia Museum of Art (B & J cat. no. 359, plate 364); (2) Cleveland Museum of Art (B & J cat. no. 364, plate 365).

**25** Piggott 1993, p. 63. The watercolours are now all in the collection of the National Gallery of Scotland; see Campbell 1993, pp. 53–4, all repr. in colour pp. 55–64, plates 40–59. See also Piggott 1993, pp. 62–5, 89, Appendix B p. 100, nos 121–40.

**26** *Poetical Works*, ed. J.L. Robertson, 1907, pp. 189–90.

**27** Gerald Massey, *Havelock's March and Other Poems*, London 1861, pp. 147–50.

**28** Pictures sold at Christie's, 24–5 March 1865, by John Pound, Mrs Booth's son by her first marriage, included 'Sunset: a study for "The Old Temeraire"', 32 x 49.5 cm, possibly a title conferred on it by Christie's (lot 203, bought Agnew, later sold to F.R. Leyland, but now untraced); see B & J 1984, p. 231: 'no authentic claimant to be this oil study has yet been produced.'

**29** B & J 1984, cat. no. 378, plate 382.

**30** B & J 1984, cat. no. 379, plate 383.

**31** B & J 1984, cat. no. 380, plate 384.

**32** B & J 1984, cat. no. 381, plate 385.

**33** See B & J 1984, cat. 376.

**34** Herman Melville, *Billy Budd* (left unfinished at Melville's death in 1891; first published 1924), as published in *Billy Budd, Sailor, and Other Stories*, Penguin edn, Harmondsworth 1970, p. 374.

**35** The author is most grateful to Brian Lavery, National Maritime Museum, Greenwich, for help in identifying these details; but he should not be held responsible for their interpretation. See Lavery 1989, chapter 3, 'Masts, Sails and Rigging', pp. 73–80.

**36** Letter to Ruskin, 25 September 1884; Ruskin, *Works*, Vol. 35, p. 576.

**37** Since John Beatson hired tugs from the Thames Steam Towing Co. to tow the *Temeraire* (see p. 41), the flag they flew would probably have been lettered 'TSTC', like that in the vignette illustration to their share-certificate (Plate 21).

**38** P. N. Thomas, *British Steam Tugs*, London 1983, p. 14: Thomas notes that the model of the *Monarch* at Newcastle shows 'a pole mast and a tall thin funnel aft of high paddle boxes'.

**39** The first quotation is from Thackeray (see note 48), the second from the *Morning Chronicle*, 7 May 1839.

**40** Tom Taylor, 'The Turner Gallery at Marlborough House', *The Times*, 13 November 1856, p. 7 column a.

**41** September 1844, p. 294, when the painting was exhibited at Mr Hogarth's, 60 Great Portland Street, in connection with the engraving of it which Hogarth was to publish the following year.

**42** This was probably first recognised by M.B. Huish, *The Seine and the Loire. Illustrated after Drawings by J.M.W. Turner R.A.*, London 1895 [n.p.]. Describing 'Between Quilleboeuf and Villequier', he notes 'Turner made a sketch of the flotilla of steam-tug and vessels coming down stream, and unconsciously obtained a first idea for his picture of the *Temeraire*'.

**43** NG 14, formerly in the collection of John Julius Angerstein; one of the two paintings by Claude next to which Turner stipulated that two of his own paintings bequeathed to the National Gallery should hang (see p. 107). George Jones recollected (*c.*1857–63) that 'when Turner was very young' he went to see Angerstein's pictures; 'the Sea Port by Claude' made him 'burst into tears', explaining passionately, 'Because I shall never be able to paint any thing like that picture' (Gage 1990, p.4). Gage (ibid., note 1) suggests that the 'Sea Port' which moved Turner to tears was probably 'The Embarkation of the

Queen of Sheba' NG 14, rather than NG 5 or NG 30); see Michael Kitson, 'Turner and Claude', *TS*, Vol. 2, no. 2, 1983, p. 5, for the alternative suggestion that it was 'Seaport with the Embarkation of Saint Ursula' (NG 30). The question must largely rest on the interpretation of Jones's recollection (some forty years later) that Turner was 'very young' when so moved by the Claude; Angerstein acquired NG 14 in 1803, when Turner was 28, and NG 30 in or soon after 1791, when Turner was about 16.

**44** W 1408; National Gallery of Ireland, Dublin, Henry Vaughan Bequest; Barbara Dawson, *Turner in the National Gallery of Ireland*, Dublin 1988, p. 112, repr. in colour p. 113.

**45** W 1004; Milner 1990, no. 30, repr. p. 61. Because it is inscribed 'Mar', the vignette is traditionally known as 'Margate', but the inscription may relate to some other port, e.g. Marseilles.

**46** A selection of reviews of the picture, based on Frances Butlin's research, is given in B & J 1984, pp. 229–31.

**47** His contributions to *Fraser's Magazine*, 1832–53, are listed in Malcolm Elwin, *Thackeray: A Personality*, London 1932, Appendix II, pp. 380–2.

**48** 'A Second Lecture on the Fine Arts, by Michael Angelo Titmarsh, Esq.', *Fraser's Magazine*, Vol. 10, June 1839, p. 744.

**49** *Blackwood's Edinburgh Magazine*, XLVI, July–December 1839, pp. 312–3.

**50** *Gentleman's Magazine*, XII, new ser., 1839, p. 66.

**51** Rawlinson, Vol. 1, 1908, no. 661 (p. 342), with details of engraver's proofs (three states). Re-issued by J. Hogarth as one of 42 plates (three after Turner) in the *Royal Gallery of British Art*, 2 vols, London 1851; Herrmann 1990, pp. 233, 245, 271, and plate 198, as republished 1859 (Rawlinson, I, p. 207) for *The Turner Gallery*, 1859–75.

**52** Thornbury, op. cit., Vol. 1, p. 336–7.

**53** The engraving (R 657) is reproduced by Herrmann 1990, p. 230 plate 185.

**54** Letter of 25 June 1884, published in Ruskin, *Works*, Vol. 31, p. 576. Leslie introduced this recollection with 'I think it was Stanfield who told me...', and added that he thought the 'mechanical marine artist' was [Edward] Duncan.

**55** *Autobiographical Recollections of the Late Charles Robert Leslie, R.A.*, ed. Tom Taylor, Vol. 1, London 1860, p. 207, reports a conversation (about 'Staffa') in which Turner said 'Indistinctness is my fault'. See John Gage, 'The Distinctness of Turner', *Journal of the Royal Society of Arts*, Vol. CXXIII, 1974–5, pp. 448–57.

56 J. Dafforne, *The Turner Gallery*, London 1877, p. 232.

57 Ruskin, *Works*, Vol. 3, p. 299.

58 *Art Journal*, 1856, p. 289.

59 Published in parts by James S. Virtue, 1859–61 (and also in parts, with commentaries, in *The Art Journal*: for *The Old Téméraire* see III, new ser., 1864, p. 108, plate facing) and later in book form, in various editions; Rawlinson notes (Vol. 2, p. 356) that the plates were so frequently reprinted that later impressions are weak. The alteration to *The Old Téméraire* does not appear to have been noticed by Rawlinson, nor by others, including Herrmann 1990 (who reproduces the *Turner Gallery* engraving of 1859, p. 245), and Shanes 1990 (who discusses the 1845 engraving, and reproduces a detail of it, pp. 42–3).

60 See *The Times*, 17 December 1877 (p. 9 column f); 18 December (p. 10 column a), 20 December (p. 7 column e), 21 December (p. 9 column f).

61 Hind, op. cit., p. 193.

62 W.L. Wyllie ARA, *J.M.W. Turner*, London 1902, p. 117.

63 B & J 1984, cat. no. 334, plate 336.

64 First published in *The Less Deceived*, Hessle, East Yorkshire 1951, p. 18.

65 B & J 1984, cat. no. 399, plate 402.

66 The last entries in the log are quoted by Allan Cunningham, *The Life of Sir David Wilkie*, Vol. 3, London 1843, pp. 473–4.

67 *The Times*, 11 June 1841, p. 7 column d; for further reports in *The Times* during 1841, see 15 June, p. 5 column d; 17 June, p. 5 column d; 24 June, p. 5 column f (and later).

68 Rawlinson, Vol. 2, no. 744.

69 *The Times*, 6 May 1842, Supplement.

70 Finberg 1961, p. 391.

71 Ruskin, *Works*, Vol. 13, p. 159.

72 John McCoubrey, 'War and Peace in 1842: Turner, Haydon and Wilkie', *TS*, Vol. 4, no. 2, 1984, p. 3.

73 Gage 1980, no. 161 p. 137. Turner's watercolour 'Funeral of Sir Thomas Lawrence: A sketch from memory' was exh. RA 1830 (W 521; Lyles 1992, p. 41, 1, repr.).

74 RA 1842 (647); 36 x 26.7 cm, collection Sir Brinsley Ford CBE; Finberg 1961, p. 390.

75 Transcript by Rosalind Mallord Turner, in Wilton 1990, p. 175.

76 *The Poems of Tennyson*, ed. Christopher Ricks, Vol. 1, London 1987, no. 156, p. 385.

77 B & J 1984, cat. no. 400, plate 403.

78 See B & J 1984, cat. no. 399, p. 248, citing Marcia Briggs Wallace, 'J.M.W. Turner's Circular, Octagonal and Square Paintings

1840–1846', *Arts Magazine*, Vol. 55, April 1979, pp. 107–17.

79 In a fictitious report of various artists' reactions to Matthew Cotes Wyatt's statue of Wellington, *Punch* (Vol. 9, 1846, p. 205) represents Turner as saying 'Heroes should be commemorated in painting as I have commemorated NAPOLEON some years since in my "Rock Limpet" picture – a noble work, but not understood'.

80 B & J 1984, cat. no. 138, plate 141; Brown 1992, p. 92 no. 35; Bachrach 1994, pp. 37–8, no. 7 repr.

81 Piggott 1993, Appendix B, no. 101, pp. 57, 59, repr. p. 112 no. 101.

82 *Macbeth*, III, iv, 136.

83 Le Comte de Las Cases, *Mémorial de Sainte-Hélène*, 4th edn, Vol. 6, Brussels 1828, p. 304.

84 B & J 1984, cat. no. 398, plate 404.

85 Ruskin, *Works*, Vol. 3, p. 571.

86 C. Ninnis, 'The Mystery of the Ariel', *TS News*, no. 20, 1981, pp. 6, 8.

87 See Lorenz Eitner, 'The Open Window and The Storm-tossed Boat: an Essay in the Iconography of Romanticism', *Art Bulletin*, XXXVII, 1955, pp. 287–90.

88 B & J 1984, cat. no. 387, plate 392.

89 Rawlinson no. 745; engraved for *The Turner Gallery*, 1859.

90 Collection City of Bristol Museum and Art Gallery; see Francis Greenacre, *Marine Artists of Bristol. Nicholas Pocock, Joseph Walter*, exhibition catalogue, City of Bristol Museum and Art Gallery, Bristol 1982, p. 96, repr.

91 *The Athenaeum*, 14 May 1842, no. 759.

92 Ruskin, *Works*, Vol. 29, p. 584.

93 *Fraser's Magazine*, June 1844, Vol. 10, pp. 712–13.

94 B & J 1984, cat. no. 409, plate 414. For a full and illuminating discussion of the picture, see Gage 1972, *passim*.

95 Davies 1946, op. cit., p. 99; Gage 1972, pp. 21–8; additional information kindly communicated by David Elliott, The Transport Trust, in correspondence.

96 The self-styled 'eminently practical' character in Charles Dickens, *Hard Times* (1854), who believes that knowledge consists only of facts and statistics.

97 Gage 1972, p. 19.

98 Gage 1972, pp. 19–21, 33; detail of the horse-drawn plough p. 18, plate 5.

99 Rawlinson no. 748.

100 Ruskin, *Works*, Vol. 35, p. 601 note 1.

101 David Lampe, *The Tunnel*, London 1963, *passim*.

102 Gage 1972, p. 22; for Brunel, see L.T.C. Rolt, *Isambard Kingdom Brunel*, London 1957, pp. 103–62.

103 *Art-Union*, September 1844, p. 294.

104 Turner's draft letter may be to Elhanan Bicknell. A letter from Ruskin to his father, 15/19 September 1845, reports 'Bicknell is quarrelling with Turner on two points – he gave him 120Gs for the loan of Temeraire to engrave & Turner besides demands 50 proofs. Bicknell resists and sends 8' (quoted in Peter Bicknell and Helen Guiterman, 'The Turner Collector: Elhanan Bicknell', *TS*, Vol. 7, no. 1, 1987, p. 35).

105 While it was in the 1839 RA exhibition, Turner appears to have priced the picture at 250 guineas; see his letter [12 June 1839] to [? William] Marshall (Gage 1980, no. 172–3 and note 2) and also an (?earlier) undated letter, not certainly relating to the 'Temeraire' (Gage 1980, no. 226, pp. 173–4).

106 Thornbury, op. cit., Vol. 2, p. 342.

107 Leslie, op. cit., Vol. 1, pp. 203, 207; W.J. Stillman, *Autobiography of a Journalist*, London 1901, Vol.1, p. 106; Gage 1980, pp. 258, 265.

108 Presumably (given the likely date) 'Fishing Boats bringing a Disabled Ship into Port Ruysdael', exh. 1844, B & J 1984, cat. no. 408, plate 413, rather than 'Port Ruysdael', exh. 1827, sold to Elhanan Bicknell in March 1844, B & J 1984, cat. no. 237.

109 Whittingham 1989 (see note 113), part 3, p. 48.

110 See Selby Whittingham, 'Turner's Second Gallery', *TS News*, no. 42, November 1986, pp. 8–11. 'The Artist showing his works' is one of a series of three pictures by George Jones shortly after Turner's death (all collection Ashmolean Museum, Oxford). In 'Turner's Body in his coffin in his gallery' (repr. Whittingham 1986, op. cit., p. 8; Wilton 1987, p. 239, fig. 307), Jones depicts the gallery from the opposite end; with the 'Fighting Temeraire' on the right, next to a chair. The third picture is 'Turner's Burial in the Crypt of St Paul's'.

111 Letter to Dr John Brown, 7 October (?1852), published in Virginia Surtees, *Reflections of a Friendship: John Ruskin's Letters to Pauline Trevelyan*, Vol. 1, 1979, p. 269.

112 *Journals and Correspondence of Lady Eastlake*, ed. Charles Eastlake Smith, Vol. 1, London 1895, pp. 188–9. The painting Lady Eastlake calls 'The Wallhalla' is 'The Opening of the Wallhalla', B & J 1984, cat. no. 401, plate 410.

113 See particularly Finberg 1961, pp. 329–31, 415, 424, 441–55; Martin Butlin, 'The Turner Bequest', B & J 1984, pp. xxii–iv; Selby Whittingham, *An Historical Account of the Will of J.M.W. Turner, R.A.*, parts 1–3, duplicated 1989, *passim*; Selby Whittingham, *The*

*Fallacy of Mediocrity*, parts 1–2, duplicated 1992, *passim*.

**114** For a description of Turner's house, see Selby Whittingham, '47 Queen Ann Street West', *TS News*, no. 39, February 1986, pp. 8–11.

**115** Report submitted to the Trustees at their meeting of 17 November 1856, NG Board Minutes, vol. 4, 1856, p. 58.

**116** For Ruskin's participation, see Ian Warrell, *Through Switzerland with Turner. Ruskin's First Selection from the Turner Bequest*, exhibition catalogue, Tate Gallery, London 1995, pp. 21–8; see also Ian Warrell, 'R. N. Wornum and the First Three Loan Collections: A History of the Early Display of the Turner Bequest Outside London', *TS*, Vol. 2, no. 1, 1991, pp. 36–9.

**117** Jacqui McComish, NG Archives, notes that *The Vernon Gift*, Tate Gallery exhibition catalogue, London 1993, p.7, states that the Gift included eight sculptures; in fact it included seven. Robert Behnes's bust of Robert Vernon was presented to the NG by Queen Victoria, Prince Albert and other subscribers in recognition of Vernon's generosity. The count of '157 pictures' included Landseer's 'High Life' and 'Low Life' framed together, and counted as one picture.

**118** J. Ruskin, *Notes on the Turner Gallery at Marlborough House, 1856*, London 1857, pp. 76–7.

**119** B & J 1984, cat. no. 2, plate 2.

**120** B & J 1984, cat. no. 402, plate 408.

**121** *Art Journal*, December 1856, p. 380.

**122** e.g. *The Times*, 10 November 1856: 'Sir Charles Eastlake and Mr Wornum have done their best with the miserable space and more miserable means of lighting at their disposal [in Marlborough House], but...the sight of these noble works, so cabined, cribbed and confined...ought to rouse the public, if anything can, to the disgraceful want of a national building to receive the treasures of art we already possess...The Turner, the Vernon and the Sheepshanks Collections are now the property...of the public: when will the public become so sensible of their treasures as to demand a fitting habitation for them? With possessions worthy of a great and enlightened nation, we hide them in holes and corners... as if we were half ashamed of what we hold.'

**123** *The Times* reviewer was Tom Taylor, dramatist and editor of *Punch*, noticed in the *Dictionary of National Biography*.

**124** Trustees' Meeting 8 July 1861, NG Board Minutes, Vol. 4, p. 278.

**125** The author is indebted to Rachel Billinge and David Thomas for help in identifying the pictures. The hang in 1883 appears to be as follows (NG acquisition numbers given in brackets): Part of west wall,

left: 'Rome from the Vatican' (503), above (?) 'Spithead: Boats and Crews recovering an Anchor' (481); right: 'Phryne going to the Public Baths as Venus' (522), above 'Snow Storm: Hannibal and his Army crossing the Alps' (490). North wall: first tier from corner: (top) 'Van Tromp's Shallop, at the Entrance of the Scheldt' (537); (middle) (?) 'The Opening of the Wallhalla' (533); (on the line) 'Apollo and Daphne' (520) . Second tier: 'The Parting of Hero and Leander' (521), above 'Dido directing the Equipage of the Fleet' (506). Third tier: (top) 'The "Sun of Venice" going to Sea' (535); (middle) 'Whalers boiling Blubber' (547); (on the line) 'The Fighting Temeraire...' (524). Fourth tier: 'The Vision of Medea' (513), above 'Childe Harold's Pilgrimage: Italy' (516). Fifth tier: 'Decline of the Carthaginian Empire' (499), above 'The Bay of Baiae, with Apollo and the Sibyl' (505). Many of these were later (at different times) transferred to the Tate Gallery.

**126** *Illustrated London News*, Vol. 87, 21 November 1885, p. 534, 28 November 1885, pp. 553–4.

**127** See tables of 'permissions to copy paintings in oil', published in the NG *Annual Report*, 1856–93. The author is indebted to Jacqui McComish, NG Archives, for abstracting this information.

**128** These three pictures, with many others, were later transferred to the Tate Gallery.

**129** Maclise's pencil drawing (approx. 18 x 10 cm, Victoria and Albert Museum, London, Forster Bequest F-88) is repr. *Art Journal*, 1888, p. 130. Samuel Jones Bouverie Haydon (1815–91), etched portraits of William Etty and Christina Rossetti. E.H. Yardley. 'A little-known portrait of Turner', *TS News*, no. 33, 1984, p. 7, reproduces an evidently later and clumsier attempt to make the portrait resemble Turner. Clarkson Stanfield's 'Wooden Walls of Old England' is untraced; for this and for Henry Dawson's three versions of the subject, see *Henry Dawson*, exhibition catalogue, Nottingham University Art Gallery, 1978, pp. 52–9. For Francis Danby, see Francis Greenacre, *Francis Danby*, exhibition catalogue, Tate Gallery and Bristol City Art Gallery, 1988, pp. 118–19, no. 47, plate 17. Wyllie's painting is in the collection of the National Maritime Museum, London, repr. Peter Kemp and Richard Ormond, *The Great Age of Sail*, London 1992, fig. 119. Albert Goodwin's two watercolour copies are (1) 56.8 x 80 cm, sold Christie's, 5 November 1993 (lot 450, repr., with a quotation from Goodwin's *Diary*, 10 November 1914); (2) 26 x 37.5 cm, repr. C. Beetles, *Albert Goodwin RWS*, [1986], plate 153.

**130** *The Year of Trafalgar*, ed. Henry Newbolt, London 1905, p. 213.

**131** R. Monckton Milnes, *Poetry for the People and Other Poems*, London 1840 [n.p.]. The sonnet was republished (minus its title) in

*TS News*, no. 63, March 1993, p. 1.

**132** Copyright 'D & S 3508': the author is indebted to her colleague Marcus Latham for tracing this to 1857. For John William Hobbs (1799–1877), composer, concert singer (tenor) and chorister, see *Macmillan's Encyclopaedia of Music and Musicians*, 1938, p. 826. J. Duff, who published this and many other songs, is more elusive. Hawes 1972, p. 30, identifies him with the amateur Scottish poet James Duff who published patriotic verses c.1805, and suggests that 'The Brave Old Temeraire' was written c.1812–20; but Duff's penultimate line '...gilds the sunset of her fate' is surely inspired by Turner's picture (exh. 1839).

**133** Rawlinson, Vol. 2, p. 418 no. 862.

**134** 7th Ser., VI, 1888, p. 371.

**135** Gerald Massey (1828–1902) is noticed in the *Dictionary of National Biography, 1901–11*, from which quotations from Ruskin and Tennyson are taken. A memoir by Samuel Smiles was published in Massey's *Poetical Works*, London 1861.

**136** First published in *Havelock's March and Other Poems*, London 1861.

**137** *The Writings of Herman Melville*, ed. H.C. Horford with Lynn North, Vol. 15, *Journals*, Evanston and Chicago 1989, p. 128; this entry is under 'April 29th 30th – May 1st [1857]'.

**138** Melville's poem was first published in *Battle Pieces and Aspects of the War*, 1866; Herman Melville, *Works*, Standard Edition, Vol. 16, Chicago 1924, pp. 11–13.

**139** The song about 'Mary, Mary of the flowing hair', the 'mascotte' of the *Temeraire* relates not to Turner's *Temeraire* but to her namesake, a First World War destroyer.

**140** J.J. Colledge, *Ships of the Royal Navy: An Historical Index*, 1, Newton Abbot 1969, p. 552. In 1939 the Admiralty ordered another [fifth] *Temeraire* to be built, but these orders were suspended on the outbreak of war and cancelled in 1944.

**141** *The Times*, 12 October 1838, p. 7 column a.

**142** R.H. Hackwood, *Notes and Queries*, 7th Ser., 10 November 1888, p. 371, stated that he had been aboard the *Temeraire* (? fifty years earlier), and 'vividly' recalled seeing Nelson's signal on a brass plate let into the deck 'somewhere about "abaft the binnacle"'; he also recalled 'being much struck on seeing a round shot cut out of her timbers, with a portion of a sailor's or soldier's cap, which had evidently been used as a wad, still adhering to it'. Subsequent correspondence in *Notes and Queries* seemingly failed to trace the engraved signal. According to *The Times*, 12 October 1838, op. cit., Nelson's signal was 'painted on canvas, and affixed to the signal-box on the quarter-deck': but this report is unreliable.

**143** Information kindly supplied by Linda Tait; and see Uden 1961, pp. 84–5.

**144** See E.J. Beck, *Memorials to Serve for a History of St Mary, Rotherhithe*, London 1907, pp. 74–5, with a photograph of St Paul's Chapel facing p. 74.

**145** The author is indebted to June A. Stubbs (a Beatson descendant) for telling her about the chair, and to Kate Pinkham, Registrar, Whanganui Regional Museum, New Zealand, for information about it.

**146** 'Neptune' was last sold, from the John T. Dorrance Jr collection, at Sotheby Parke-Bernet, New York, 18 October 1989 (lot 3, repr.).

**147** Henry Humpherus, *History of the Watermen's Company*, n.d., pp. 391–2. For the ship model, see Ewart C. Freeston, *Prisoner of War Ship Models, 1775–1825*, London 1973, reprinted 1987, pp. 101–2.

**148** Established 1837: see also A. King, 'George Godwin and the Art Union of London 1837–1911', *Victorian Studies*, Vol. 8, December 1964, pp. 101–30, and Elizabeth Aslin, 'The Rise and Progress of the Art Union of London', *Apollo*, LXXXV, no. 59, 1967, pp. 12–16.

**149** *Report of the Council of the Art-Union for the year 1876*, 1876, pp. 6, 14, 23–131 (list of members), 109–114 (list of prizes selected), back cover (list of statuettes, medals, etc.). Twenty-four British artists, from Reynolds and Gainsborough to Roberts and Gibson, had already featured on Art-Union medals; the fact that Turner's portrait had been used in 1859 for the RA medal may have delayed his selection by the Art-Union.

**150** Leonard Charles Wyon (1826–91) was the eldest son of William Wyon (1795–1851), engraver of the first coin portrait of Queen Victoria (see Plate 19); like his father, he became chief engraver to the royal mint.

**151** See Richard Ormond, *Daniel Maclise 1806–1870*, exhibition catalogue, National Portrait Gallery, London 1972, pp. 118–19 (nos 125–7; repr.); and see ibid., pp. 107–16 for Maclise's 'Death of Nelson' and 'Meeting of Wellington and Blucher'.

**152** The author is indebted to Peter Boughton, Grosvenor Museum, Luke Syson, British Museum, and Paul Williamson, Victoria and Albert Museum. Laurence Brown, *British Historical Medals, 1837–1901*, London 1987, p. 311, no. 3030, notes other examples in the Ashmolean, Fitzwilliam, Museum of London and National Maritime Museums. It appears that one example of the medal was struck in gold (now in the Museum of London), as well as thirty in silver and an unrecorded number in bronze.

**153** The author is indebted to Thomas Woodcock, Somerset Herald, for elucidating the motto and its particular relevance.

### THE MAKING OF 'THE FIGHTING TEMERAIRE'

**1** Martin Davies, *National Gallery Catalogues. The British School*, 2nd edn, revised, London 1959, p. 96, ref. 1 under no. 498.

**2** *National Gallery Report*, 1857: 'Director's Report', p. 38.

**3** Unusual and complex formulations for paint media are well-documented in Turner's work, particularly the use of gelled or bodied paints comprising drying oil mixed with natural resin, principally mastic, with other additions such as fillers and driers. See, for example, Joyce Townsend, *Turner's Painting Techniques*, Tate Gallery, London 1993, pp. 50–1.

**4** Analysis by Raymond White of samples from 'The Fighting Temeraire' using gas-chromatography linked to mass-spectrometry has revealed a fairly conventional oil technique, based on walnut oil, in some cases showing evidence of having been pre-polymerised by heat treatment. Minor resinous components were also detected in certain samples and some late touches in the sunset suggested the use of a spirit-soluble varnish medium of 'gum benzoin' (Siam or Sumatra benzoin) as a binder.

**5** The particular effects of poor drying caused by the use of bitumen in British eighteenth-century pictures came to be known as 'craquelure Anglais' in nineteenth-century writings. However, it was recognised that there were a great many methods of preparing bitumen (or asphaltum) for painting, and while some recipes were disastrous, others yielded quite satisfactory results. See R. Redgrave and S. Redgrave, *A Century of Painters of the English School…*, London 1866; also A. H. Church, *The Chemistry of Paints and Painting*, London 1890, pp. 208–9.

**6** Turner's almost obsessive interest in yellow as a colour and its role in painting light is commented on by John Gage in *Colour in Turner: Poetry and Truth*, London 1969, pp. 19–20, 124. The relatively large range of yellow pigment types found in Turner's palettes and paintings, particularly his oil paintings, is described by Joyce Townsend in 'The Materials of J.M.W. Turner: Pigments', *Studies in Conservation*, Vol. 38, 1993, pp. 242–3, 249.

**7** In addition to a variety of earth pigments of yellow, red, orange and brown, a considerable range of more brightly coloured warm pigments is used in 'The Fighting Temeraire', including deep red lakes, several kinds of orange and orange-yellow chromate pigment, red lead, vermilion, iodine scarlet as well as tints made with white of these colours.

**8** Barium chromate pigment (lemon yellow) was popularised by George Field who prepared it as a substitute for the very expensive platina yellow he had introduced first as a permanent pigment under the name 'lemon yellow'. Field probably supplied Turner with specimens of the new chromate pigment and its use in 'The Fighting Temeraire' is particularly early. See John Gage, *George Field and his Circle*, exhibition catalogue, Fitzwilliam Museum, Cambridge 1989, pp. 30, 36, 56.

**9** The very fugitive nature of iodine scarlet was noted early on in its history by, among others, George Field (*Chromatography; or a Treatise on Colours and Pigments, and of their Powers in Painting, &c.*, London 1835) and George Bachhoffner (*Chemistry as Applied to the Fine Arts*, London 1837, p. 100); several authors note the seductive appeal of the pigment, for example Field, who writes: 'Its charm and beauty and novelty have recommended it, particularly to amateurs; and its dazzling brilliancy might render it valuable for high and fiery effects of colour….' (p. 94). Since iodine scarlet was less opaque than vermilion it was suitable for a wash-like technique in watercolour, but as Field's experiments showed, even more vulnerable to fading in this medium.

**10** Turner is known to have used absorbent unsized egg-based primings for his canvas painting, some prepared in the studio by his father. Poor adhesion between this form of ground and diluted oil paint laid on top is inevitable; egg-based primings are also vulnerable to mould growth. See Townsend, *Turner's Painting Techniques*, op. cit., pp. 18–23, 71, and Townsend, 'The Materials and Techniques of J.M.W. Turner: Primings and Supports', *Studies in Conservation*, Vol. 39, 1994, pp. 148–9. The canvas for 'The Fighting Temeraire' is prepared with an off-white ground, found to be a mixture of lead white and calcium carbonate bound in oil. This may be a commercial preparation, although the canvas is not one of the suppliers' more common standard sizes.

**11** See note 4 above on paint medium. Some of the early paint layers are remarkably thin and extensively brushed out in a highly fluid manner. Drying oil was the only binder detected in any quantity by analysis, but a diluent, if one had been used, would not have survived in the paint film.

**12** B & J 1984, cat. no. 484, plate 485.

# BIBLIOGRAPHY

*A SHORT BIBLIOGRAPHY OF WORKS CONSULTED OR CITED IN THE TEXT*

## THE TEMERAIRE AND THE ROYAL NAVY

Admiralty records, MSS, Public Record Office, Crown copyright; the class chiefly consulted was Adm. 51, Captains' Logs. Also consulted: Adm. 52: Masters' Logs; Amd. 53: Ships' Logs; Adm. 92: Surveyors' Letter-Books; Adm. 95: Ships' Covers.

Robert Gardiner, ed., Brian Lavery, consultant: *The Line of Battle*, London 1992

Louis Hawes, 'Turner's "Fighting Temeraire"', *Art Quarterly*, XXXV, Detroit 1972, pp. 23–48

Brian Lavery, *The Ship of the Line*, 2 vols: I *The Development of the Battlefleet, 1650–1850*, London 1983; II *Design, Construction and Fittings*, London 1984

Brian Lavery, *Nelson's Navy: The Ships, Men and Organisation, 1793–1815*, London 1989

Brian Lavery, *Building the Wooden Walls*, London 1991

David Lyon, *The Sailing Navy List. All the Ships of the Royal Navy – Built, Purchased and Captured, 1688–1860*, London 1993

Martin Postle, 'Chance Masterpiece: Turner and Temeraire', *Country Life*, 15 September 1988, pp. 248–50

Eric Shanes, 'Picture Note: "The Fighting Temeraire"', *Turner Studies*, Vol. 8, no. 2, 1988, p. 59

Eric Shanes, *Turner's Human Landscape*, London 1990, pp. 38–44

Grant Uden, *The Fighting Temeraire*, Oxford 1961

## TURNER'S LIFE AND WORKS

Nicholas Alfrey *et al.*, *Turner en France*, exh. cat., Centre Culturel du Marais, Paris 1982

Martin Butlin and Evelyn Joll, *The Paintings of J. M.W. Turner*. 2 vols (Text; Plates), London 1977, revised edn 1984

Mungo Campbell, *Turner in the National Gallery of Scotland*, Edinburgh 1993

E. T. Cook and Alexander Wedderburn, eds, *The Works of John Ruskin*, 39 vols, London 1903–12

Malcolm Cormack, *J. M. W. Turner, R.A., A Catalogue of Drawings and Watercolours in the Fitzwilliam Museum, Cambridge*, Cambridge 1975

Barbara Dawson, *Turner in the National Gallery of Ireland*, Dublin 1988

A. J. Finberg, *The Life of J. M. W. Turner, R.A.*, second edn, London 1961

Herbert E. A. Furst, *Individuality and Art*, London 1912 (a discussion centred on 'The Fighting Temeraire')

John Gage, *Turner: Rain, Steam and Speed*, London 1972

John Gage, *Collected Correspondence of J. M.W. Turner*, Oxford 1980

John Gage, *J. M.W. Turner: 'A Wonderful Range of Mind'*, Oxford 1987

Craig Hartley, *Turner Watercolours in the Whitworth Art Gallery*, Manchester 1984

Luke Herrmann, *Turner Prints: The Engraved Work of J. M.W. Turner*, Oxford 1990

Frank Milner, *J. M.W. Turner: Paintings in Merseyside Collections*, Liverpool 1990

W. G. Rawlinson, *The Engraved Work of J.M.W. Turner, R.A.*, 2 vols, London 1908–13

John Ruskin, *Notes on the Turner Gallery at Marlborough House. 1856*, London 1857

(Where the source for other quotations from Ruskin is given as *Works*, see Cook and Wedderburn, fully cited above.)

Eric Shanes, *Turner's England, 1810–38*, London 1990

Andrew Wilton, *The Life and Work of J. M.W. Turner*, London 1979

Andrew Wilton, *Turner and the Sublime*, London 1981

Andrew Wilton, *Turner in his Time*, London 1987

W. L. Wyllie ARA, *J. M.W. Turner*, London 1902

## TATE GALLERY EXHIBITION CATALOGUES

Fred Bachrach, *Turner's Holland*, 1994

David Blayney Brown, *Turner and the Channel: Themes and Variations c.1845*, 1987

David Blayney Brown, *Turner and Byron*, 1992

Anne Lyles, *Young Turner: Early Work to 1800*, 1989

Anne Lyles, *Turner: The Fifth Decade*, 1992

Anne Lyles and Diane Perkins, *Colour into Line*, 1989

Diane Perkins, *Turner: The Third Decade*, 1990

Jan Piggott, *Turner's Vignettes*, 1993

Robert Upstone, *Turner: The Second Decade*, 1989

Robert Upstone, *Turner: The Final Years*, 1993

Ian Warrell, *Turner: The Fourth Decade*, 1991

Ian Warrell, *Through Switzerland with Turner. Ruskin's First Selection from the Turner Bequest*, 1995

Andrew Wilton, *Painting and Poetry. Turner's Verse Book and his Work of 1804–1812*, with transcriptions from Turner by Rosalind Mallord Turner (pp. 148–81), 1990

**1** *Page 8* 'The Fighting Temeraire, tugged to her last berth to be broken up, 1838'. Exhibited RA 1839 (43). Oil on canvas, 90.7 x 112.6 cm. Turner Bequest: London, Trustees of the National Gallery. (NG 524; B & J 377)

**2** *Plate 26* Cornelius Varley (1781–1873): 'J.M.W. Turner at the age of about fifty', *c*.1825. Pencil on paper, 50.3 x 37.4 cm. Inscribed along the left edge of the sitter's coat 'Drawn by C. Varley in Pat$^t$ Graphic Telescope'. Sheffield City Art Galleries (2262).

**3** *Plate 71* 'Rain, Steam, and Speed – The Great Western Railway'. Exhibited RA 1844 (62). Oil on canvas, 90.8 x 121.8 cm. Turner Bequest: London, Trustees of the National Gallery. (NG 538; B & J 409)

**4** *Plate 48* 'Staffa, Fingal's Cave'. Exhibited 1832 (453). Oil on canvas, 90.9 x 121.4 cm. New Haven, Yale Center for British Art, Paul Mellon Collection. (B 1978.43.14; B & J 347)

**5** *Plate 33* 'Dudley, Worcestershire', *c*.1832. Watercolour and bodycolour on paper, 28.8 x 43 cm. Engraved by Robert Wallis for *Picturesque Views in England and Wales*, 1835 (R 282). Board of Trustees of the National Museums and Galleries on Merseyside (Lady Lever Art Gallery, Port Sunlight). (LL 4030; W 858; Milner 26)

**6** *Plate 52* 'The Burning of the Houses of Parliament', 1834. Watercolour and bodycolour with scraping out and stopping out on paper, 30.2 x 44.4 cm. Tate Gallery. Bequeathed by the artist 1856. (D 36235; W 522)

**7** *Plate 10* 'The Battle of Trafalgar, as seen from the Mizen Starboard Shrouds of the Victory'. Exhibited in Turner's Gallery 1806;

British Institution 1808 (359). Oil on canvas, 171 x 239 cm. Tate Gallery. Bequeathed by the artist 1856. (N 00480; B & J 58)

**8** Key sketch for 'The Battle of Trafalgar, as seen from the Mizen Starboard Shrouds of the Victory' (No. 7), identifying the principal figures and describing the action. Watercolour and pen and ink on paper, 18.6 x 23.4 cm. Tate Gallery. Bequeathed by the artist 1856. (D 08266)

**9** 'Quarter Deck of the Victory', drawn on the spot, probably on 23 December 1805. Pencil, watercolour and pen and ink on paper, 42.4 x 56.5 cm. Inscribed by the artist 'Quarter deck of the Victory. J M W Turner' lower right and 'Guns 12$^{lb:rs}$ used in the Ports mark i.x'; inscriptions on the old mount (not in Turner's hand) include 'Splinter hitting marks in pencil/ 9 inches thick', and 'Rail shot away during the action'. Tate Gallery. Bequeathed by the artist 1856. (D 08275)

**10** Model of a two-decker ship of the line, apparently a 74-gun Third Rate, in a glass-fronted case, owned by Turner, who painted in a background (including a similar painted ship) and sea *c*.1810. Overall size 45 x 60 x 19.5 cm. Tate Gallery. Bequeathed by Miss M.H. Turner 1946 (TGA 7315.1).

**11** Models of a ship-rigged sloop of war and three luggers in a glass-fronted case, owned by Turner, who painted in a background and sea *c*.1810. Overall size 29.2 x 45 x 21 cm. Tate Gallery. Bequeathed by Miss M.H. Turner 1946 (TGA 7315.2).

**12** *Plate 1* Nicolaus Heideloff (1761–1837): 'A View of the Royal Navy of Great Britain, 1804'. Engraving, coloured by hand, 61.5 x 45 cm, published London 15 March 1804 by E. Seaton, No. 10 Oxford Street, and by the author, No. 7 Bath Place, New Road, Fitzroy Square. Greenwich, National Maritime Museum.

**13** *Plate 5* 'Shipbuilding (An Old Oak Dead)', *c*.1832. Pencil and watercolour vignette, approx. 10 x 14 cm on paper 19.1 x 24.8 cm. One of two illustrations to Samuel Rogers's poem 'To an Old Oak', engraved by Edward Goodall for the 1834 edition of Rogers's *Poems*. Tate Gallery. Bequeathed by the artist 1856. (D 27692; W 1196; Piggott 45)

**14** *Plate 6* 'A First Rate Taking in Stores'. Watercolour over pencil with scratching out

on paper, 28.6 x 39.7 cm. Inscribed 'J M W Turner 1818' lower right. Lent by kind permission of the Trustees of the Cecil Higgins Art Gallery, Bedford. (P.99; W 499)

**15** *Plate 28* 'Chatham, Kent', *c*.1830–1. Watercolour on paper, 28.2 x 45.7 cm. Based on sketches in the 'Gravesend and Margate' sketchbook (TB CCLXXIX). Engraved by William Miller for *Picturesque Views in England and Wales*, 1832 (R 262). England, Private Collection. (W 838)

**16** 'Ever-Memorable Battle off Cape Trafalgar 21 October 1805', showing the two-column sailing order of the British fleet (with the *Temeraire* immediately astern of the *Victory* in the weather column) as it moved into battle against the line of combined French and Spanish fleets. Above is a map of the coastline, showing 'Cape Trafalgar' to the east of 'Entrance of the Straits of Gibraltar'. Inset below is a vignette of Nelson, fatally wounded. Engraving and aquatint by anon., image 28.7 x 42.3 cm, published 10 December 1805 by Robert Laurie and James Whittle, No. 53 Fleet Street, London. Greenwich, National Maritime Museum (PAF 4725).

**17** William Miller after Clarkson Stanfield RA, 'The Battle of Trafalgar' (exhibited RA 1836). Engraving, 24 x 43 cm, proof before letters [published E. & W. Finden, November 1839]. Greenwich, National Maritime Museum (PAG 9036).

**18** *Plate 67* 'War. The Exile and the Rock Limpet'. Exhibited RA 1842 (353). Oil on canvas, 79.5 x 79.5 cm (canvas is square, but framed as if corners cut). Tate Gallery. Bequeathed by the artist 1856. (N 00529; B & J 400)

**19** *Plate 9* Prisoner-of-war bone model of the *Temeraire*, *c*.1805. Largely bone; some wood in the ship's core and lower mastheads. Hull from figurehead to taffrail 85 cm; gun-deck 68 x 18.5 cm; depth in hold approx. 9 cm. Southampton, City Heritage Services.

**20** *Plate 11* Sketch for the large 'Battle of Trafalgar', *c*.1822–3. Oil on canvas, 90 x 121 cm. One of two oil sketches (both in the Tate) for the very large (259 x 365.8 cm) painting now in the National Maritime Museum. Tate Gallery (B & J 252). Bequeathed by the artist 1856. (N 00556; B & J 251)

**21** *Plate 49* 'French Prizes entering an

English Harbour, (?) Portsmouth', *c.*1818. Watercolour over pencil with scratching out on paper, 28.4 x 39.6 cm. Inscribed 'J M W Turner RA' on the rampart lower right. England, Private Collection. (W 487)

**22** *Plate 53* 'The Battle of the Baltic', *c.*1835. Vignette, watercolour over pencil on paper, 14 x 13 cm. Engraved by Edward Goodall (R 620) for *The Poetical Works of Thomas Campbell*, 1837. Edinburgh, National Gallery of Scotland. (W 1278; Piggott 128; Campbell 47)

**23** *Plate 69* 'The Bellerophon, Plymouth Sound', *c.*1833. Vignette, watercolour over pencil on paper, 13 x 10 cm. Engraved by Edward Goodall (R 540) for the title-page of the concluding volume of Sir Walter Scott's *Life of Napoleon Buonaparte*, Vol. XVI (1835) in *The Miscellaneous Prose Works of Sir Walter Scott*, 1834–6. The Property of the Executors of the 2nd Viscount Camrose. (W 1117; Piggott 101)

**24** *Plate 68* 'The Field of Waterloo', *c.*1817. Watercolour on paper, 28.7 x 38.8 cm. Based on studies made in 1817 on the spot in the 'Waterloo and Rhine' sketchbook (TB CLX). Cambridge, Lent by the Syndics of the Fitzwilliam Museum. (Cormack 14; W 494)

**25** 'Small boats coming alongside an armed vessel in a choppy sea', 1796. Watercolour and some bodycolour on paper, 35.9 x 59.2 cm. Tate Gallery. Bequeathed by the artist 1856. (D 00902)

**26** 'Sheerness: preparatory study', *c.*1823–4. Watercolour on paper, 17 x 24 cm. The finished watercolour is exhibited here as No. 27. Tate Gallery. Bequeathed by the artist 1856. (D 25389)

**27** *Plate 30* 'Sheerness', 1824. Watercolour on paper, 16 x 23.8 cm. For the preparatory study, see No. 26. Engraved by Thomas Lupton for *The Ports of England*, 1828 (R 783; reissued as Plate V in *The Harbours of England*, with text by John Ruskin, 1856). Tate Gallery. Bequeathed by the artist 1856. (D 18153; W 755)

**28** *Plate 18* Edward William Cooke RA (1811–80): 'The Temeraire stationed off Sheerness'. Inscribed 'E W Cooke July 1 1833' lower right. Watercolour on paper, 23 x 32.4 cm. London, The Board of Trustees of the Victoria & Albert Museum (177–1889).

**29** *Plate 29* 'Portsmouth', *c.*1824–5. Watercolour on paper, 16 x 24 cm. Small

pencil studies of Portsmouth harbour and shipping are in the 'Old London Bridge and Portsmouth' and 'Gosport' sketchbooks (TB CCV, CCVI). Engraved by Thomas Lupton for *The Ports of England*, 1828 (R 784; reissued as Plate VII in *The Harbours of England*, with text by John Ruskin, 1856). Tate Gallery. Bequeathed by the artist 1856. (D 18152; W 756)

**30** *Plate 31* 'Castle Upnor, Kent: preparatory study', *c.*1829–30. Watercolour on paper, 33 x 55.1 cm. Inscribed 'H Water' top right corner. Based on studies in the 'Medway' sketchbook (TB CXCIX). The finished watercolour is exhibited here as No. 31. Tate Gallery. Bequeathed by the artist 1856. (D 25246)

**31** *Plate 32* 'Castle Upnor, Kent', *c.*1829–30. Watercolour and bodycolour with some scraping out on paper, 29 x 43.7 cm. For the preparatory study, see No. 30. Engraved by J. B. Allen for *Picturesque Views in England and Wales*, 1833 (R 271). The Whitworth Art Gallery, The University of Manchester. (D 41.1924; W 847)

**32** *Plate 34* 'Dover', *c.*1825. Watercolour on paper, 16.1 x 24.5 cm. Based on a colour study in the 'Ports of England' sketchbook (TB CCII f.14). Engraved by Thomas Lupton for *The Ports of England*, 1827 (R 781; reissued as Plate I in *The Harbours of England*, with text by John Ruskin, 1856). Tate Gallery. Bequeathed by the artist 1856. (D 18154; W 753)

**33** 'Newcastle on Tyne', *c.*1823. Pencil and watercolour on paper, 15.2 x 21.5 cm. Inscribed 'J M W T' in red, lower right (as if sloping up the hill). Based on a pencil study in the 'Scotch Antiquities' sketchbook (TB CLXVII–2). Engraved by Thomas Lupton for *The Rivers of England*, 1823 (R 753). Tate Gallery. Bequeathed by the artist 1856. (D 18144; W 733)

**34** *Plate 46* 'Boats off Margate Pier' *c.*1835–40. Watercolour and bodycolour heightened with white on grey-buff paper, 21 x 27.7 cm. From the 'Margate' sketchbook purchased by Ruskin from Mrs Booth after Turner's death, and broken up by him. England, Private Collection. (W 1397)

**35** *Plate 47* 'Steamers off Margate', *c.*1835–40. Watercolour and bodycolour heightened with white on buff paper, 22.5 x 29.5 cm. From the 'Margate' sketchbook broken up by Ruskin. England, Private Collection.

**36** 'Steamer leaving harbour'. From the 'Whalers' sketchbook *c.*1844–5 (TB CCCLIII). Black and white chalks over grey preparation on paper, 22.1 x 33.2 cm. Tate Gallery. Bequeathed by the artist 1856. (D 35244)

**37** 'Ideas of Folkstone' sketchbook, 1845. Page size 23 x 32.7 cm. Open at f.3: 'Steamer at the pier'. Watercolour. Tate Gallery. Bequeathed by the artist 1856. (D 35363)

**38** 'A steamboat and small craft by a quay', *c.*1829. Probably observed on one of Turner's tours in connection with the 'Rivers of France' project, and sketched on the spot. Pencil, pen and brown ink and grey wash heightened with white on blue paper, 14 x 19.1 cm. Tate Gallery. Bequeathed by the artist 1856. (D 24871)

**39** *Plate 41* 'La Chaire de Gargantua, near Duclair', *c.*1830–2. Bodycolour on blue paper, 13.7 x 18.8 cm. Based on studies in the 'Tancarville and Lillebonne' sketchbook (TB CCLIII). Engraved by Robert Brandard for *Turner's Annual Tour – The Seine, 1834* (R 464). Tate Gallery. Bequeathed by the artist 1856. (D 24671; W 962)

**40** 'Havre, Tower of François 1er: Twilight outside the Port', *c.*1832. Bodycolour on blue paper, 14 x 19.2 cm. Engraved by Robert Wallis for *Turner's Annual Tour – The Seine, 1834* (R 455). Tate Gallery. Bequeathed by the artist 1856. (D 24699; W 953)

**41** *Plate 38* 'Light Towers of the Hève', *c.*1830–2. Watercolour and gouache, with some pen and brown ink, on blue paper, faded to grey, 18.9 x 13.4 cm. Based on pencil sketches in the 'Seine and Paris' sketchbook (TB CCLIV–87v, 88); and see No. 42. Engraved by John Cousen as the frontispiece for *Turner's Annual Tour – The Seine, 1834* (R 453). Tate Gallery. Bequeathed by the artist 1856. (D 24701; W 951)

**42** *Plate 39* 'Light Towers of the Hève', *c.*1830–2. Watercolour over traces of pencil on paper, 19.7 x 15.9 cm. On white paper; perhaps a first idea for the vignette frontispiece of *Turner's Annual Tour – The Seine, 1834* (see No. 41). Board of Trustees of the National Museums and Galleries on Merseyside (Lady Lever Art Gallery, Port Sunlight). (LL 4715; W 1001; Milner 29)

**43** *Plate 60* 'Lighthouse and Harbour', *c.*1832. Watercolour over pencil on paper,

21.1 x 18.4 cm. Inscribed 'Mar-' in pencil, and long known as Margate, but not positively identifiable. Board of Trustees of the National Museums and Galleries on Merseyside (Lady Lever Art Gallery, Port Sunlight). (LL 4398; W 1004; Milner 30)

**44** *Plate 42* 'Between Quilleboeuf and Villequier', c.1830–2. Bodycolour on blue paper, 13.7 x 19.1 cm. Based on a pencil drawing in the 'Tancarville and Lillebonne' sketchbook (TB CCLIII–55v). Engraved by Robert Brandard for *Turner's Annual Tour – The Seine, 1834* (R 470). Tate Gallery. Bequeathed by the artist 1856. (D 24669; W 968)

**45** 'Steamboat off a harbour (? Calais) at sunset', c.1830. Bodycolour on blue paper, 13.6 x 18.8 cm. Tate Gallery. Bequeathed by the artist 1856. (D 24640)

**46** 'Shoal', c.1832. Bodycolour with pen and brown ink on blue paper, 13.9 x 19.1 cm. Tate Gallery. Bequeathed by the artist 1856. (D 24646)

**47** John Beatson's Ledger, 1835–9. MS volume, page size 41 x 27 cm; displayed open at page 456, headed 'The Lords Commissioners of the Admiralty'. Under the date 16 August 1838, John Beatson, the Rotherhithe ship-breaker, records (in the right-hand column) his purchase from the Admiralty for £5,530 of 'Ship Temeraire 104 Guns 2121 Tons – lying Sheerness'. London, Southwark Local Studies Library (MS 1684).

**48** *Plate 21* Thames Steam Towing Company Share Certificate issued in 1836. Engraving with pictorial heading by J.S. Hobbs, 34 x 25 cm. London, Richard F. Moy.

**49** *Plate 23* Model of the tug *Monarch*, c.1870. Wood, with some metal, 16 x 30 x 10 cm, in a display case 33 x 46 x 23 cm. Gravesend, Alexandra Towing Co. (London) Ltd, a subsidiary of Howard Smith Towage and Salvage.

**50** *Plate 24* William Beatson (1806–died c.1870): 'The Temeraire at John Beatson's wharf at Rotherhithe'. Lithograph, image 13.8 x 23.2 cm, from a sketch made in September 1838. Below image, lettered 'Drawn by Wᵐ Beatson. THE TEMERAIRE 104 guns. September 1838', followed by 'This vessel, now lying at the wharf of Mʳ John Beatson of Rotherhithe, (who has purchased her of H.M. Commissioners for/ the purpose of

breaking up,) is the largest ship ever conducted so high up the River Thames, being in fact the largest ever sold/ by government. The name of the Téméraire is immortalized by the distinguised [sic] part she bore in the memorable Battle of Trafalgar when she was commanded by Captain Eliab Harvey.' Greenwich, National Maritime Museum (PAD 6048).

**51** *Plate 25* J.J. Williams Esq., engraved by R.G. & A.W. Reeve: 'The Temeraire at Rotherhithe', c.1838–9. Aquatint, image 22.3 x 32.3 cm. Greenwich, National Maritime Museum (PAD 6047).

**52** J.T. Willmore after J.M.W. Turner: 'The Old Téméraire'. Progress proof, before the addition of the sunset, image 17.8 x 26 cm. London, The Trustees of the British Museum. (1852–7–5–277; R 661 a)

**53** *Plate 62* J.T. Willmore after J.M.W. Turner: 'The Old Téméraire'. Line engraving on steel, image 17.8 x 26 cm; as first published in 1845 (R 661); the engraver has 'corrected' Turner's placing of the tug's funnel foremost. Edinburgh, National Gallery of Scotland.

**54** J.T. Willmore after J.M.W. Turner: 'The Fighting Temeraire'. The plate used to print No. 53 has been reworked for publication in *The Turner Gallery*, 1859 (R 738, and subsequent issues), so that the tug's funnel is foremost, as in Turner's painting. London, Dr Jan Piggott.

**55** *Plate 75* Draft of an unfinished letter from Turner, c.1845, refusing to lend a painting – almost certainly 'The Fighting Temeraire' – to an unidentified engraver or print-publisher. MS, pencil, on the verso of the first leaf of a small sketchbook, 11.2 x 7 cm. London, The Trustees of the British Museum (1981–12–12–15).

**56** *Plate 36* Anon., 'Margate Pier, with Steam Packets' c.1825. Hand-coloured engraving by E. Wallis, image 25 x 35 cm; published by E. Wallis, 42 Skinner Street, London, not dated. Kent Arts & Libraries, Margate Library Local Studies Collection (MAR 1274).

**57** 'A Russian Packet', c.1825. Hand-coloured engraving, 17.8 x 26.8 cm. Greenwich, National Maritime Museum (PAD 6664).

**58** *Plate 57* 'The Magnificent Steam Ship

The Great Western'. Etching and aquatint, printed in colour with much additional hand-colouring in watercolour, image 46.5 x 69.5 cm, by R.J. & A.W. Reeve after Joseph Walter; published 1840, '*In Commemoration of the Establishment of Steam Navigation between Great Britain and America*'. Bristol Museums and Art Gallery (J 463).

**59** *Plate 74* 'The Thames Tunnel'. Broadsheet published by the Thames Tunnel Office, September 1839 (reissue of 1838), 41 x 26 cm. Guildhall Library, Corporation of London.

**60** *Plate 64* 'Sun setting among dark clouds', c.1825–30. Watercolour on paper, 27.3 x 47 cm. Tate Gallery. Bequeathed by the artist 1856. (D 25429)

**61** 'Storm clouds looking out to sea'. From the 'Ambleteuse and Wimereux' sketchbook, 1845 (TB CCCLVII). Watercolour over pencil on paper, 28.7 x 33.5. Tate Gallery. Bequeathed by the artist 1856. (D 35397)

**62** 'Rain Clouds', c.1843–5. Watercolour on paper, 29.1 x 44.1 cm. Tate Gallery. Bequeathed by the artist 1856. (D 36309)

**63** 'Running wave in a cross-tide, evening', c.1825. Watercolour on paper, 17.6 x 26.4 cm. Tate Gallery. Bequeathed by the artist 1856. (D 25433)

**64** *Plate 65* 'Peace – Burial at Sea'. Exhibited RA 1842 (338). Oil on canvas, 87 x 86.5 cm, corners cut, triangular painted corners added. Tate Gallery. Bequeathed by the artist 1856. (N 00528; B & J 399)

**65** *Plate 70* 'Snow Storm – Steam-boat off a Harbour's Mouth, making signals in shallow water, and going by the lead. The author was in this storm on the night the Ariel left Harwich'. Exhibited RA 1842 (182). Oil on canvas, 91.5 x 122 cm. Tate Gallery. Bequeathed by the artist 1856. (N 00530)

**66** *Plate 45* 'Sunset off Margate with mackerel shoals', c.1835–40. Pencil, watercolour and bodycolour on grey-buff paper, 19.1 x 27.9 cm. From the 'Margate' sketchbook broken up by Ruskin. England, Private Collection.

**67** *Plate 43* 'Dawn after the Wreck', c.1841. Pencil, watercolour, bodycolour and touches of red chalk on paper, 25.2 x 36.8 cm. London, Courtauld Institute Galleries (Stephen Courtauld bequest). (9.74; W 1398)

**68** 'Figures on the shore', c.1835–40. Watercolour and bodycolour on grey-buff paper, 22.3 x 29.2 cm. Probably from the 'Margate' sketchbook broken up by Ruskin. England, Private Collection. (W 1386)

**69** 'Clouds over sand', c.1845–50. Watercolour over pencil on paper, 22.8 x 29.5 cm. England, Private Collection. (W 1419)

**70** 'Steamboat and crescent moon', c.1835–40. Pencil and watercolour on paper, 22.9 x 32.7 cm. England, Private Collection. (W 1423)

**71** 'Sun setting over the sea in orange mist', c.1825. Watercolour on paper, 24.3 x 34.5 cm. Tate Gallery. Bequeathed by the artist 1856. (D 25332)

**72** 'Heaped thundercloud over sea and land', c.1835–40. Watercolour and bodycolour, with some white chalk, on grey-buff paper, 22.4 x 29.2 cm. From the 'Margate' sketchbook broken up by Ruskin. London, Courtauld Institute Galleries (Stephen Courtauld Bequest). (2.74; W 1392)

**73** 'Flying scud of thundercloud', c.1835–40. Watercolour and bodycolour, white and red chalks and black crayon, on grey-buff paper, 22.4 x 29.4 cm. From the 'Margate' sketchbook broken up by Ruskin. London, Courtauld Institute Galleries (Stephen Courtauld bequest). (3.74; W 1391, as 'Storm on Margate Sands')

**74** 'Two figures on a beach with a boat', c.1840–5. Oil on millboard, irregular, 24.5 x 34.5 cm. Tate Gallery. Bequeathed by the artist 1856. (D 36681; B & J 499)

**75** 'Red sky over a beach', c.1840–5. Oil on millboard, irregular, 30.5 x 48 cm. Tate Gallery. Bequeathed by the artist 1856. (D 36676; B & J 488)

**76** 'Sunset seen from a beach with a breakwater', c.1840–5. Oil on millboard, irregular, 25.8 x 30 cm. Tate Gallery. Bequeathed by the artist 1856. (D 36679; B & J 497)

**77** Plate 63 'Calais Sands, Low Water, Poissards collecting Bait'. Exhibited RA 1830 (304). Oil on canvas, 73 x 107 cm. Bury Art Gallery and Museum. (B & J 334)

**78** 'Yacht approaching the Coast', c.1835–40. Oil on canvas, 102 x 142 cm. Tate Gallery. Bequeathed by the artist 1856. (N 04662; B & J 461)

**79** Plate 82 Altar chair, one of a pair made from the timbers of the Temeraire and presented by John Beatson, ship-breaker, to St Paul's Chapel of Ease, Rotherhithe, c.1850. Oak, 162 x 65 x 53 cm. London, The Rector and Churchwardens of St Mary's, Rotherhithe.

**80** Plate 81 Barometer made by William and Samuel Jones, c.1840, mounted on oak from the Temeraire, 39 x 10 cm. A silver disc inset in the mount is inscribed '*This oak formed part of the stern post of his Majesty's ship Temeraire 98 that bore so distinguished a part in Nelson's Victory off Cape Trafalgar 21st Oct 1805*'. Greenwich, National Maritime Museum (MT/BM 13)

**81** Plate 85 Gong stand made from the timbers of the Temeraire and presented by H. Castle & Sons to HRH Captain the Duke of York RN (later King George V) on his marriage with Princess May of Teck, 1893. Overall size 109 x 127 x 37 cm, with two inscribed shields. Lent by Her Majesty The Queen.

**82** 'A National Relic'. Photograph, c.1930, of the mantelpiece supported by the carved Atlas-like figures from the stern-galleries of the Temeraire (*see Plate 80*), formerly in the offices of Castles' Shipbreaking Company, Limited, Baltic Wharf, Millbank, London; moved to Bristol on the outbreak of World War II and destroyed by enemy action in 1944. Castles of Plymouth Ltd.

**83** Plate 79 Sheet-music of 'The Brave Old Temeraire', 24.2 x 18 cm. Words by J. Duff, music by J. W. Hobbs, copyright 1857, published by Duff & Stewart, 147 Oxford Street, W., London, probably 1857–8. The wrapper reproduces Thomas Packer's chromolithograph of 'The Fighting Temeraire', published in 1858 by G. P. McQueen (R 862), here compressed to an upright shape. London, Judy Egerton, the gift of Hugh Belsey.

**84** Plate 78 S. Haydon (probably Samuel Jones Bouverie Haydon 1815–91), partly after Daniel Maclise (1806–70): An unidentified artist inspired by Turner and 'The Fighting Temeraire', c.1860. Drypoint, 21.6 x 14 cm; lettered 'S. Haydon' (in reverse) and 'D. Maclise del' within plate. London, National Portrait Gallery.

**85** Plate 84 Turner commemorative medal commissioned by the Art-Union of London 1876. Engraved by Leonard Charles Wyon. Bronze, diam. 5.5 cm. Two medals exhibited, to show both sides. (i) Obverse: portrait of Turner (originally designed by Daniel Maclise and engraved by Leonard Charles Wyon for the Royal Academy Turner Prize Medal); incised 'L.C. Wyon 1876' below shoulder, and lettered 'JOSEPH MALLORD WILLIAM TURNER R.A./1775–1851' around rim; (ii) reverse: a detail from 'The Fighting Temeraire'; lettered 'ART-UNION OF LONDON. 1876.' around rim. London, Trustees of the British Museum (1991–7–40–1); London, The Board of Trustees of the Victoria & Albert Museum (A.2–1971).

**86** Plate 77 Bertha Mary Garnett (exh. 1882–1904): 'A Corner of the Turner Room in the National Gallery'. Exhibited Liverpool Academy 1883 (1424). Oil on canvas, 25.2 x 35.8 cm. Inscribed 'Bertha Garnett/1883' on skirting-board lower right. London, National Gallery Archives Collection (D/E4).

**87** Edward Richard Taylor (1838–1912): 'Twas a Famous Victory'. Oil on canvas, 79.3 x 121.8 cm. Dated 1883; exhibited RA 1883 (104). Birmingham Museums and Art Gallery (1987 P24).

**88** 'The Nelson Column, Trafalgar Square'. Engraving, domed top, 24 x 15.8 cm, margins cut, by J. B. Allen after G. Hawkins; published in *The Art Journal*, Vol. XII, April 1850, facing p. 126. Guildhall Library, Corporation of London (W2 TRA).

Richard Monckton Milnes
*ON TURNER'S PICTURE, OF THE TEMERAIRE MAN-OF-WAR TOWED INTO PORT BY A STEAMER FOR THE PURPOSE OF BEING BROKEN UP*

*Poetry for the People and other Poems*, London 1840

> See how that small concentrate fiery force
> Is grappling with the glory of the main,
> That follows, like some grave heroic corse,
> Dragged by a suttler from the heap of slain.
> Thy solemn presence brings us more than pain—
> Something which Fancy moulds into remorse,
> That We, who of thine honour hold the gain,
> Should from its dignity thy form divorce.
> Yet will we read in thy high-vaunting Name,
> How Britain did what France could only *dare*,
> And, while the sunset gilds the darke'ning air,
> We will fill up thy shadowy lines with fame,
> And, tomb or temple, hail thee still the same,
> Home of great thoughts, memorial Temeraire!

J. Duff

*THE BRAVE OLD TEMERAIRE*

Set to music by J. W. Hobbs, London 1857
Voice *Maestoso* and *declamatory*

Behold! behold! how chang'd is yonder ship,
The wreck of former pride;
Methinks I see her, as of old,
The glory, the glory of the tide
As when she came to Nelson's aid,
The battle's brunt to bear,
And Harvey sought to lead the van
With the brave old Temeraire

The fighting Temeraire,
The fighting Temeraire,
That nobly sought to lead the van,
With the fighting Temeraire.

When sailors speak of Trafalgar,
So fam'd for Nelson's fight,
With pride they tell of her career,
Her onward course, her might.
How, when the victory was won,
She shone triumphant there,
With noble prize on either side.
The brave old Temeraire.

The brave old Temeraire,
The brave old Temeraire,
With noble prize on either side,
The brave old Temeraire.

Our friends depart, and are forgot,
As time rolls fleetly by;
In after years none, none are left,
For them to heave a sigh:
But hist'ry's page will ever mark
The glories she did share,
And gild the sunset of her fate,
The brave old Temeraire

The brave old Temeraire
The brave old Temeraire,
And gild the sunset of her fate,
The brave old Temeraire.

Gerald Massey
*THE FIGHTING TEMERAIRE TUGGED TO HER LAST BERTH*

*Havelock's March and other Poems*, London 1861

It is a glorious tale to tell,
    When nights are long and mirk,
How well she fought our fight; how well
    She did our England's work;
        Our good ship Temeraire;
        The fighting Temeraire!
She goeth to her last long home,
    Our grand old Temeraire.

Bravely over the breezy blue,
    They went to do or die;
And proudly on herself she drew
    The Battle's burning eye!
                    *Chorus*

Round her the glory fell in flood,
    From Nelson's loving smile,
When, raked with fire, she ran with blood,
    In England's hour of trial!
                    *Chorus*

And when our darling of the sea
    Sank dying on his deck;
With her revenging thunders, she
    Struck down his foe—a Wreck!
                    *Chorus*

And when our victory stayed the rout,
    And Death had stilled the storm,
How gallantly she led them out—
    Her prize on either arm!
                    *Chorus*

Her day now draweth to its close,
    With solemn sunset crowned;
To death her crested beauty bows;
    The night is folding round.
                    *Chorus*

No more the big heart in her breast,
    Will heave from wave to wave;
Weary and war-worn, ripe for rest,
    She glideth to her grave.
                    *Chorus*

In her dumb pathos desolate
    As night among the dead!
Yet wearing an exceeding weight
    Of glory on her head.
                    *Chorus*

Good bye! good bye! Old Temeraire;
    A sad, a proud good bye!
The stalwart spirit that did wear
    Your sternness, shall not die.
                    *Chorus*

Thro' battle blast, and storm of shot,
    Your Banner we shall bear;
And fight for it, like those who fought
    Your guns, old Temeraire!
        The fighting Temeraire;
        The conquering Temeraire;
She goeth to her last long home,
    Our grand old Temeraire.

Herman Melville

*THE TEMERAIRE*

(Supposed to have been suggested to an Englishman of the old order by the fight of the *Monitor* and *Merrimac*)

*Battle Pieces and Aspects of War*, New York 1866

The gloomy hulls, in armor grim,
    Like clouds o'er moors have met,
And prove that oak, and iron, and man
    Are tough in fibre yet.

But Splendors wane. The sea-fight yields
    No front of old display;
The garniture, emblazonment,
    And heraldry all decay.

Towering afar in parting light,
    The fleets like Albions forelands shine—
The full-sailed fleets, the shrouded show
    Of Ships-of-the-Line.

    The fighting Temeraire,
        Built of a thousand trees,
    Lunging out her lightnings,
        And beetling o'er the seas—

O Ship, how brave and rare,
    That fought so oft and well,
On open decks you manned the gun
    Armorial.
What cheerings did you share,
    Impulsive in the van,
When down upon leagued France and
    Spain
We English ran—
The freshet at your bowsprit
    Like the foam upon the can.
Bickering, your colors
    Licked up the Spanish air,
You flapped with flames of battle-flags—
    Your challenge, Temeraire!
The rear ones of our fleet
    They yearned to share your place,
Still vying with the Victory
    Throughout that earnest race—
The Victory, whose Admiral,
    With orders nobly won,
Shone in the globe of the battle glow—
    The angel in that sun.
Parallel in story,
    Lo, the stately pair,
As late in grapple ranging,
    The foe between them there—
When four great hulls lay tiered,
And the fiery tempest cleared,
And your prizes twain appeared,
    Temeraire!

But Trafalgar is over now
    The quarter-deck undone;
The carved and castled navies fire
    Their evening-gun.
O, Titan Temeraire,
    Your stern-lights fade away;
Your bulwarks to the years must yield,
    And heart-of-oak decay.
A pigmy steam-tug tows you,
    Gigantic, to the shore
Dismantled of your guns and spars,
    And sweeping wings of war.
The rivets clinch the iron-clads,
    Men learn a deadlier lore;
But Fame has nailed your battle-flags—
    Your ghost it sails before:
O, the navies old and oaken,
    O, the Temeraire no more!

Sir Henry Newbolt

*THE FIGHTING TEMERAIRE*

*The Island Race*, London 1898

It was eight bells ringing,
    For the morning watch was done,
And the gunner's lads were singing,
    As they polished every gun.
It was eight bells ringing,
And the gunner's lads were singing,
For the ship she rode a-swinging,
    As they polished every gun.

*Oh! to see the linstock lighting,*
    *Temeraire! Temeraire!*
*Oh! to hear the round shot biting,*
    *Temeraire! Temeraire!*
*Oh! to see the linstock lighting,*
*And to hear the round shot biting,*
*For we're all in love with fighting*
    *On the Fighting Temeraire.*

It was noontide ringing,
    And the battle just begun,
When the ship her way was winging,
    As they loaded every gun.
It was noontide ringing
When the ship her way was winging,
And the gunner's lads were singing
    As they loaded every gun.

*There'll be many grim and gory,*
    *Temeraire! Temeraire!*
*There'll be few to tell the story,*
    *Temeraire! Temeraire!*
*There'll be many grim and gory,*
*There'll be few to tell the story,*
*But we'll all be one in glory*
    *With the Fighting Temeraire.*

There's a far bell ringing
    At the setting of the sun,
And a phantom voice is singing
    Of the great days done,
There's a far bell ringing,
And a phantom voice is singing
Of renown for ever clinging
    To the great days done.

*Now the sunset breezes shiver,*
    *Temeraire! Temeraire!*
*And she's fading down the river,*
    *Temeraire! Temeraire!*
*Now the sunset breezes shiver,*
*And she's fading down the river,*
*But in England's song for ever*
    *She's the Fighting Temeraire.*

# PICTURE CREDITS

Map by Tony Wilkins: Plate 22

Bedford, The Trustees, The Cecil Higgins Art Gallery: Plates 6, 7

Bristol Museums and Art Gallery: Plate 57

Bury Art Gallery and Museum: Plate 63

Cambridge Central Library, Local Studies: Plate 19

Cambridge, Fitzwilliam Museum: Plates 50, 68

Cambridge, MA, Courtesy of The Fogg Art Museum, Harvard University Art Museums, Gift of Charles Fairfax Murray in honor of W.J. Stillman: Plate 4

Executors of the 2nd Viscount Camrose: Plate 69

Devon, Castles of Plymouth Ltd: Plate 80

Dublin, Courtesy of the National Gallery of Ireland: Plate 59

Edinburgh, National Gallery of Scotland: Plates 53, 62

England, Private Collection: Plate 47

England, Private Collection: Plate 49

England, Private Collection, Courtesy of Agnew's, London: Plates 28, 45, 46

London, The Alexander Towing Co. (London) Ltd. Photo Stuart Rintoul: Plate 23

London, The Trustees of the British Museum: Plates 27, 75, 84

London, Copyright College of Arms: Plate 14

London, Courtauld Institute Galleries (Stephen Courtauld Collection): Plate 43

London, by kind permission of the Crown Estates/Institute of Directors. Photo The Bridgeman Art Library, London: Plates 12 and 13

London, Judy Egerton: Plate 79

London, Guildhall Library, Corporation of London. Photo Geremy Butler Photography: Plate 74

London, Richard F. Moy: Plate 21

London, National Maritime Museum: Plates 1, 2, 16, 24, 25, 81

London, by Courtesy of the National Portrait Gallery. Archive Engravings Collection: Plate 78

London, The Rector and Churchwardens of St Mary's, Rotherhithe: Plate 82

London, Southwark Local Studies Library: Plate 20

London, Courtesy of Spink & Son Ltd: Plate 83

London, Tate Gallery, Turner Collection: Plates 5, 10, 11, 29, 30, 31, 34, 38, 40, 41, 42, 52, 58, 64, 65, 66, 67, 70, p. 144

London, by Courtesy of the Board of Trustees of the Victoria & Albert Museum: Plates 18, 56

Manchester, University of, The Whitworth Art Gallery: Plate 32

Margate Library Local Studies Collection, Kent Arts & Libraries: Plate 36

New Haven, Yale Center for British Art, Paul Mellon Collection: Plates 15, 37, 44, 48

New York, Private Collection: Plate 35

Oxford, Ashmolean Museum: Plate 76

Petworth House, Tate Gallery and the National Trust (Lord Egremont Collection): Plates 3 (Photo John Webb), 17

Port Sunlight, Board of Trustees of the National Museums and Galleries on Merseyside (Lady Lever Art Gallery, Port Sunlight): Plates 33, 39, 60

The Royal Collection © 1995 Her Majesty The Queen: Plate 85

Sheffield City Art Galleries: Plate 26

Southampton City Heritage Services: Plates 9, 55

*Edward Duncan (1803-88): Three pencil sketches, page size 9.5 x 24.8 cm, inscribed 'The Temeraire being towed to Deptford to be broken up'. From an album of the artist's sketches in the collection of Mr Michael Heron, who kindly brought the album into the National Gallery after Neil MacGregor's discussion of the picture on television in the spring of 1995, but too late for inclusion in the main text of this book. The Temeraire is depicted from three angles, with two tugs, correctly, but with her masts in, incorrectly. A further detail indicating that this sketch must be imaginative is the fact that Duncan depicts the yards as 'cock-billed' or slanted, to indicate a ship in mourning. R.C. Leslie (see p. 91 and note 54), noted that when J. T. Willmore was working on the engraving of the 'The Fighting Temeraire' (published in 1845), he had called in 'some marine artist or other', perhaps Duncan, to help over the rigging. If Duncan did assist Willmore, he may have made this sketch then, perhaps as an idea for a picture of his own, evidently not painted.*

# INDEX

TAILPIECE OVERLEAF
*'Studies of steamboats', c.1826-30. Pencil, detail from a page (11 x 17 cm) in Turner's 'Nantes, Angers and Saumur' sketchbook, TB CCXLVIII-17a. Turner Bequest: London, Tate Gallery.*